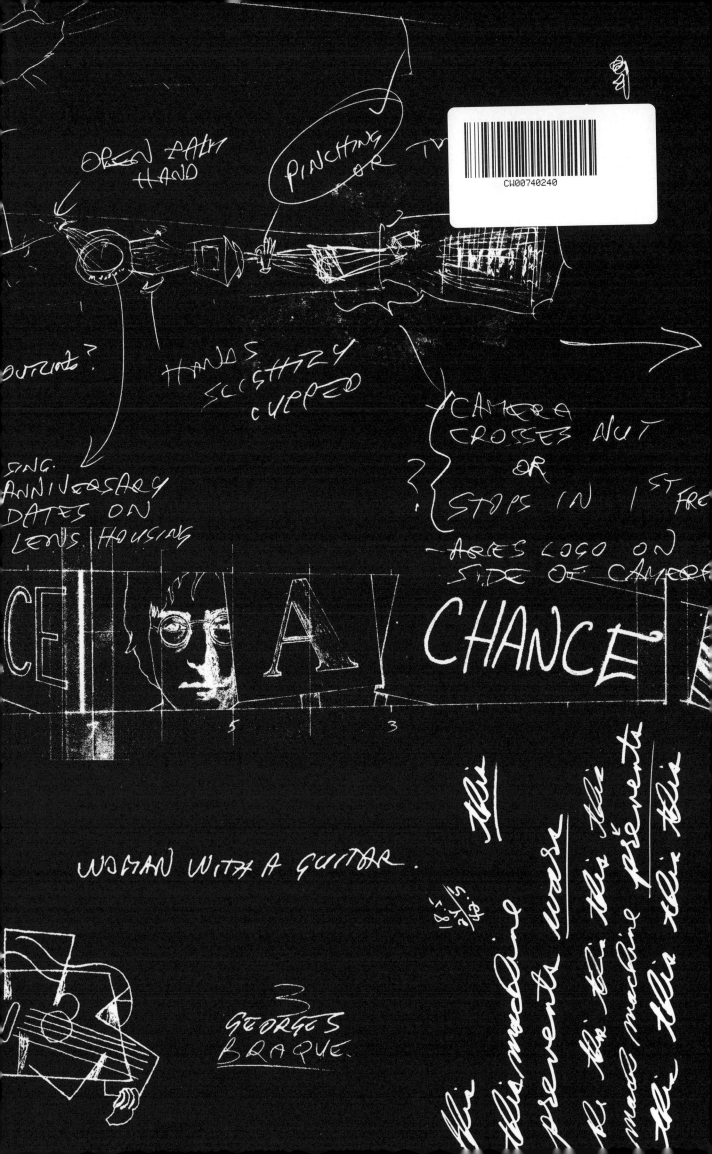

GRAND COMPLICATIONS

GRAND

COMPLICATIONS

50 GUITARS
+ **50** STORIES
FROM
INLAY
ARTIST
WILLIAM
"GRIT"
LASKIN

Figure.1
Vancouver / Berkeley / London

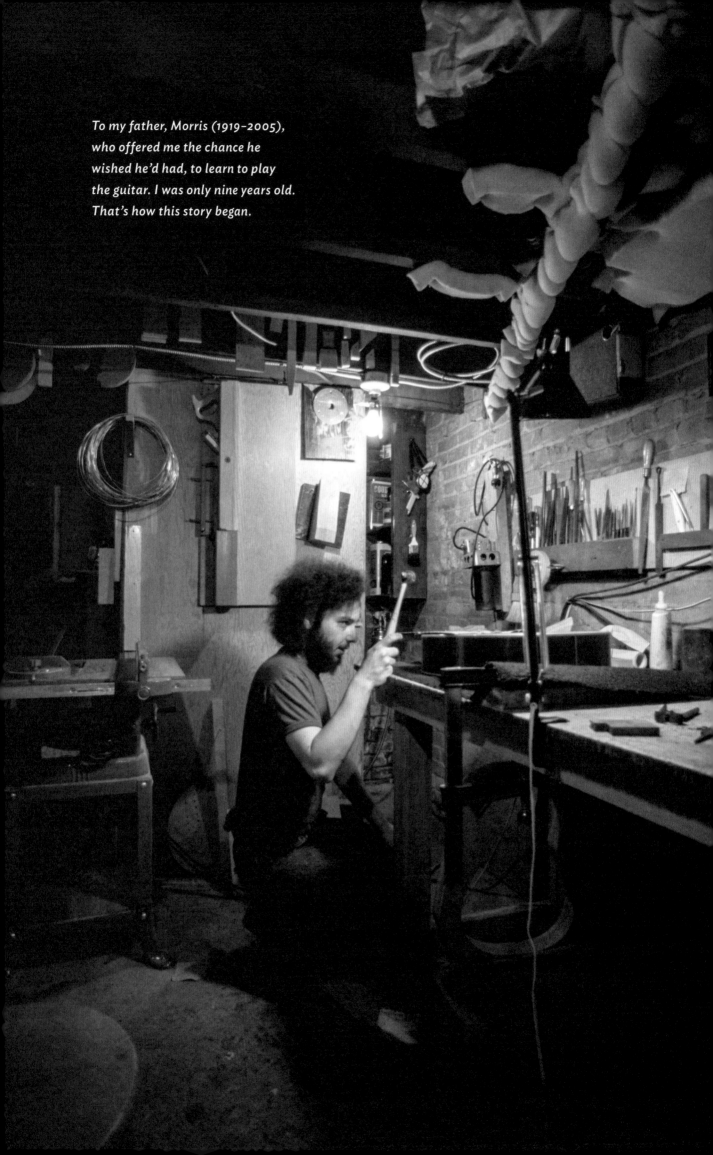

*To my father, Morris (1919–2005),
who offered me the chance he
wished he'd had, to learn to play
the guitar. I was only nine years old.
That's how this story began.*

PREFACE

I'm on the phone, long distance, with a client. I've reached the point in the construction of this guitar that a decision on the theme of the inlay must be made.

"Umm…" he says, then pauses. "Peace! That's what I want. Do something on peace."

"Okay. Okay… sure. I can do that," I reply. "But what are you seeing when you say the word *peace*?" I ask.

"Oh, nothing specific," he answers. "I want to see what you come up with."

I hang up. My mind is immediately swamped with images of people, places, events, all in some way or other linked to my sense of the word *peace*. Simultaneously, my left brain is deluging me with questions: do I know enough about this client to be able to guess his sympathies? His nation is currently at war. What if I make too bold an anti-war statement with my design? Will I offend him? Please him? I think he's old enough to have participated in or protested against the war in Vietnam—should I pull images from that era? From today? From the Occupy Movement? On and on goes my thinking.

Sometimes the creative freedom offered by a client like this is a blessing; other times, a curse. In direct contrast are clients who bombard me with multiple disparate themes and concepts, in email after email, phone call after phone call, which can be both a blessing and a curse in equal measures. Yes, I may be given much to work with, but how do I extract only the right elements from another person's very personal experiences? How do I distill a novel's worth of their themes and digressions into a film script with a focused central narrative?

Does this sound like I'm complaining? I hope not. Because I truly revel in the challenges I'm given. Right from the start, I tell my clients not to constrain their imagination, that there isn't any theme I can't depict—and I choose to believe that. I see it as my job to get as far inside the mind of my client as possible. I prod and probe, describe and dissect images, concepts, points of view, until I feel confidently close to what they must be seeing in their mind's eye and how they feel about what they picture. I feel like an armchair psychoanalyst.

But by profession I'm just a guitarmaker, a luthier (maker of stringed instruments). I've been building guitars since 1971, shortly after my eighteenth birthday. After a very traditional one-on-one master/apprentice relationship with Jean Larrivée that lasted for two wonderful years, at age twenty I set up my own workshop and had orders for instruments before I had purchased my first tool. I've been lucky.

I certainly learned how to cut basic shapes from mother-of-pearl and abalone shell while working with Jean, as all guitarmakers would, but it wasn't until years later, while flipping through a book on the work of American illustrator Maxfield Parrish, that I had a revelation. I suddenly saw the headstock area of the guitar as if I were looking through the viewfinder of a camera; in that moment it became not just a place for decoration but a place where an inlay could show movement and the elements of a larger scene.

The first inlay design that followed was one of Parrish's simple, humorous characters, depicted as if he were walking across the headstock. That began a decades-long adventure in which I continued to expand what I can show on the neck of a guitar. No longer is it just an area for decoration, it is now my canvas. Over this same period, my desire to create within the designs a narrative flow, something

Facing **At work in my first workshop, September 1973.**

vii

not traditionally found on musical instruments, has become my default position.

I taught myself the hand-engraving, the technique of cutting detail into the materials, and bought various shapes of graver—the tool that does the cutting—from the local jewellers' supply store and began to experiment. Ultimately, I found the right graver type to cut cleanly into shell and stone—even worked out a unique grip on the tool—and hesitantly began to make my first real cuts. That was 1975. In the forty-one years since, I can honestly say I've improved a bit.

In truth, when I shift my workday from the woodworking routine of guitarmaking to "inlay mode" I feel more like an illustrator, someone tasked with visually depicting the essence of the tale. And to do that, since it's not my story but my client's, it's incumbent upon me to understand as thoroughly as possible where they're coming from.

What you will discover in this book is fifty separate inlay projects that represent my more complex work from late 2003 to 2015. Thirteen years have passed since the publication of the previous volume on my work, *A Guitarmaker's Canvas: The Inlay Art of Grit Laskin*. This next installment seemed overdue. Over these thirteen years there have, of course, been any number of simpler projects that I felt didn't warrant inclusion in this collection. And there were some that had themes too intimately personal to the client to make public. But all the designs in this book have a story to tell.

This gallery of guitars has been organized chronologically. There's no special rhyme or reason for that. My purpose wasn't necessarily to indicate incremental growth or development of technique, although I can't deny that some will make itself evident. It was more than that. I wanted to give a sense of how my work unfolded as I moved from client to client, guitar to guitar, and responded to each commission.

I've titled this collection of work *Grand Complications* because the literal meaning of those words seemed like a fit. I feel that I'm pushing the boundaries of what has historically been done in this inlay medium. For me, this work routinely becomes riddled with complications but just as often feels like a wonderful grand adventure. Truth is, I didn't invent that phrase. It's an oft-used term in the field of high-end mechanical watchmaking, where it's specifically used to describe a timepiece engineered with the utmost sophistication and complexity. Appropriating it for this book just felt right. And the fact is, I also chose that title for one of my inlays, a design based around one particular Grand Complication from the history of watchmaking: Abraham-Louis Breguet's tourbillon movement. I've placed that guitar at the start of the book, willfully ignoring my own planned sequencing, simply because its theme so perfectly embodies its own and the book's title—and sets a grand tone for the complications that follow.

In the preface to his collection of essays, *What the Dog Saw*, the extraordinary Malcolm Gladwell made this statement: "Curiosity about the interior life of other people's day-to-day work is one of the most fundamental of human impulses." My goal in writing this book has been to reveal the interior life of a guitar-making inlay artist, to open as wide a window as I could into my own creative process. I hope it will convey a sense of how each design evolved over the many conversations and the many weeks of thinking and drawing that preceded the first cut of the saw and ultimately the final cut of my graver.

Digging back as far as twelve years seemed daunting at first. Would I remember details? Could I truthfully capture what had occurred? For each project essay, I began by pulling out my file of drawings and support material and, more importantly, re-reading my stash of handwritten notes and printed emails. On its own, the latter, this hard evidence of my conversations with clients, often resulted in file folders a centimetre thick or more.

To my delight and, frankly, great relief, when I began re-reading these notes and emails I found myself transported back to the moments when these discussions were taking place. At times I could vividly hear my client's voice again as they described their ideas. My relief was palpable. I took courage from this realization and began re-creating with some confidence the circumstances and incidents that birthed my inlay designs.

Along the way I knew there would be times when I had to resort to a bit of "historical reconstruction" to more completely tell my tales. In all instances I stayed as true to the reality I'd documented as I possibly could. Any errors are entirely my own.

What Is Engraved Inlay?

Many of the projects in this book took over 100 hours to complete, some 150. To accurately engrave the details of a human face can take two full days. For those unfamiliar with the medium of engraved inlay, what follows is a capsule summary of the process. To be clear, this is not *marquetry*, which is the technique of assembling wood veneer on the surface of a backing board. Nor is it *scrimshaw*, which is more of a shallow scratching, traditionally on bone or ivory. It most definitely is not a decal, and nor is it simply painted on!

Engraved inlay is the result of using semi-precious materials—10 different species of shell, more than 20 different varieties of stone, 3 different types of bone and ivory, 4 different metals—and hand-cutting them to recreate an original drawing. The process involves insetting the materials 1.4 millimetres deep into a corresponding cavity in the ebony fretboard and ebony headstock veneer of a guitar, grinding and sanding them level to the wood surface, cutting detail into them line by line with a simple hand-held graver (not a power tool), and then filling in those cuts with a black wax/stearate/dye compound.

Here are the specific materials I use, listed from most frequently to least often used:

Shell

White Mother-of-Pearl	Pale Abalone
Gold Mother-of-Pearl	Tahitian Blacklip Pearl
Brown Mother-of-Pearl	Agoya
Green Abalone	Awabi
Red Abalone	Donkey

Stone

I use a form called Recon stone, short for Reconstructed stone. To break up the structure of the rock and literally reconstruct it, natural ore is crushed and then compressed into blocks using an acrylic gem resin to bind it. This changes it from pure rock to a material that is still hard but more brittle than in its original form, closer to bone in its qualities, and that can be worked with saws and files. Recon stone consists of 85 per cent the original stone and 15 per cent resin.

Agate	Larimar	Red Spiney
Asian Pink Coral	Malachite	Red/Orange Spiney
Azurite	Mexican Turquoise	Rhodonite
Chryscolla	Obsidian	Sodalite
Gaspeite	Pink Conch	Sugilite
Jasper	Pipestone	Turquoise
Lapis	Red Coral	Yellow Spiney

Ivory and Bone

I use only legal ivory. One type is Mastodon ivory, which is cut from unearthed prehistoric tusks that are not deemed to have rare or historic value. The other is walrus tusk, which I purchase from Inuit hunters in Nunavut, in Canada's Far North. The walrus are hunted for sustenance by the Inuit, so the ivory from these tusks is commercially allowed. The bone comes from camels and is bleached.

Metals

In my designs, I use gold, silver, and two equivalents used by apprentice jewellers that have the same look and hardness: Dix gold, an alloy of copper and brass; and nickel silver, an alloy of copper, nickel, and zinc.

And a final note to answer two of my most frequently asked questions:
1 I inlay only the guitars that I build.
2 I never repeat a design. Every one is an original.

LANG + SON
- "DATEBOXES"
best for a date

GLASHUTE

- engraving
on back
spring
- add to date info

- MARIE ANTOINETTE
watch just
recovered
(BREGUET)
made → his
patron

something?
from this?

INTRODUCTION
Grand Complications 2008

My regular UPS driver plunked down the weighty box on the floor of my office. The glued sides of the box were partially ripped open, and inside were dozens of publications with names like *Watch International, Grand Complications, Revolution,* and *International Watch*. What they all had in common was their dedication to watches with prices that begin in the tens of thousands and rise to seven figures. This world of high-end mechanical watches—micro-precision engineering marvels—was an eye-opening discovery for me.

The Project Begins

It was this very rarified world that I was tasked with celebrating in inlay. Specifically, my client wanted me to focus on, and somehow celebrate, extraordinary watch movements, and they had shipped this box full of books and magazines to get me started. I relish this stage in an inlay design, when I'm given leave to pour myself into a subject that's new to me and learn everything I can. In this case, not only did I explore all the publications my client shipped, but I also sought to learn all I could about mechanical watches—how they function, where and when historical developments occurred. I very quickly became intimately familiar with mainsprings, balance wheels, escapements, wheel trains, the use of jewel bearings, and a fascinating movement called a tourbillon.

Prior to the late eighteenth century, watches were relatively inaccurate as timekeepers. Most commonly, they were pocket watches hanging vertically, and in this position gravity had a negative effect on the escapement, the part of the watch containing the balance wheel. As the wheel rotated, its speed was affected by the position of the watch in space, either speeding up or slowing down, and thus altering the regular revolution that determined its timekeeping accuracy. Then along came a French-Swiss watchmaker named Abraham-Louis Breguet, who mounted the escapement and balance wheel in a rotating cage that revolved fully once per minute. This speed of its revolution negated most of the effects of gravity and revolutionized the accuracy of watches. Breguet's new movement was named a tourbillon (French for "whirlwind"), and to this day it remains the standard not only for ensuring accurate timekeeping but also for demonstrating watchmaking skill.

As my client and I exchanged emails and had many lengthy phone conversations, it became clear that the tourbillon, somehow, would be the focus of the inlay design. It symbolized all that was excellent in mechanical watches. Other phrases that popped out of our discussions, and that I would heavily underline in my notes as significant, were such things as "the history of watchmaking," "Art Deco fantasy," "moon-phase movements," and "display backs" (transparent watch faces, intended to show off the underlying engineering). This was the point where theme and focus had been settled and it was time for me to start thinking about the actual design.

My first step was to look for pictures of a tourbillon movement. Of course, I found some in the pages of the publications I'd been sent, but I found more—and more detailed views—online. No surprise there. The tourbillon, despite its complexity, is not much larger in diameter than a dime. Yet I very quickly realized that to show the complicated engineering that is this mechanism's genius, I would need to greatly

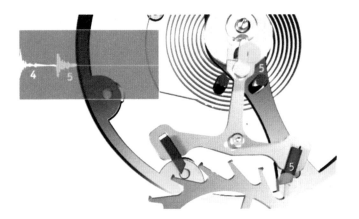

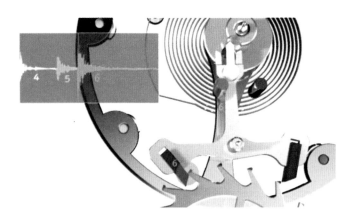

enlarge it to depict it in inlay. If the details were too small and needed to be engraved too tightly, the shell or stone might crumble as one deep graver cut passed too close to another. With this decision tentatively settled, I selected a certain angled view that clearly illustrated the tourbillon's workings and began to play with it.

As is my routine, I had already outlined the headstock and fretboard of this specific guitar on tracing paper, with clear indications of machine head (tuner) and fret locations, and, of course, all accurate dimensions. I now took the selected image of the tourbillon and slid it under the headstock and fretboard tracings, shifting its angle and position. While I'm "playing" in this manner, another section of my brain is running parallel footage of other possible elements the design might contain and how they might all link together. I had yet to gather and consider most of those other elements, but my brain was way ahead of me, reviewing things I'd seen as I flipped through the box of magazines and Googled my way across the horological universe.

I pictured the tourbillon being near the physical centre of the design. It was, after all, the focus. This would allow other elements to flow into it both above and below my canvas on the neck of the guitar, specifically the inlayable headstock and fretboard.

With any design, I have the option of creating it vertically (imagine the guitar resting on a stand) or horizontally (the guitar is in playing position). Traditional inlay on stringed instruments considered the instrument vertically, which is perhaps one reason why players accept more of my inlay work on the vertical orientation as looking natural. On occasion, when I get an early, instinctive sense that I will need the width of a horizontal view, then that's how I begin imagining it. But with this inlay, I was already sensing how I'd use the upper and lower areas vertically. With that decided, I set aside the tourbillon for the moment. Its precise size and orientation and location were still fluid at this point.

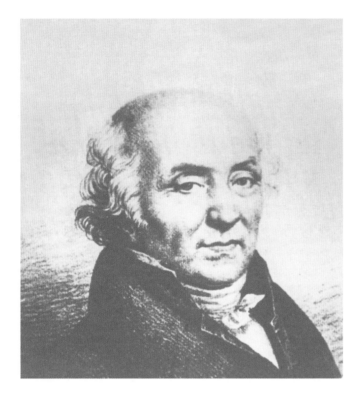

Facing **Learning about the escapement mechanism in mechanical watches.**
Left **Abraham-Louis Breguet.**

The next logical step was to learn more about the man who invented this movement — A.-L. Breguet. The watchmaking company that Breguet formed in 1775 in Paris has existed continuously since that time, and though it is now based in Switzerland, it still makes watches. From the company's website I learned that Breguet was the creator of the world's first wristwatch, built for the Queen of Naples in 1812. Further searching unearthed countless images of the man himself as well as views of his original watches. I liked the look of some of his early watches — both their front faces as well as the layered gearing, springs, levers, and decoratively engraved plates of the revealed interiors — and the idea of depicting one or more of them felt true to the emerging logic of the design.

I also came across images of Breguet himself. One of them, an engraving with a chiaroscuro nature, stood out because of its strong contrasts between the light and dark elements. Cutting into light-coloured shell or stone naturally creates filled dark lines, which creates a similar effect to chiaroscuro and simplifies the process of translating the image into inlay. Happening upon this appealing image forced me to conclude that Breguet should appear in the design: this inlay was, after all, about his groundbreaking work and he should definitely be part of the story.

Thus far, then, the elements of the overall design that were in the running for inclusion were:

— The tourbillon movement, hugely magnified and in the centre — the heart — of the layout.

— One or more of the early Breguet watches, but the face? Or the back view showing the internal workings?

— Breguet himself.

It's at this stage that I typically take the potential elements into my mind's eye and begin manipulating them. One of my favourite ways to do this is to sit on the couch in my little office, put my feet up, and close my eyes.

I begin moving the elements around, changing their sizes. I'll also shift the viewer's angle or horizon point, and try viewing them from above, from below, from left, or from right. What I'm doing is trying to find the unifying thread that logically links all of the varied and various elements of my design. I'm adamant about the continuity of the story, and this is the reason I often refer to inlays that occupy the entire real estate of the neck (as this one will) as a "full narrative." I find this visualization process far quicker and more enjoyable than endless rough-sketching. Clearly I'm just doing what's easiest for me.

I remembered my client's offhand request that I consider a way to pull Art Deco into the design. In that conversation, as ideas were being tossed around, my client had mentioned the stylized nudes used in the Deco period. That was a lucky moment for me. While still on the phone, an image had burst into my head of the large central spring within the tourbillon, with its numerous tight windings, unravelling itself into the strands of a woman's long hair. It was just a quick flash, but it felt absolutely right. An imaginary woman would become part of the functioning tourbillon mechanism itself, linking it visually and logically. And if I had one imaginary woman, why not another?

Recall that I felt fairly certain the tourbillon would be near the physical centre of the design and that I had settled on a vertical orientation. This, to me, made it natural that the woman whose hair becomes the spring should be standing above the device and allowing her hair to cascade downward into it. That would leave an open space below the tourbillon that I would try to fill with a second imaginary woman. But what would link her? I stared and stared at each

part, each corner, each edge of the particular tourbillon image I'd chosen. I considered it from angle after angle, and then suddenly the answer stared me in the face. At this particular final angle, the toothed escapement wheel was jutting downward outside the general perimeter of the mechanism. From my early reading about how watches function, I knew that two jewels (called "entry" and "impulse"), each held in one arm of a T-shaped "pallet fork," connected with the escapement. My new character could represent these parts. I imagined this woman with arms upraised and holding in each of her hands one of these jewels called rubies (even though they are now most often synthetic).

I began to feel the energy of the design coalescing. On the headstock, I decided to place an enlarged section of one of Breguet's actual watch faces, within which I would place his portrait. This idea logically led me to show the opened back of the same watch at the very end of the fretboard, the bottom of the design. That kind of symmetry, in this instance with a Breguet watch essentially acting as visual bookends, always feels right to me. In the theatre world, Russian playwright Anton Chekhov is credited with declaring that if one shows a loaded gun on stage in the first act then it must be fired in a later act. What this principle—called Chekhov's Gun—says to me is twofold: 1. There needs to be a reason for every element you include, and 2. There needs to be symmetry in the story arc. I apply this to my inlay designs in general as well as to the spread of the materials—but more on that later.

It was time to gather these last elements and begin roughing out precisely how they would all fit together.

From Brain to Paper

Here I took my cue from centuries of artists who work with the human figure. They rarely just guess what the body looks like in a given position; they hire live models. I booked an artist's model from a short list I have of people who model for drawing classes and are comfortable posing nude. We went to the studio next door to my workshop, where there was more open space and much less dust. I set up my eight-foot ladder, climbed to the top step, and began calling out instructions. I needed to be well above my model. My vision of these two magical women saw them on another plane, as if they were physically below the tourbillon. To enable that conceit, and most easily depict the foreshortening effect, I chose to capture the angle with my camera.

For the woman whose hair entwines with the tourbillon, I asked my model to turn her back to me and tilt her head upward so that her mid-length hair flowed down. I took a few shots, but I felt something wasn't working. I asked her to splay the fingers of her hands and run them through her hair as if she were separating the strands. That gave me what I needed: her hair in strand "bundles" that would ultimately flow down and become the curls of the wound spring. For the woman whose arms held the jewels, I handed the model a block of wood for each hand and described to her the function of reaching upward with the blocks, endeavouring to connect with the escapement.

I now cleared my workbench, brought out my drawing board, pulled out some sheets of Canson tracing paper, and sharpened a half-dozen 4H drafting pencils. I laid out every element, every image that I'd been collecting up to this point:

- The tourbillon.

- The Breguet watch, front and back views.

- The engraving of Breguet himself.

- Prints of the two views of my model.

I took my paper tracings of the headstock and the fretboard on which I had marked the locations of the machine head (tuner) holes, which had already been drilled, and the fret positions. My goal now was to bring all the separate elements together into a visual, linear narrative. To do this, I had to consider their size, their precise locations, and whether or not they should overlap.

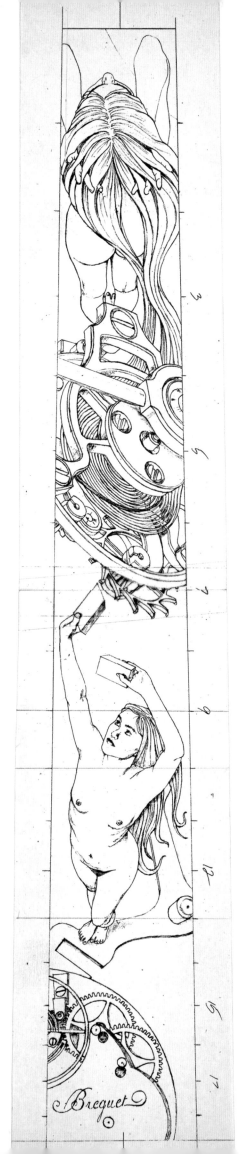

When considering the size, I had to think about whether the design would be too large for any of the materials I'd want to use, whether it would be too small to properly engrave the details, and whether its size would require a material that doesn't take a clean graver cut.

When considering the placement, I was making sure that key elements such as hands and the critical details of a face were clear of the frets and machine head washers. Each design is different, which means I make arbitrary decisions about which parts are most important to that particular story and then endeavour to keep those elements as clearly and wholly visible as possible.

And when considering whether to overlap elements, I was thinking about how best to create connectivity among different parts. I also make use of this technique when I quite consciously "break the nut barrier," which is to say that I have the design act as if the nut that separates the headstock from the fretboard were not present. (The nut is the string spacer, which is typically made of bone or, in lesser instruments, plastic or another synthetic material.) I spill the design from the headstock onto the fingerboard, or vice versa. Traditional instrument inlay designs quite consistently separated the headstock from the fretboard, but I view the entire neck as a seamless canvas on which to link my narrative without interruption. I also must admit that I take some personal satisfaction in breaking an unwritten rule.

Now I began "playing" again, sketching very roughly and loosely, perhaps bordering on cartoonishly. To start, I slipped the printed image of the tourbillon underneath the traced

layout of the fretboard and took a close look at where the various frets would cross it. To my utter surprise, the size of the printed image worked perfectly. By centring it around the fifth fret, I found it would span up to the third fret and down just past the seventh, and the frets themselves would not obscure any important part of this complex mechanism. At this particular size, the minute parts would be large enough that I could recreate them with my palette of materials but not so large that they would dominate the design. It's unusual to say the least that my starting size is the one that works. I was lucky this time. I roughly sketched the tourbillon in place.

Moving outward, I had to place my model(s) and link them to the mechanism. I began with the woman whose hair would become the windings of the spring. My first step was to slip the photo print I'd made under the fretboard tracing, as I'd done with the tourbillon image. I could immediately see that her body's position — the angle of her head, the location of her arms and hands, her legs — was going to work, but her image in the print was a bit too small. I measured the distance from where I wanted her extended elbows, her uppermost point, to stop (just shy of the nut) and where I felt her feet should rest (just sneaking under the protruding portion of the tourbillon). I compared that measurement to her dimensions in the photo and determined that I needed her about 10 per cent larger. I noted that, marked these north and south points on my sketch, and just very loosely pencilled her in place. At the larger scale, the elements of her form that I'd decided must be shown — one full arm, the outer edge of her hip, all eight

fingers (no thumbs) of her hands — would fall safely within the edges of the fretboard. The chosen location also meant her hands, which carried primary value, would not be interrupted by a fret.

With Woman A placed, I needed to create the shape and flow of her long, gently waving hair so that it would logically become the spring. I overlaid a new piece of tracing paper, a third layer, on top of the emerging rough sketch, which itself still sat over the fretboard layout, and began drawing. I started with my model's actual hairlines and began extending the natural fall of her (relatively short for my purposes) hair. I played with curves and shape over and over, until the form began to coalesce into something aesthetically pleasing as well as directionally logical to flow into the spring's position. To keep the hair flow from becoming so dense that it would obscure her foreshortened form and potentially diminish my intent to have these fantasy women appear to be standing below the tourbillon, I broke up the strands, allowed some "air" between them, and curved them to one side. Satisfied, I transferred this form to the main rough sketch and turned my attention to Woman B.

As I slipped the photo print under the ongoing rough sketch, I very quickly sensed that there was something missing. I stared at Woman B and the partial sketch. I absent-mindedly flipped through the collection of printed and copied images I'd assembled as the project evolved. Nothing. I went into my office, sat down on my couch, and closed my eyes. I imagined Woman B smaller, larger. I wondered if I was going to need the model back to photograph her in a different pose.

I was discounting nothing. I mentally reviewed all the images I'd just re-examined. At about the twenty-minute mark, I told myself to think again about the mechanics of the watch and what exactly Woman B was doing. My eyes popped open. I ran back to my main work-room and dug into my stack of paper printouts until I found a view of the pallet fork itself. I scribbled a version of the fork almost as large as the printed image I had of Woman B. Next, I did a rough-and-ready sketch of her on the tracing paper and began playing with how these two would interact. What had popped into my mind's eye was an image of the woman balanced on one arm of the pallet fork. The body language would say: "This is my base. This is where I come from."

As I was playing with the juxtaposition of the woman and the fork, it struck me that where the arm of the fork would normally hold a ruby, I would show it as empty. This void carried through the logic of the rubies being in the woman's hands—she is embodying the pallet fork, after all—and in a small way further cemented her connection to the pallet fork. Finally, I needed only to size and locate her. As Woman B was situated farther down the fingerboard, my constraint was the narrowing of the spaces between the frets. It was most critical that her face and hands missed frets, but also important that her feet, shown balanced on one arm of the fork, were clearly visible. And, of course, one arm of the fork had to be clearly shown without a jewel. I roughed them both into the sketch.

The fretboard design as it stood was taking me approximately as far as the fourteenth fret, but I decided to set that part aside for the moment and shift my attention to the headstock. Understanding that a viewer of inlay art on any guitar will typically begin at the headstock, I knew this portion had to very firmly establish the theme. This is why I'd saved it for the image of Breguet himself. I'd imagined him drawn as if on the face of one of his own pocket watches, and I drew the watch face larger and ever larger. Its diameter (almost 27 centimetres) placed within the headstock appeared much as I imagined a large planet would appear, rolling into the viewing field of a telescope. Making it this large meant three things:

1 It offered lots of space to insert Breguet's portrait.

2 It filled a healthy amount of the headstock.

3 Its size gave me the opportunity to break the nut barrier and allow a reasonable portion to curve well into the first fret.

Extending the watch edge into the first fret also allowed me to have it run underneath, be overlapped by, one of Woman A's raised arms, which provided a visual link.

My next task was to draw Breguet into the watch face, making certain that key aspects of his face, eyes, nose, mouth, indicative edge of his jawline, avoided the future location of the machine head (tuner) washers. I roughly sketched him in, in imitation of the style of the old engraving. With Breguet in place, I drew in the minute and hour markings as well as enough of the visible numbers to provide yet more visual clues about what this big circular thing was. As a final touch, I drew in the tip of the minute hand and made sure it avoided that main area of Breguet's face.

With the headstock sketch complete (or so I thought at the time), I returned to the opposite end of the design, to the unused space at the high fret end of the board, and completed the theme. I found my printout of the open back side of the same pocket watch I used as my model in the headstock. I began by drawing circles of a variety of sizes on my tracing paper and examined their effect when I slipped them over the lower region of my rough sketch. I liked the idea of it overlapping an edge of the pallet fork, and it needed to be large enough to allow me to successfully cut and assemble the various gears, springs, and screws, etc., that I intended to depict.

I knew I wanted to have this sphere entering the design from the left side in balanced opposition to the watch face on the headstock, which rolled into the frame from the right. Although this design was to be inlaid on a guitar having a neck joint at the twelfth fret and only eighteen frets total (vs. twenty-one on my standard-sized guitars), I found the optimum size that would enable all the gearing to be cut cleanly from shell and stone. I roughly sketched it in place. My final touch was to write the name Breguet, in the ornate engraved style of his era, across the part of the watch back that fell between the final two frets.

I rose from my stool, took a deep breath, and stood back from my completed rough sketch. I made a few reminder notes about some minor adjustments I wanted to make as I drew the finished design. But aside from that, I felt I had successfully sized, located, and linked all the elements. I had a cohesive visual narrative. The hardest stage was over.

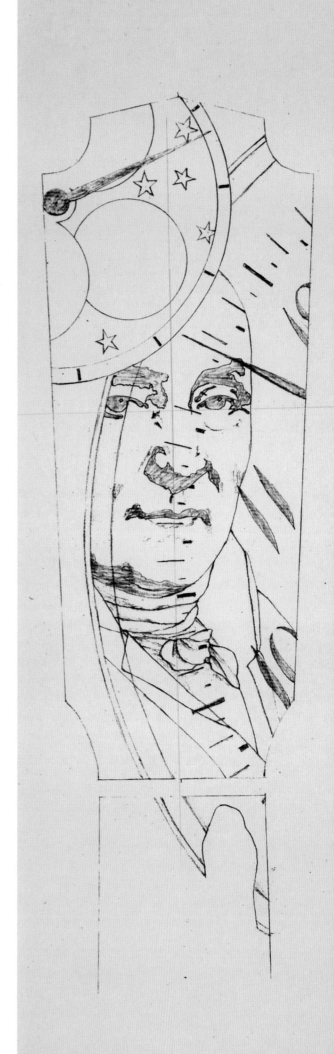

The Final Drawing

The finished drawing for an inlay design has one primary purpose: to clearly show the outlines of every separate element. Of necessity, it is a detailed line drawing, and those lines guide the cutting of the myriad shells and stones and metals and ivories that I select for the inlay. When the drawing's purpose is to deliver my cut lines, aesthetic details like facial features, which will be engraved later, aren't required. That said, it is naturally more creatively pleasing to see all of the details in a finished drawing, and I routinely draw them in. I must also consider the client's preferences. In this instance, my client wished to see and approve the drawing, so the internal detailing was important.

My final drawing is done not on normal tracing paper but on a wonderfully transparent thin acetate sheet called cephalometric tracing paper. The dental industry uses it, apparently for drawing overtop of developed x-ray film. Because sheets of this material have glass-like transparency, they are ideal for drawing in the minutest detail overtop my outlines of the headstock and fretboard. It took me about a day and a half to complete the finished drawing. Within minutes I alerted my client, scanned the file, and emailed it. Happily, within the hour, he called. His single-word review was "Wow."

As we spoke at length, however, it emerged that he wished to add some elements to the design. One was a moon-phase movement, a small revolving disc on a watch face that indicates the waxing and waning of the moon as the days pass. In his view, it would add a further sense of whimsy to the design and also capture what is historically acknowledged as the first "complication." He also felt it would provide a logical opportunity to insert a portrait of me, yet another item on his wish list. The second, more unusual, one was an inlay on the back side of the headstock of a display-back watch. On this model of watch the back plate is clear glass, allowing all of the beautiful and complex engineering to be seen and appreciated.

Typically it also includes decorative touches in the metalwork. My client suggested a couple of watch brands I should consider. So, in a partial sense, it was back to the drawing board.

My first bit of research unearthed a large variety of moon-phase movements. I settled on one particular version that appealed to me aesthetically and evoked the early styles, and then did a rough sketch of it. Where to put it? The only place that offered enough space to include the necessary minimum of visual detail was the upper left-hand corner of the headstock. And it wouldn't interfere there with any key aspects of Breguet's portrait and his watch face.

I imagined this smaller sphere in some ways as the moon to the watch face's earth. Given that this was a moon-phase movement, that image made some sense. I tried out a few different diameters, rolling each one into the scene until I found a balance of size and location. My mind was also working on the problem of where and how to include my portrait, and it wasn't long before the age-old concept of the Man in the Moon occurred to me. In this design, that man would, of course, be me. I added the moon-phase movement to my final drawing and, with the aid of a self-timer on my camera, took some photos of my face. When those images were printed, I drew my face into the nearly full moon shape I'd prepared for it. In the end, though the headstock portion of the design had become somewhat crowded, the complete design now had balanced "weight." By that I mean that the complexity in the fretboard portion was more evenly complemented by a degree of activity in the headstock.

I then turned my attention to the inlay to connect with the back of the headstock. My first step was to flip through the stack of glossy publications again, searching for the most visually appealing display-back models. Very quickly I winnowed my selection to two companies: Glashütte and Blancpain. I based my selection of a Blancpain purely on the aesthetics of the elements in view.

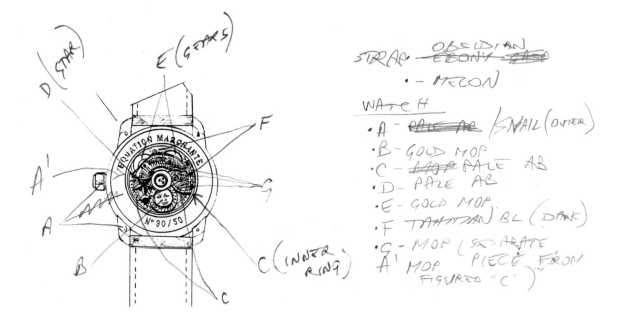

The back of the headstock presented two difficulties. The first was that the space there was more limited than on the front due to the encased gearing of the tuners. The second was that I would be inlaying into mahogany. This wood's lighter shade — much lighter than ebony, my norm for inlaying — might limit which materials I could select (not enough contrast), and its softness (it is a softer hardwood) might make it harder to inset the inlay. To solve the latter problem, I decided to inlay the watch first into ebony and then cut it out of the ebony leaving a 1-millimetre border of black edging. Only then would I re-inlay the ebony-edged watch into the mahogany. First I needed to find a way for it to fit into the space.

I decided to depict the Blancpain at precisely life size, which would be big enough — though just barely — to successfully engrave the fine details without the material crumbling. (To facilitate that, I would stick to shell species or metals, the least brittle options of my palette.) A quick bit of playing with the Blancpain image showed me that tilting the watch diagonally not only kept the watch back centred, but also kept enough of the strap in view for the degree of realism to be maintained. Plus, I just liked it better that way. I added the Blancpain to my finished set of drawings and quickly scanned and sent it to my client. His initial reaction was another "Wow," but this time with an added "Perfect."

The Hiccup

Less than twelve hours later, my client phoned, anxious. It seemed that two different lawyers had warned him there was no way that the name Breguet could appear in the inlay. They felt he and I could be sued for copyright infringement. Apparently, not content with these opinions, my client had taken his copy of the design to a large gathering of Swiss watchmakers in Philadelphia. Though everyone who saw the artwork loved it, the first words out of the Breguet representative's mouth were: "So, you feel like getting sued?" With these warnings in mind, my client suggested that instead of Breguet's name, I engrave the date the guitar was finished. In the end I inserted the date that the inlay art was completed.

Now fully spooked about stomping on copyrights, we talked about the Blancpain. Though my client was somewhat less worried about offending this company — even the Blancpain people at the Philadelphia gathering had not expressed much concern — I still decided to play it safe. I'd come to understand that only fifty copies of the watch I was depicting had ever been produced. So to indicate that my depiction wasn't a copy of one of theirs, I labelled mine "51/50," the fifty-first one produced out of a run of fifty. To this day I have counted on Blancpain's sense of humour.

I took a few deep breaths, stood back from my finished drawing, and made every effort to see it with fresh eyes and assess it dispassionately — which is harder than it sounds when you've been living with a design for many days and nights! Did it flow, have continuity? Yes. Did it convey the full story? Was it a complete narrative? Yes. Did it include all aspects of special importance to the client? Yes. Was it going to be extremely difficult to execute? Actually … yes.

The Materials

Twenty-three different varieties of shell, stone, and metal were used in this project. Settling on which materials would be used for which part of this inlay took approximately thirteen hours. As I considered each material, I was asking myself questions like:

1 Will it look appropriate? Will it be perceived as real and/or a logical colour and/or sheen for that part?

2 Is there a pleasing variety of colour and sheen in the overall mix — a balance?

3 Will it take a clean cut from my graver (or will the edges of the cut chatter and be ragged) if it is heavily engraved?

4 Does it exist in big enough pieces to reproduce a part that allows for no seams or joints?

5 If shell, can I use the natural figure or will it be distracting, inappropriate for the part, and possibly compete with the engraving?

6 If stone, is it stable enough to handle the thin delicate lines I'll be cutting? Will it be too brittle? Will its graining enhance or diminish the visual logic of what it's representing?

As I began my search, I pulled out drawer after drawer from my repurposed old file-card cabinet and laid the materials side by side on my bench. Typically, to find the perfect piece of shell, I dump my entire drawer onto my bench and sift through it piece by piece. I look at the graining and at how steeply the grain moves through the 1.6-millimetre thickness. I look at the reflective angle. I test the integrity to be engraved by making a tiny sample cut in a corner. I can spend an hour or more on this process, stopping only when I've found the most perfect one I can, judging all its properties and how they'll bring to life the part it's to become. Extend this process to the hundreds of separate parts in a complex design like this one and you can easily understand why selecting the materials takes time. In fact, selecting the materials for this project in little more than a day and a half felt fairly speedy.

As I chose the various materials, I placed a piece of each one on my workbench in roughly the location it would occur in the design. Eventually I had an assemblage of materials that spanned the width of my bench top. To the uninitiated, it may have looked like a messy construction, but it is a very necessary stage. Where an element of the design touched or overlapped with or connected to another, so too did my random pieces touch, overlap, or connect so I could ensure proper contrasts such as dark to light, shiny to flat. It also gave me a sense of the overall colour balance. When the piled assemblage was seemingly complete, I stood back and took it all in at once. Squinting, I noted the colour shift from top to bottom. Had I used one colour at the top but nowhere else?

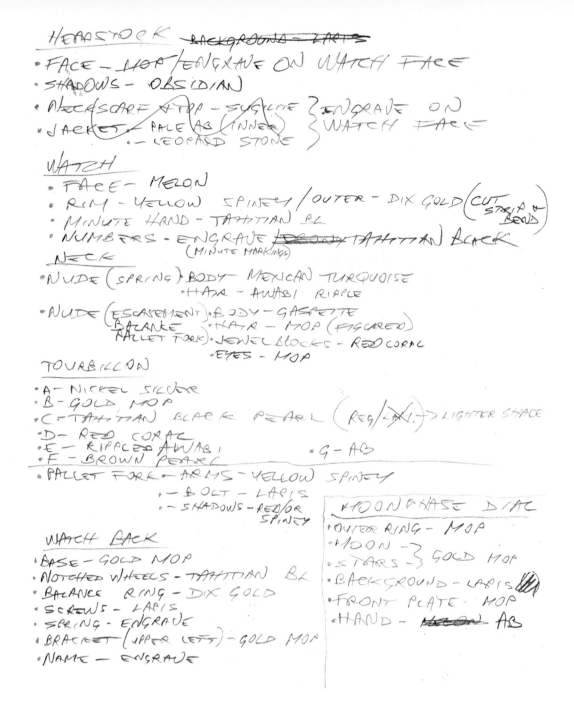

HEADSTOCK ~~BACKGROUND - LAPIS~~
• FACE - MOP/ENGRAVE ON WATCH FACE
• SHADOWS - OBSIDIAN
• NECKSCARF (TOP) - SUGILITE } ENGRAVE ON
• JACKET - PALE AB (INNER) } WATCH FACE
 • - LEOPARD STONE }

WATCH
• FACE - MELON
• RIM - YELLOW SPINEL / OUTER - DIX GOLD (CUT STRIP & BEND)
• MINUTE HAND - TAHITIAN BL
• NUMBERS - ENGRAVE ~~BROWN~~ TAHITIAN BLACK
 (MINUTE MARKINGS)
NECK
• NUDE (SPRING) BODY - MEXICAN TURQUOISE
 • HAIR - AWABI RIPPLE
• NUDE (ESCAPEMENT) BODY - GASPEITE
 BALANCE • HAIR - MOP (FIGURED)
 PALLET FORK) • JEWEL BLOCKS - RED CORAL
 • EYES - MOP

TOURBILLON
• A - NICKEL SILVER
• B - GOLD MOP
• C - TAHITIAN BLACK PEARL (REG/~~XL.~~) → LIGHTER SHADE
• D - RED CORAL
• E - RIPPLED AWABI • G - AB
• F - BROWN PEARL
• PALLET FORK - ARMS - YELLOW SPINEL
 • - BOLT - LAPIS
 • - SHADOWS - RED/OR SPINEL

WATCH BACK
• BASE - GOLD MOP
• NOTCHED WHEELS - TAHITIAN BL
• BALANCE RING - DIX GOLD
• SCREWS - LAPIS
• SPRING - ENGRAVE
• BRACKET (UPPER LEFT) - GOLD MOP
• NAME - ENGRAVE

MOONPHASE DIAL
• OUTER RING - MOP
• MOON - } GOLD MOP
• STARS - }
• BACKGROUND - LAPIS
• FRONT PLATE - MOP
• HAND - ~~MELON~~ AB

Did I need to add some of that colour near the bottom for balance? Or had I inadvertently leaned too heavily to certain colours, and it could use some contrast? Fine-tuning the colour balance is usually the last step in the materials selection process, but it is no less critical for being last.

There is one final procedure to complete before I begin sawcutting. With the materials selected, I make multiple photocopies of the final drawing and, with my scalpel, carefully cut out the individual sections, gluing each paper cutout to its corresponding material. The surface paper, with the sketch lines visible, becomes my guide for the cutting.

I will leave the story of this particular inlay right here. My intention, after all, was to take you into my head as I moved the design from concept to finished drawing. The how-to of achieving the actual inlay is not what this book is about.

Before you turn to the finished views of *Grand Complications*, let me conclude with one final detail. The nude women playing roles in the story were, as I've described, imaginary creatures. To enhance that aspect, I have quite deliberately cut them from materials that were as far from human skin tones as I could get. I certainly don't know any actual people with skin that's turquoise or lime green. If you do, please never tell me. I prefer to keep my illusions intact. **x**

THE
GUITARS

Grand Complications

steel string guitar

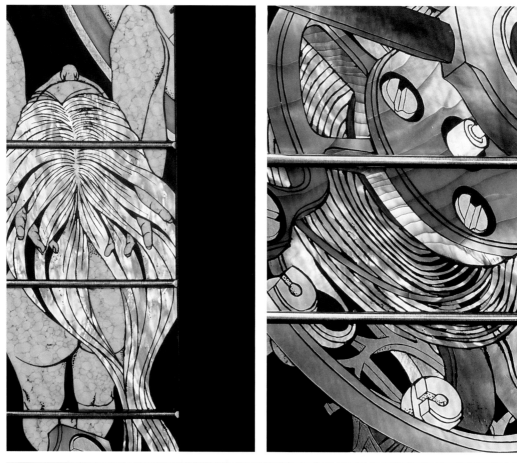

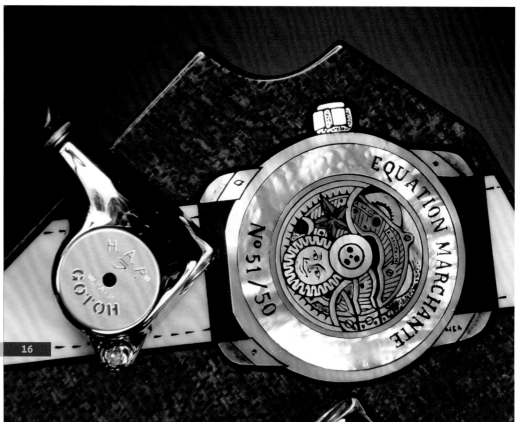

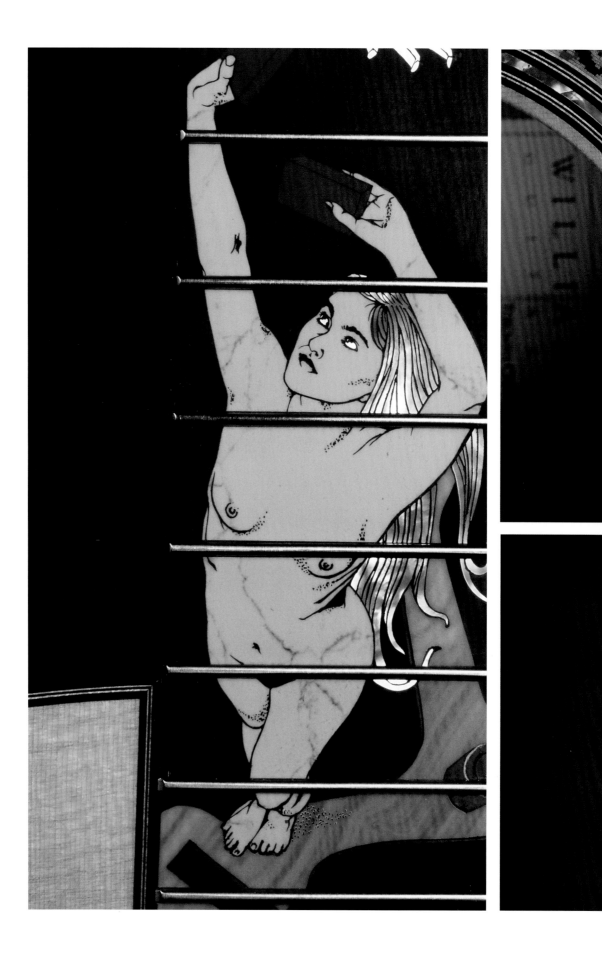

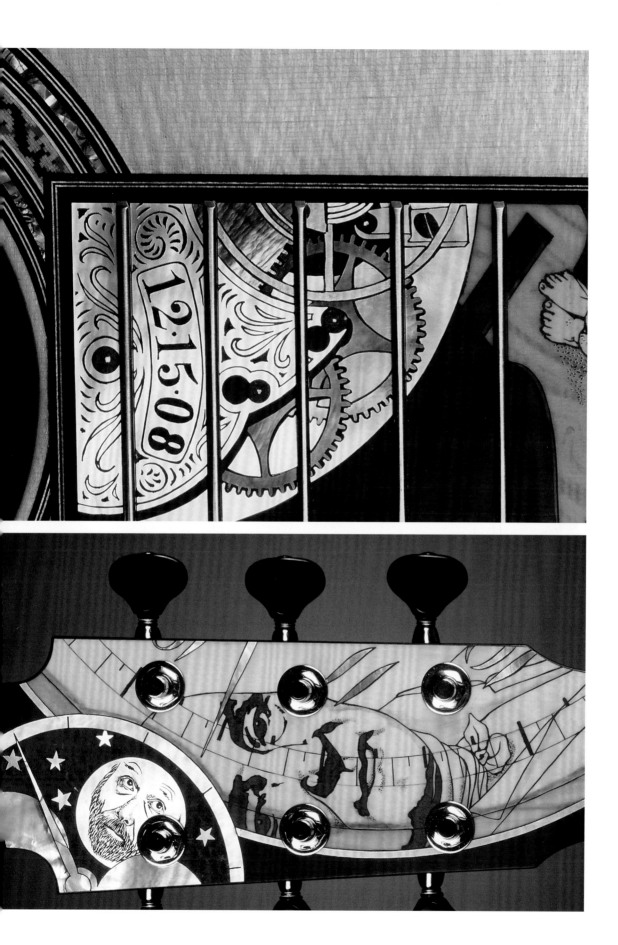

The Bridge

tenor mandolin

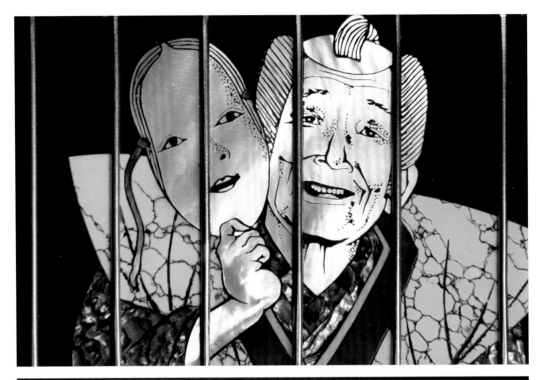

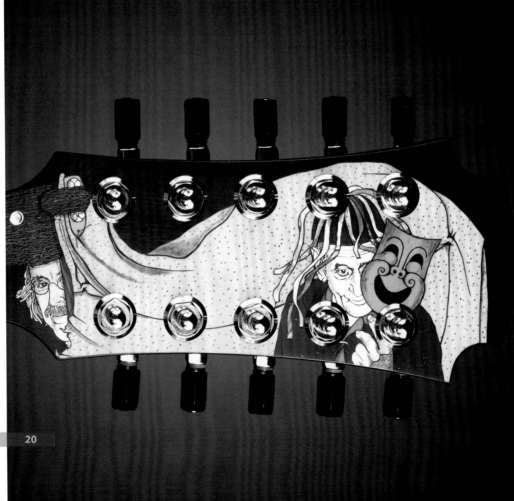

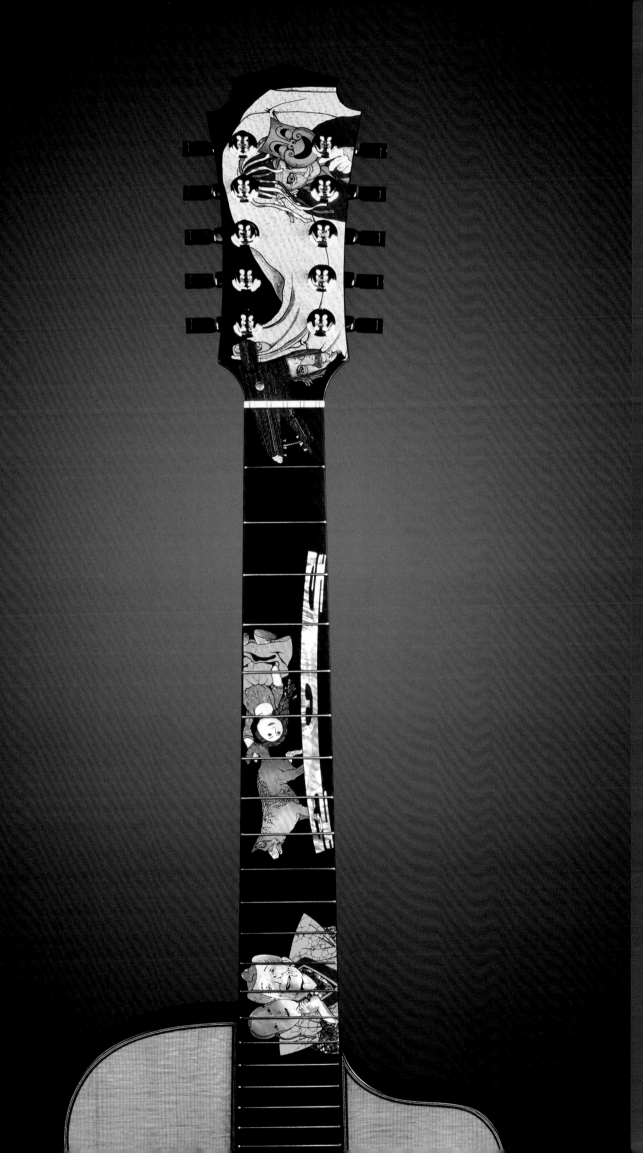

The Willow Chair

steel string guitar

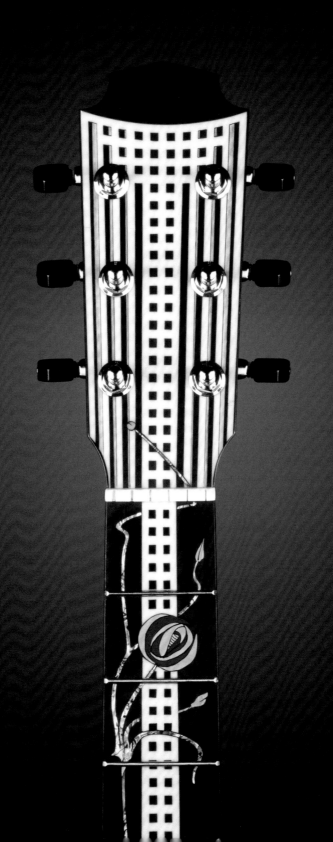

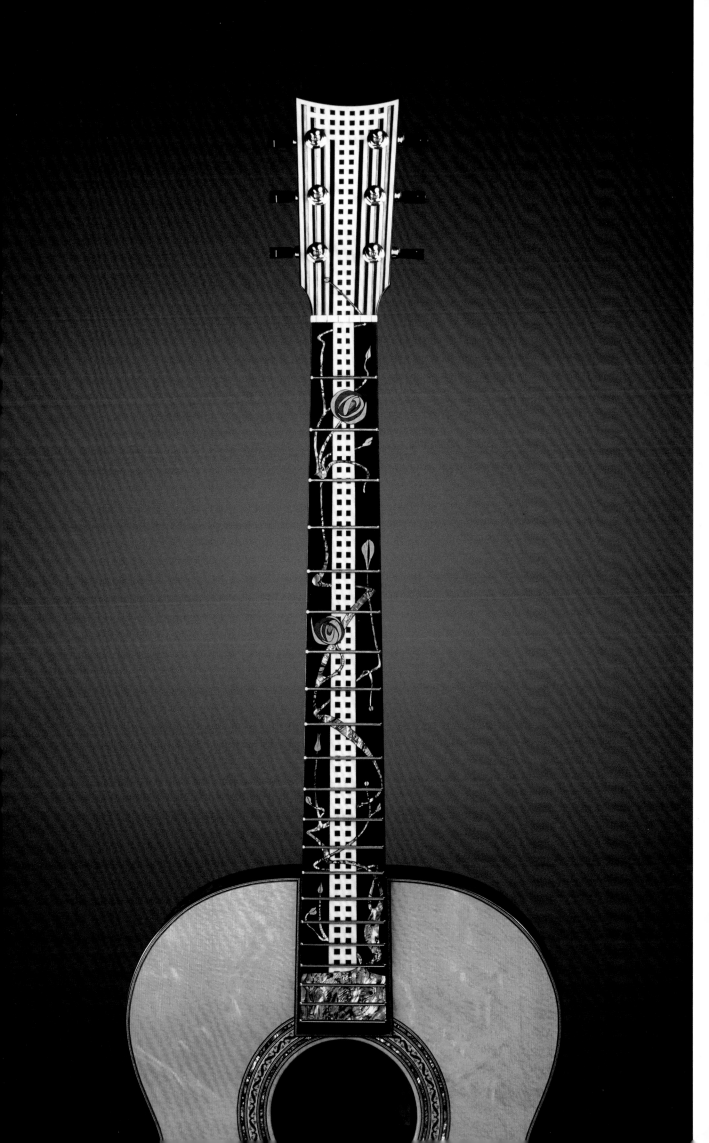

Cubists

steel string guitar

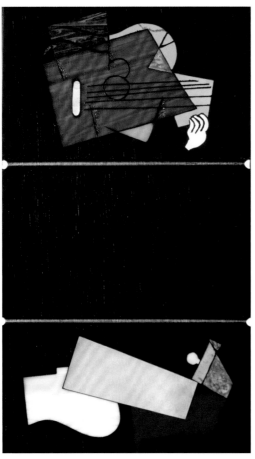

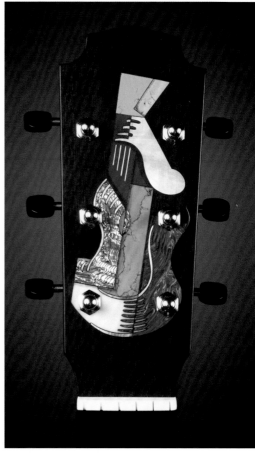

2004

Pursuit

steel string guitar

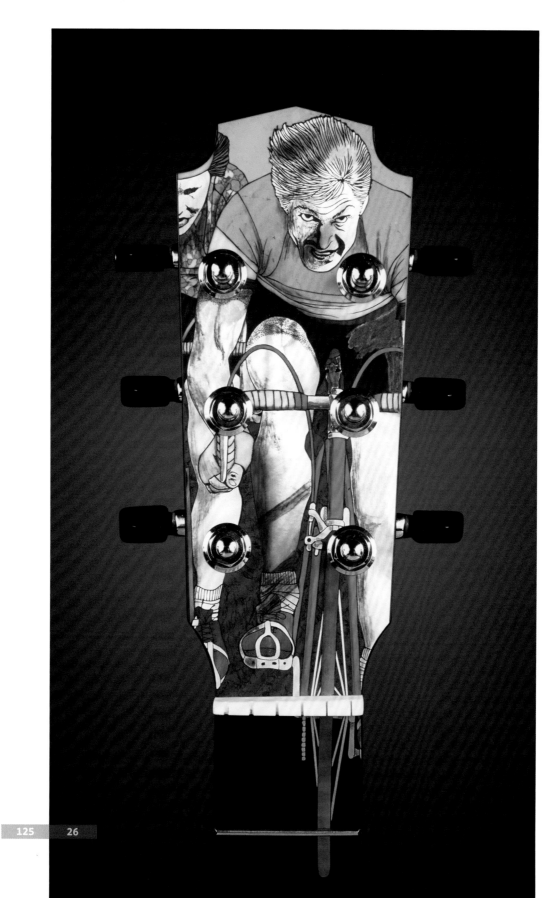

2004

Ritmo Flamenco

flamenco guitar

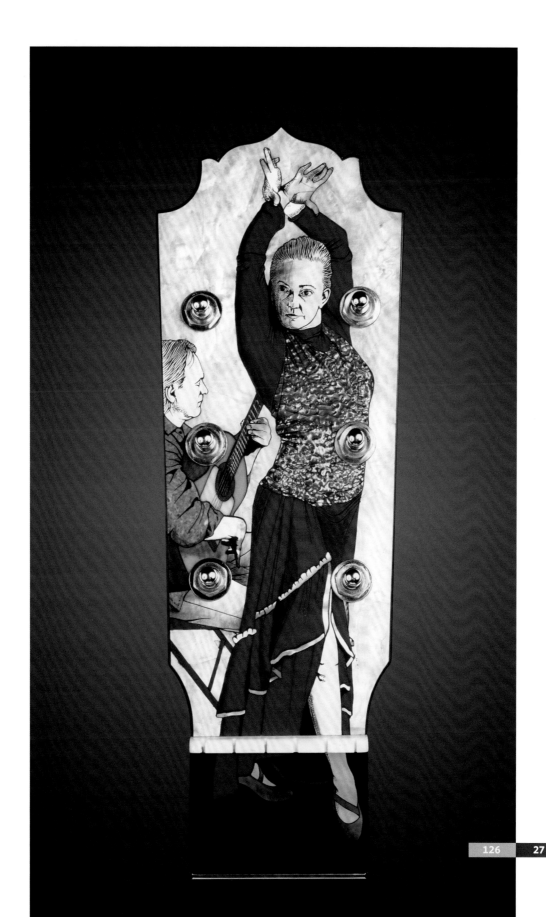

2004

Toronto the Best

steel string guitar

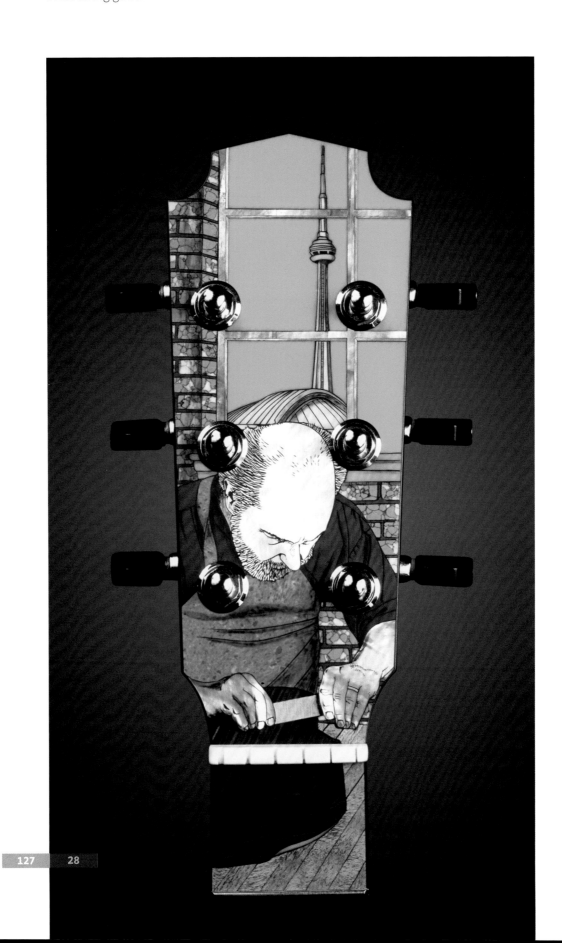

Forever David

2004

steel string guitar

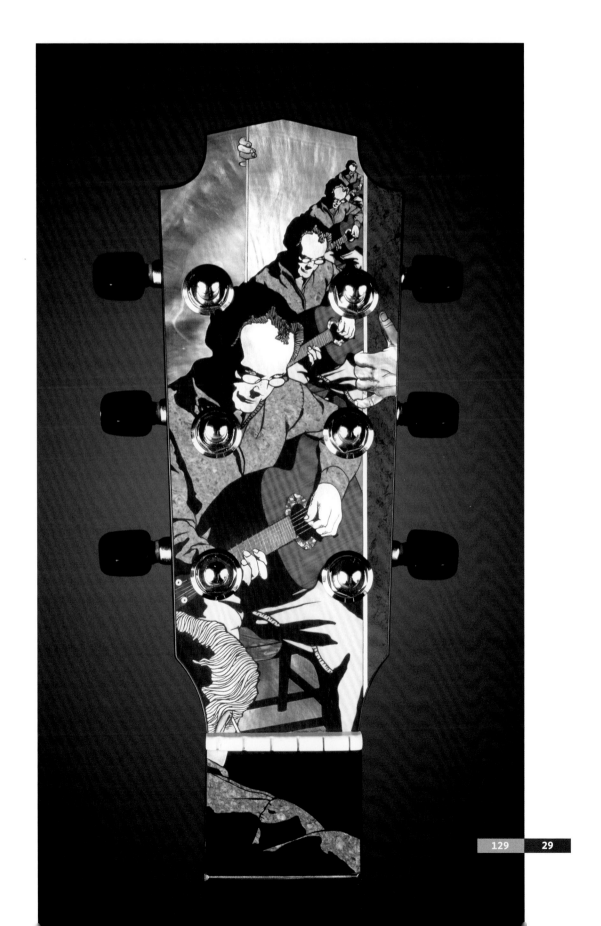

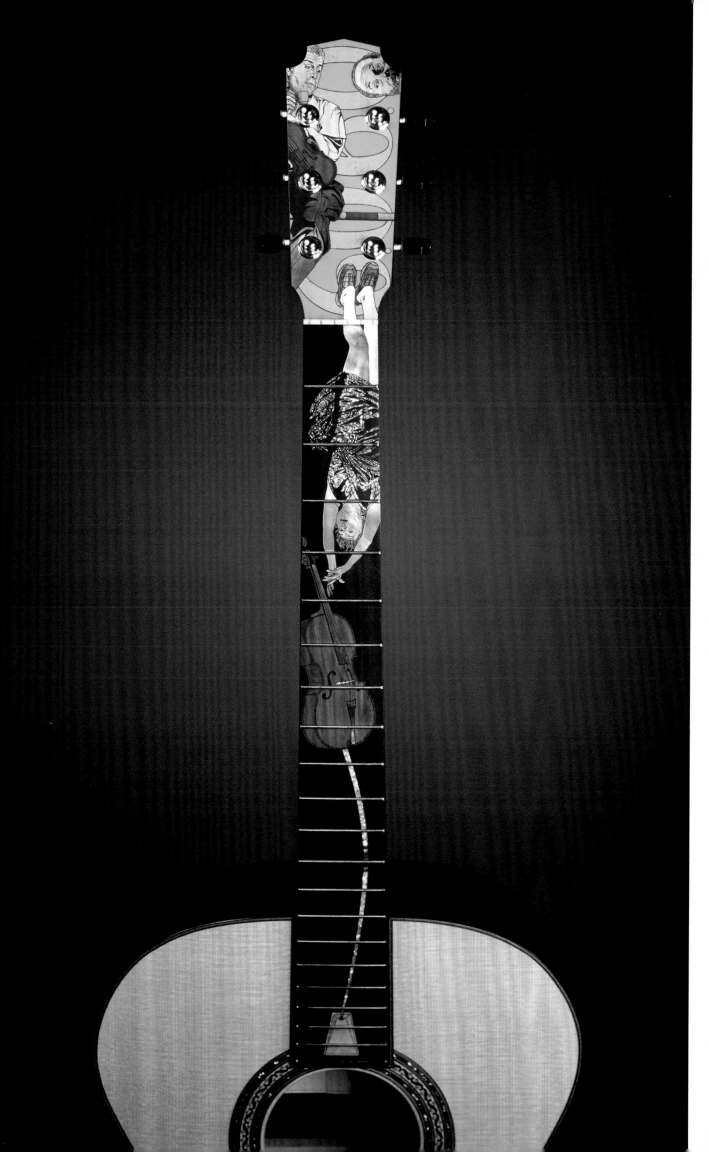

The Big Bang

steel string guitar

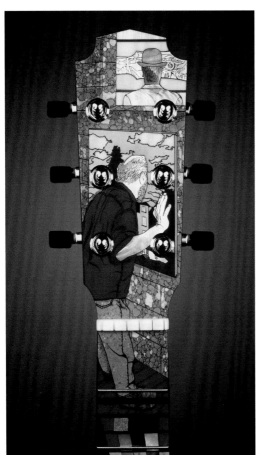

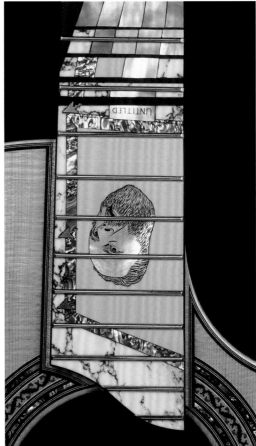

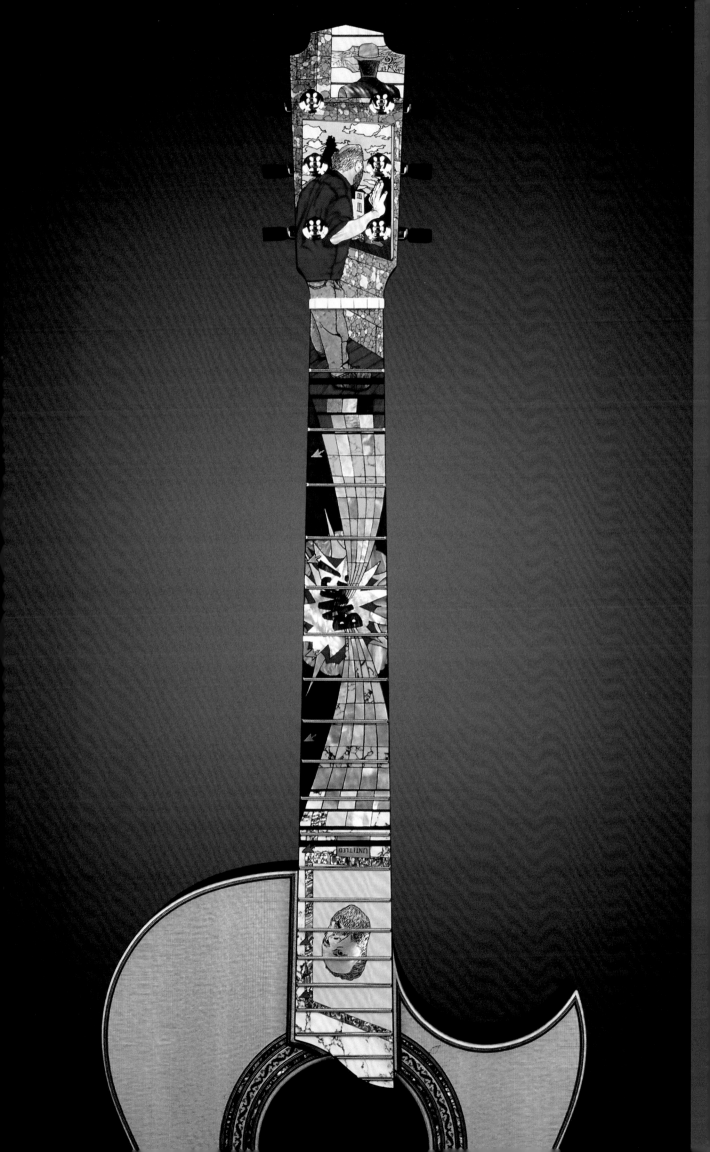

Bettie on Red

steel string guitar

The Red Canoe

steel string guitar

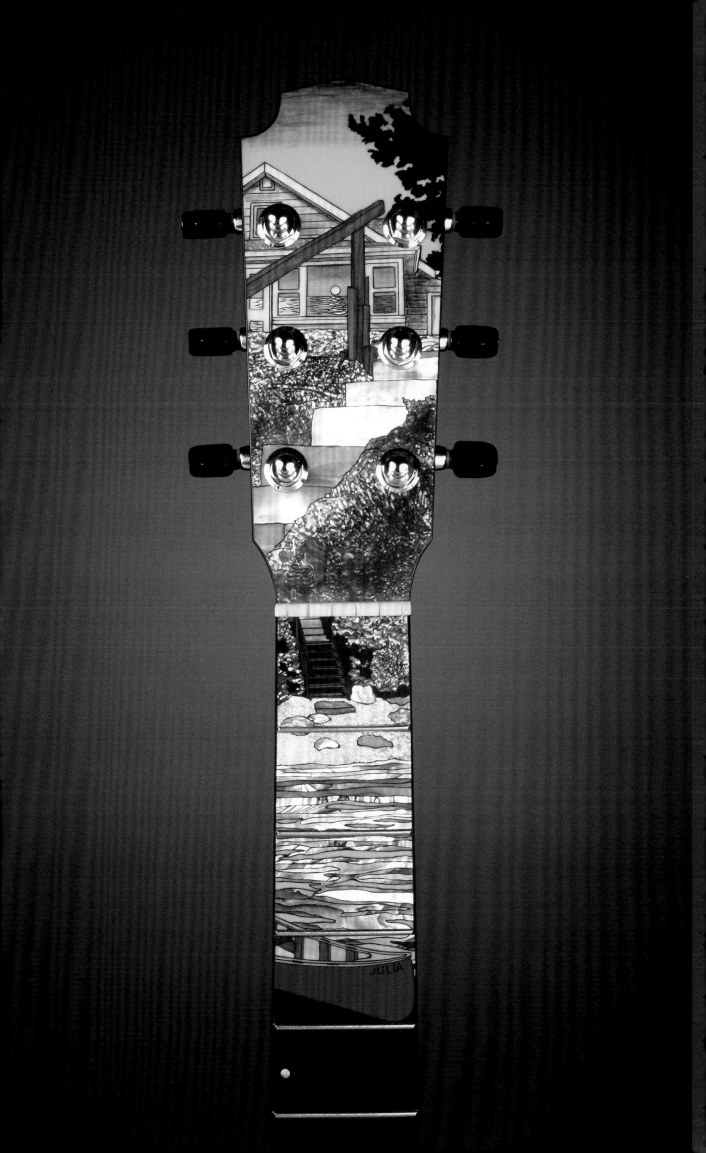

Matt & Jody & Hieronymus

steel string guitar

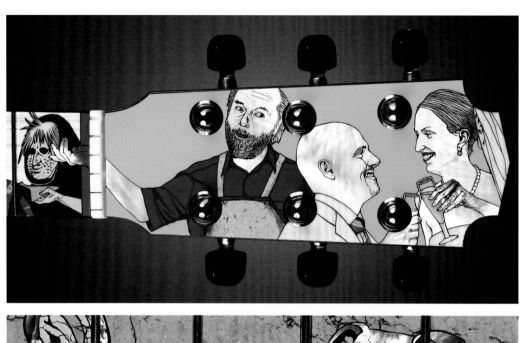

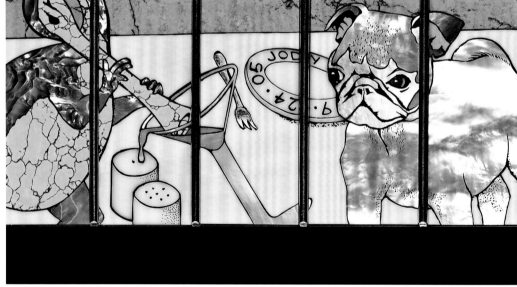

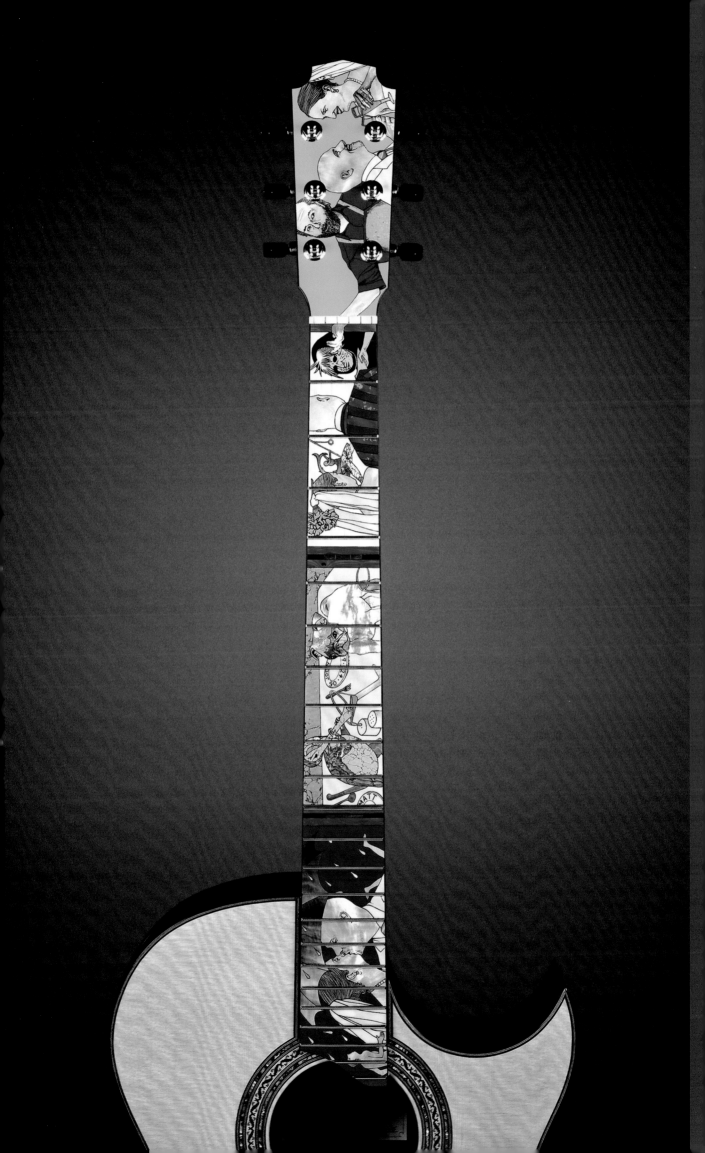

This Machine Prevents Wars

steel string guitar

The Hill in Autumn

steel string guitar

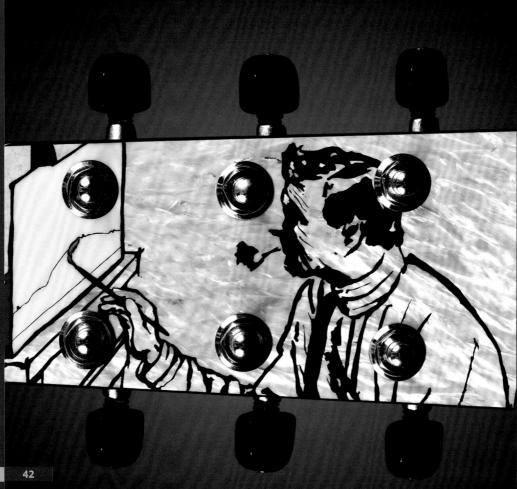

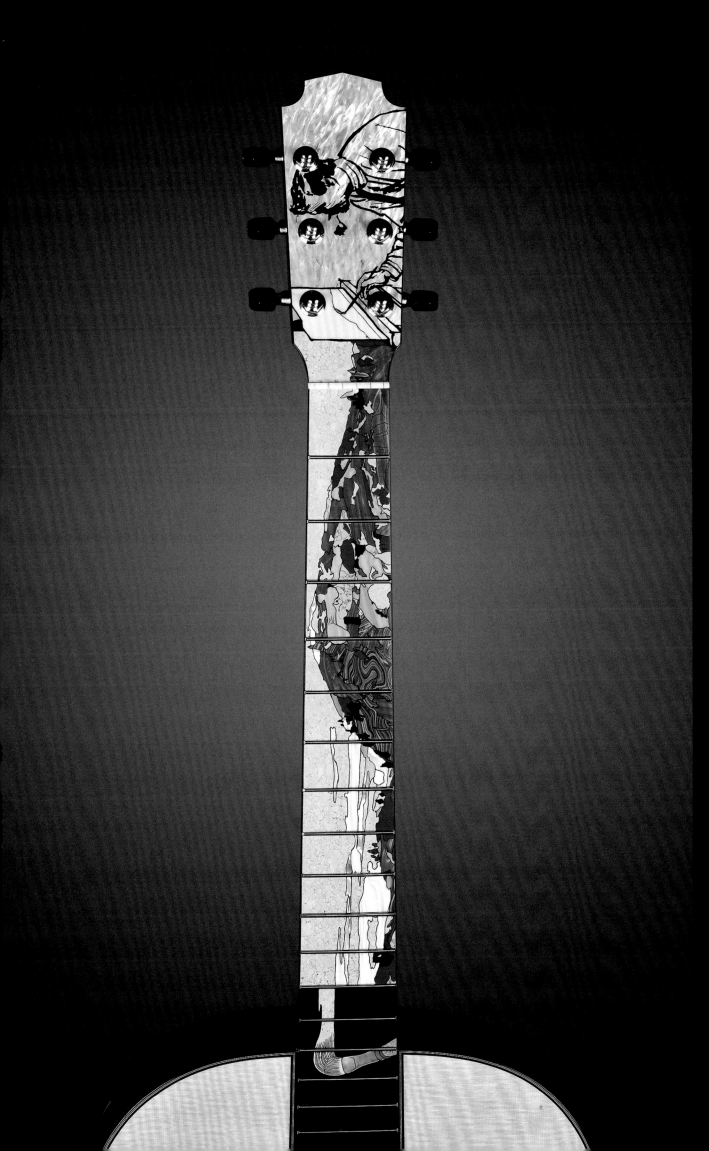

What Is Your Desire?

steel string guitar

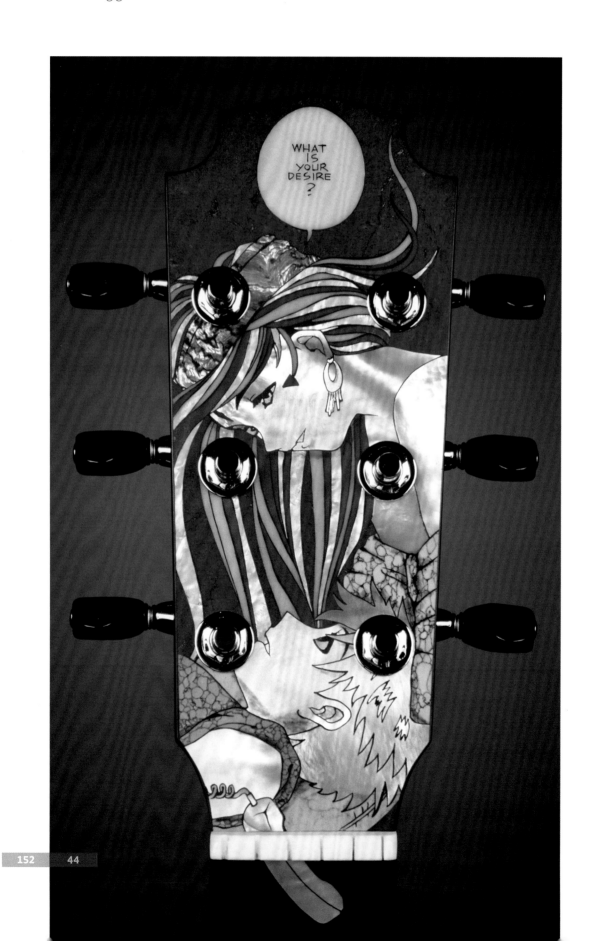

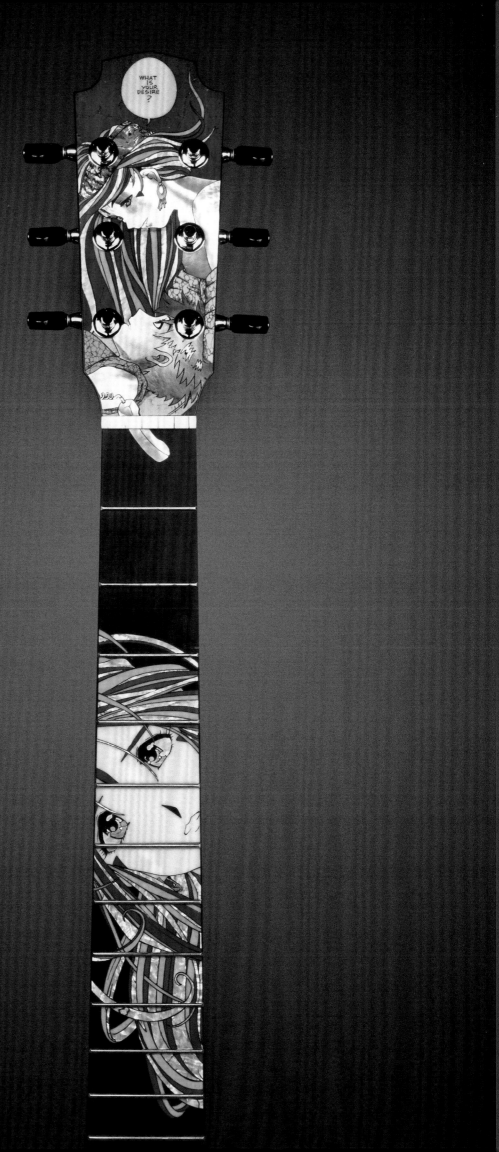

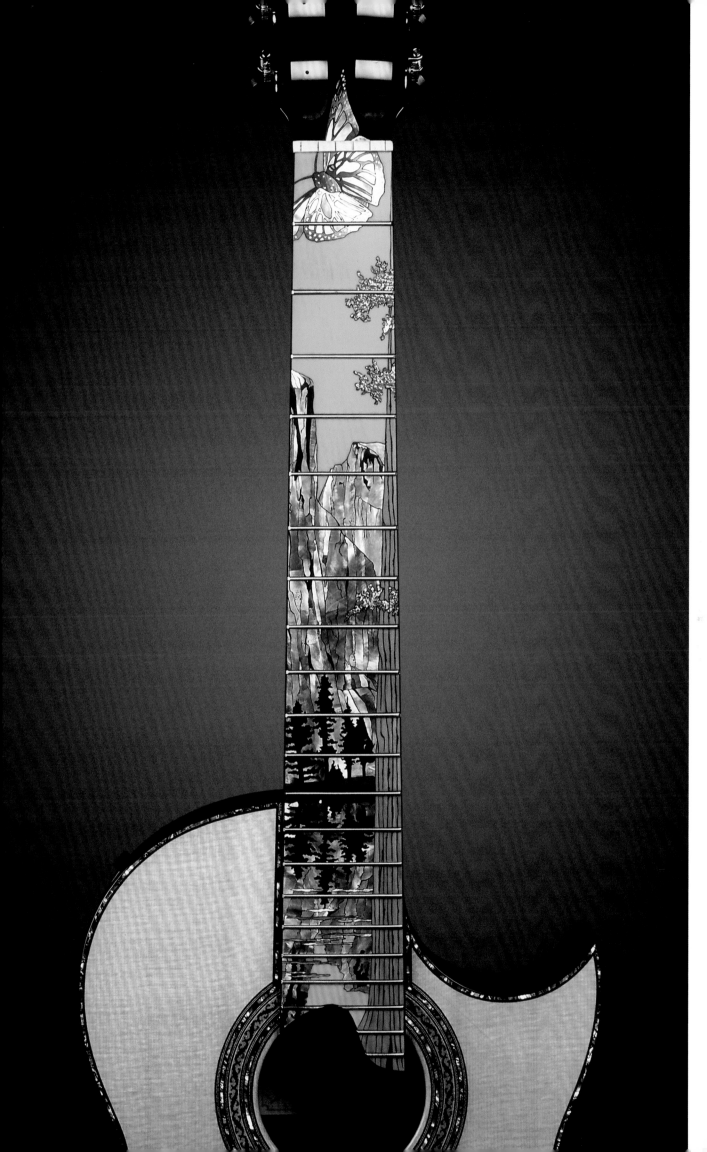

Ibis Redux

steel string guitar

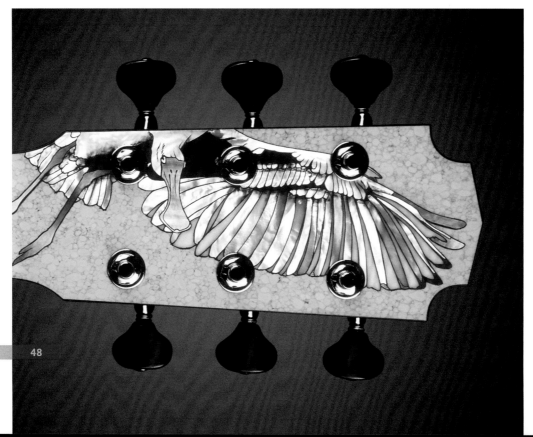

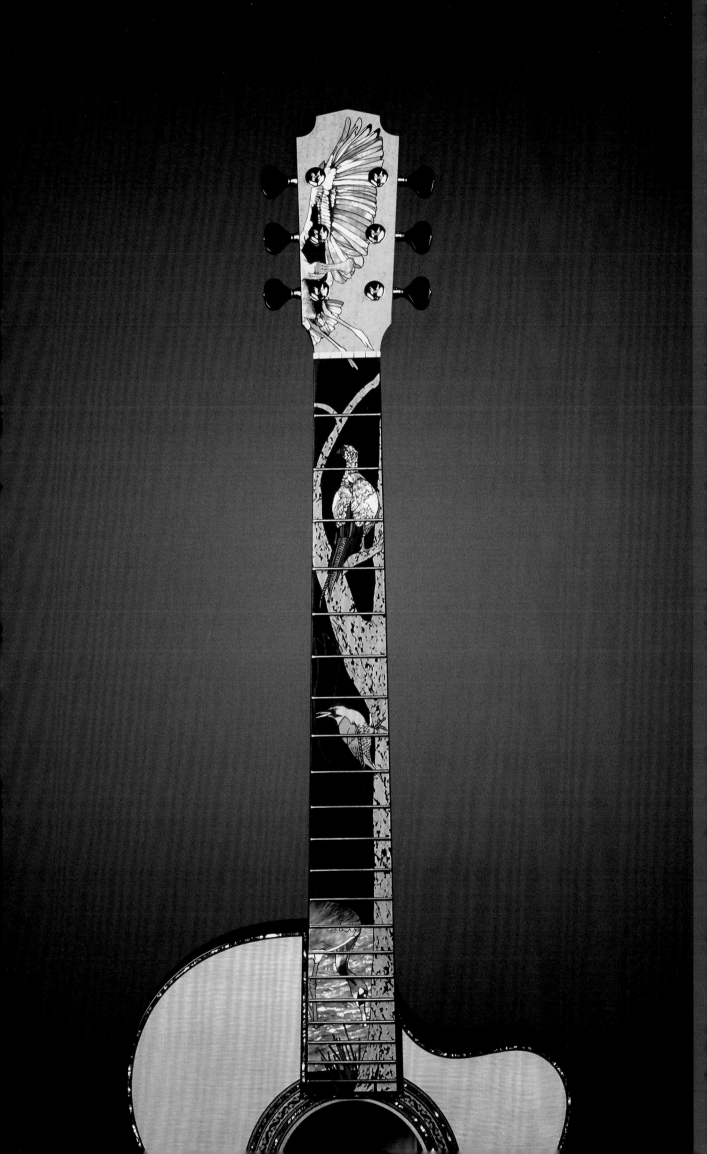

Acoustic vs. Electric

steel string guitar

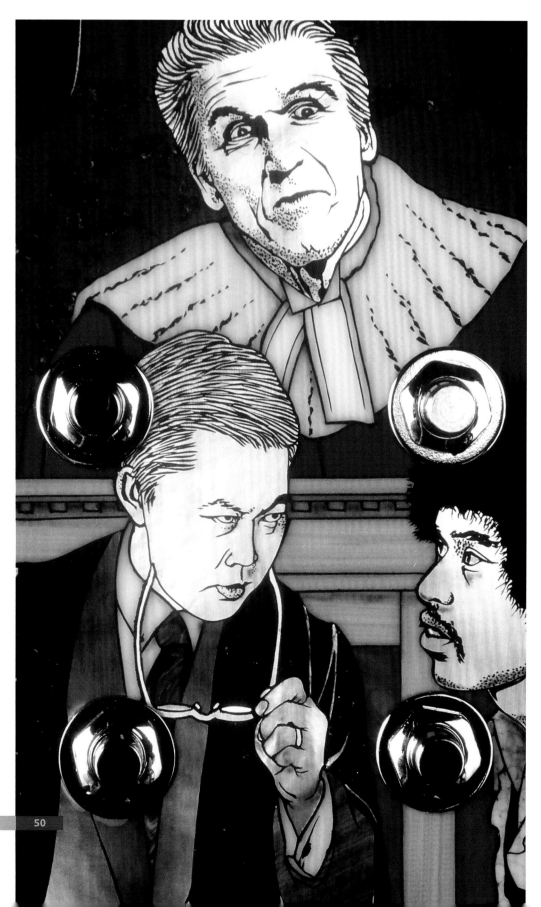

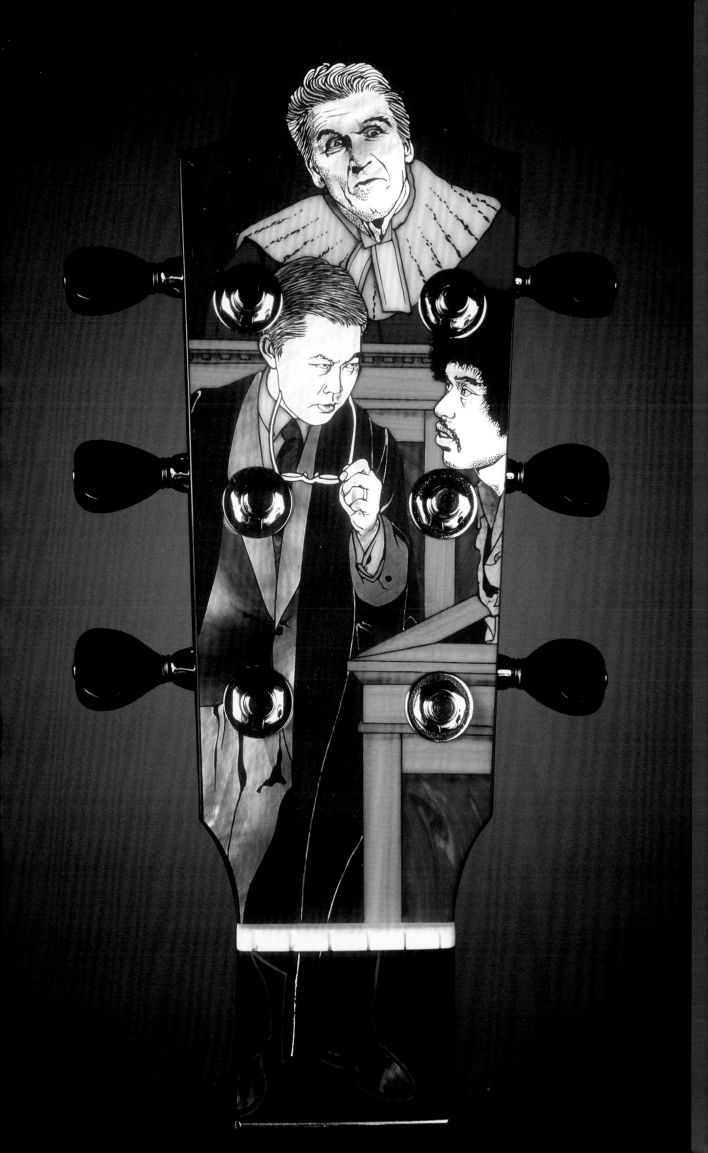

The Blue Fiddle

steel string guitar

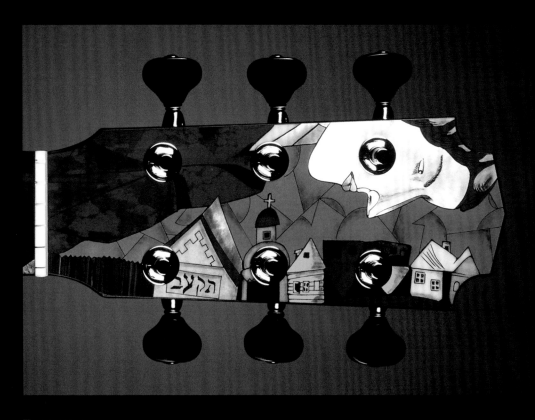

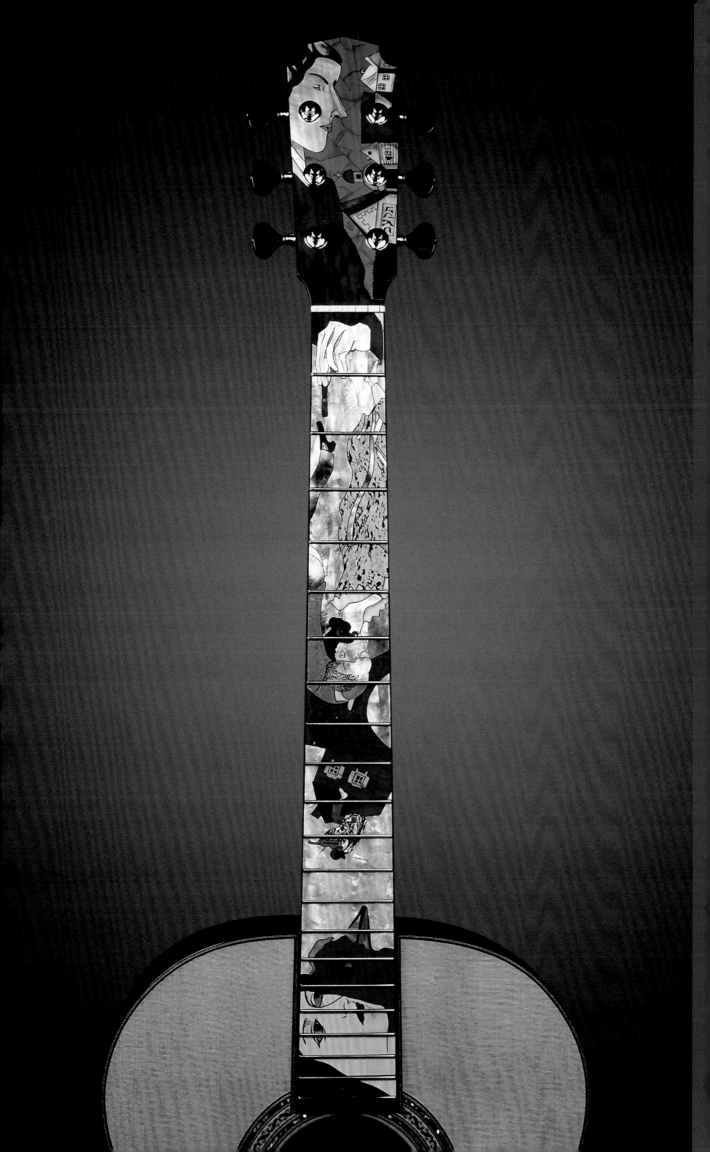

Marc's Menagerie

steel string guitar

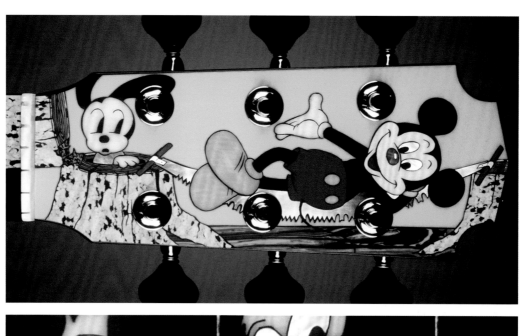

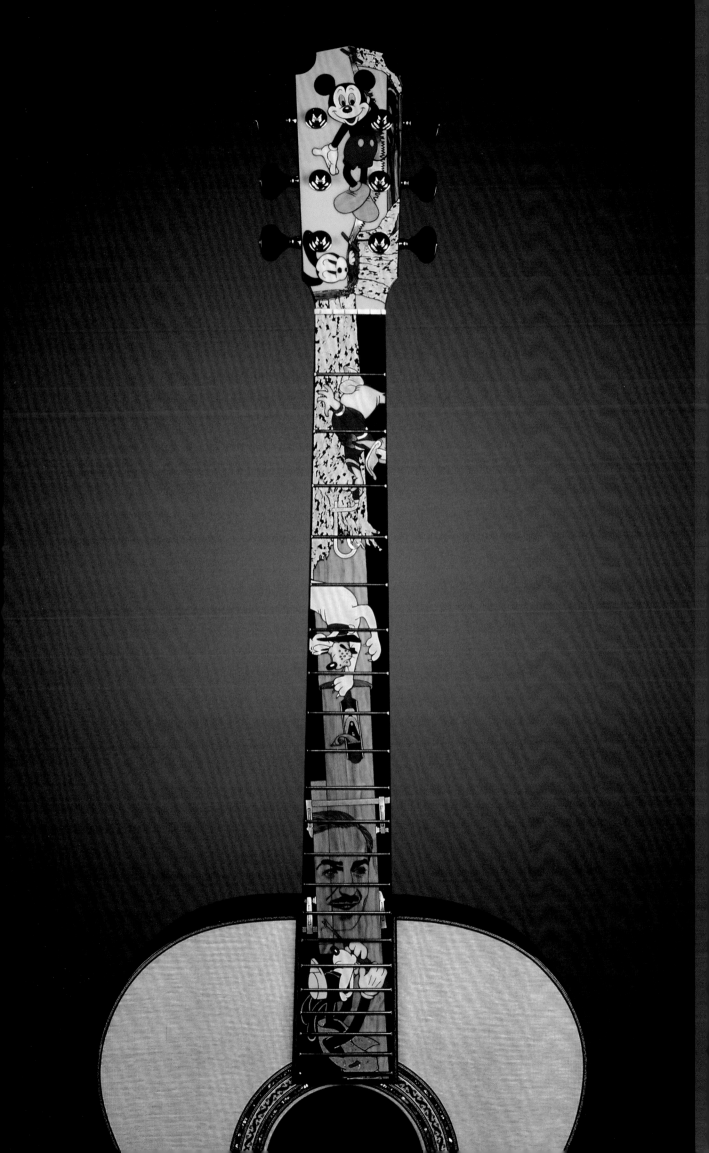

43

12-string steel string guitar

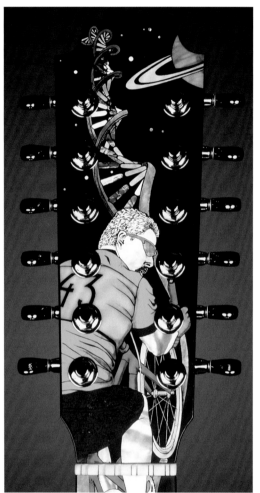

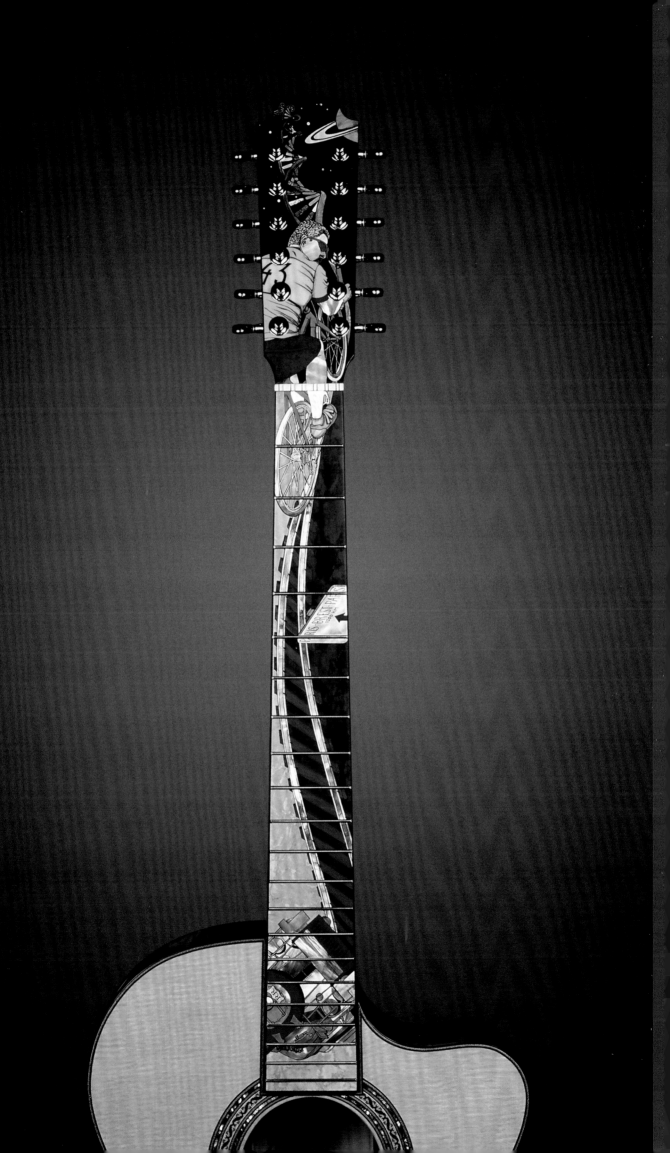

The Blue Notes

steel string guitar

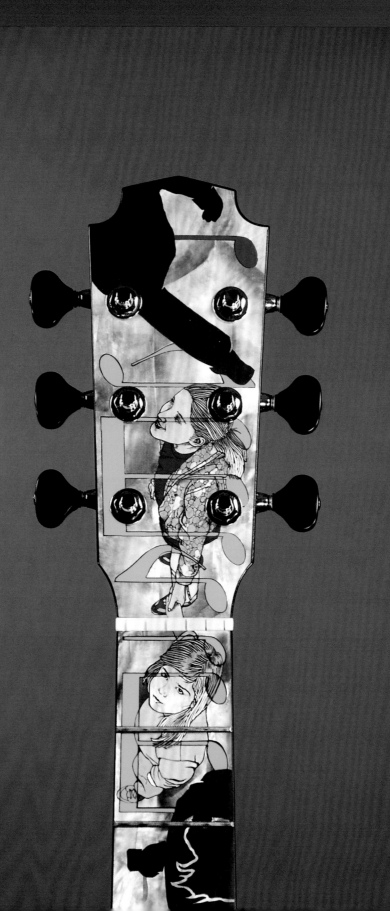

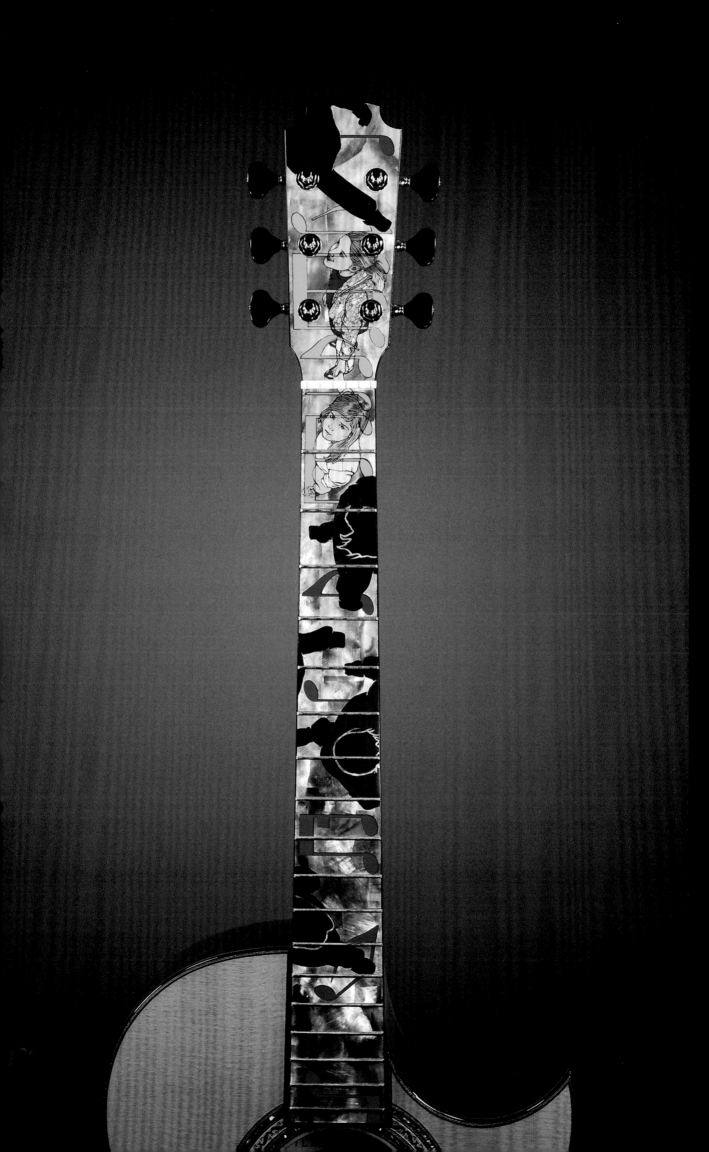

Finding Bobby

steel string guitar

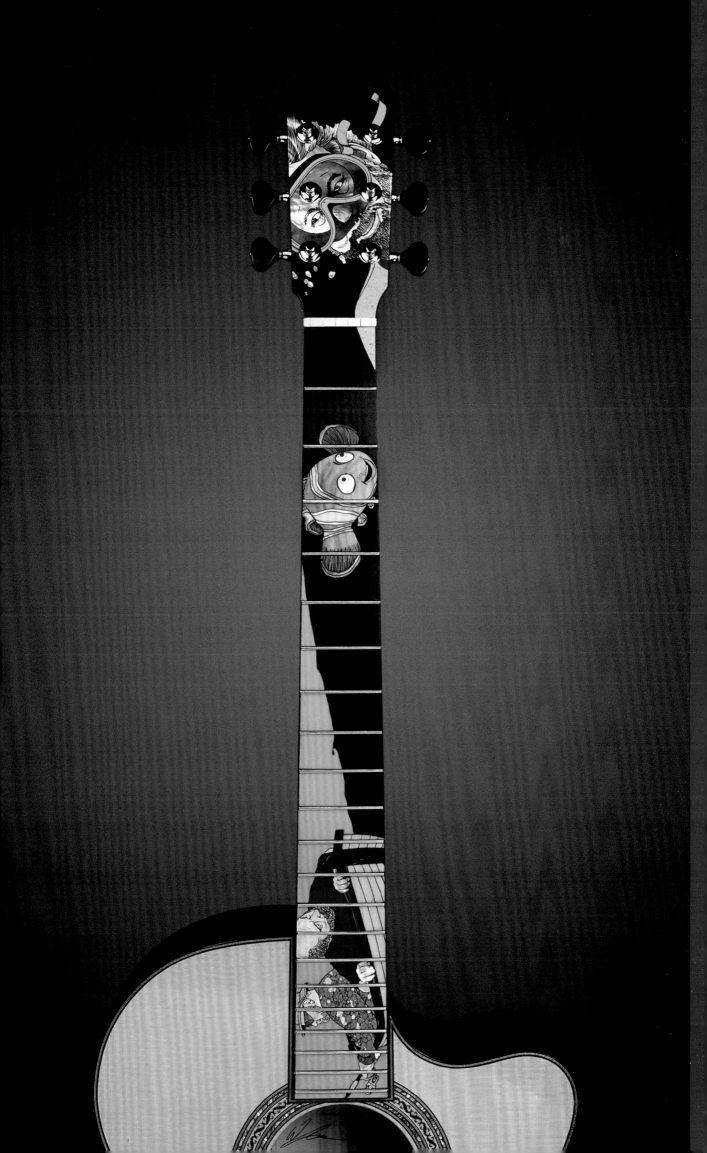

Emilia's Journey

steel string guitar

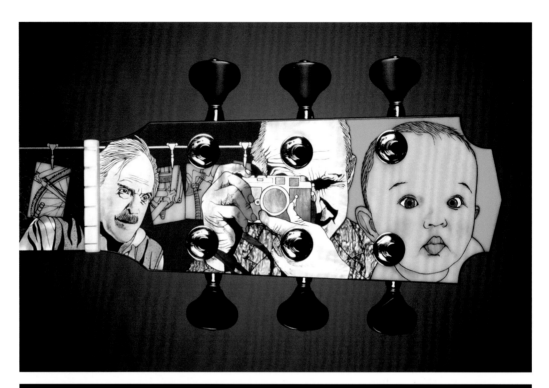

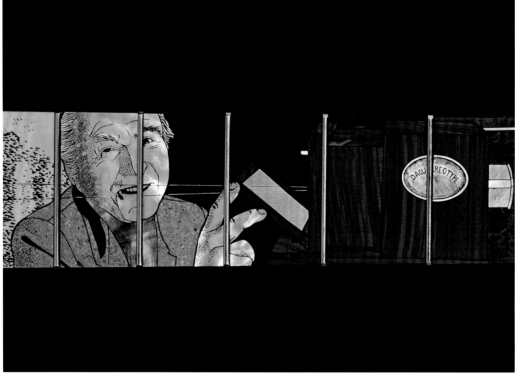

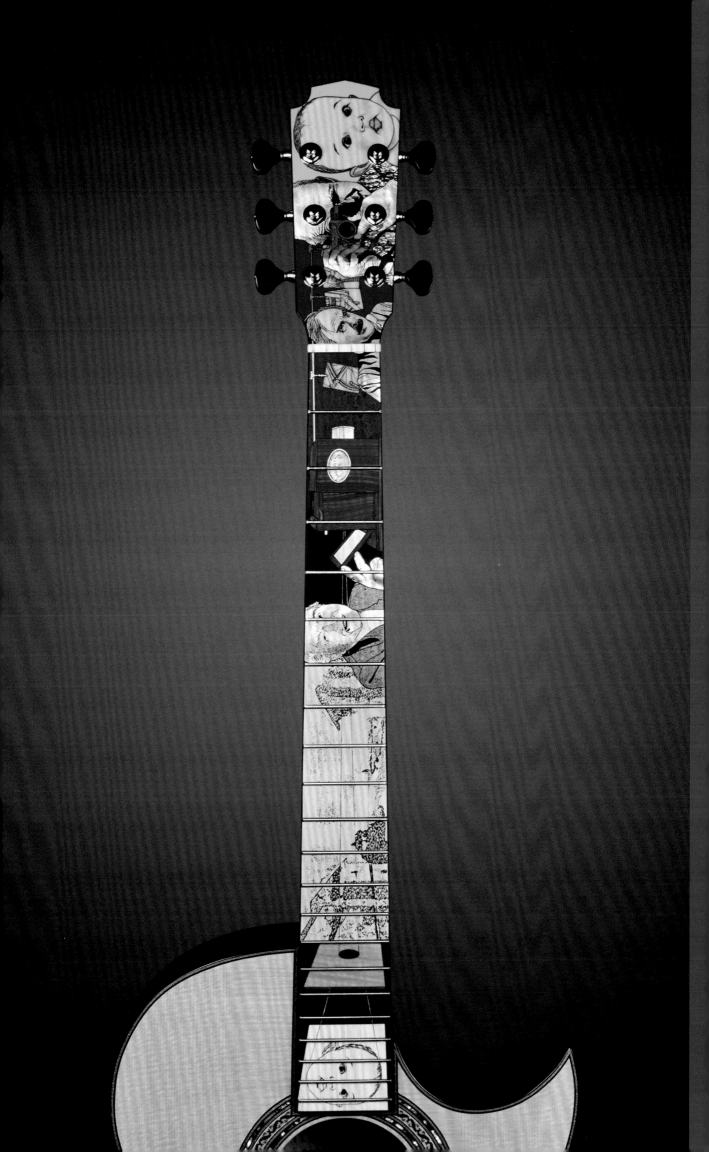

Imagine

steel string guitar

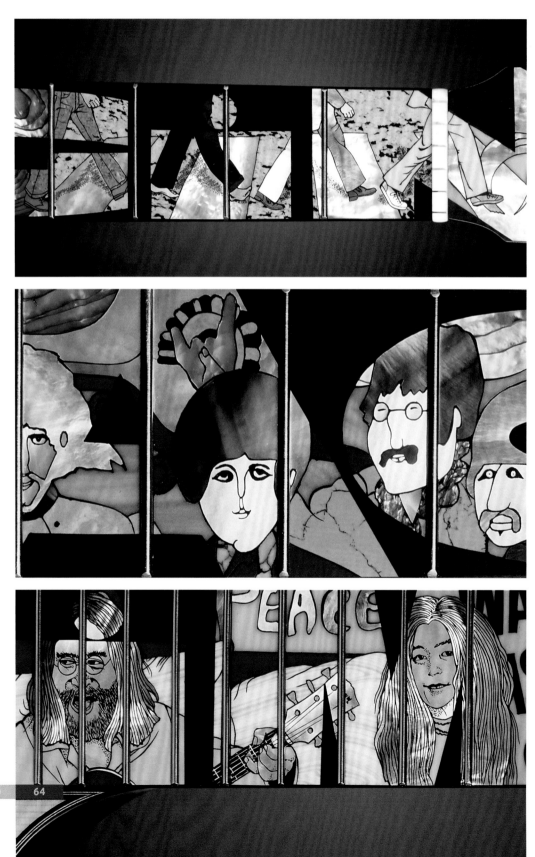

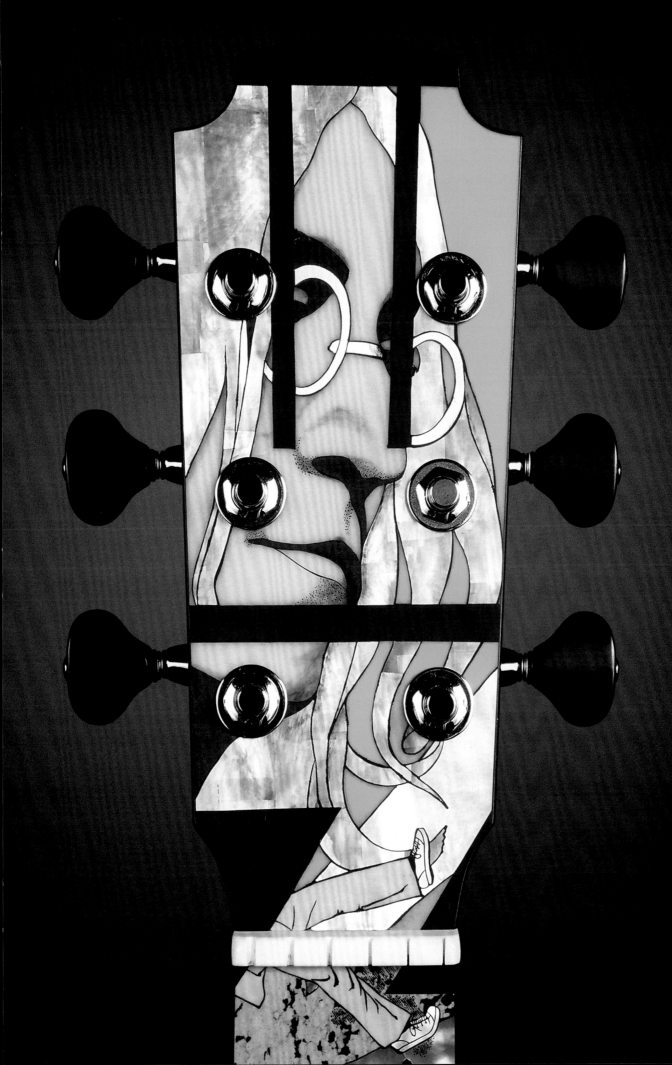

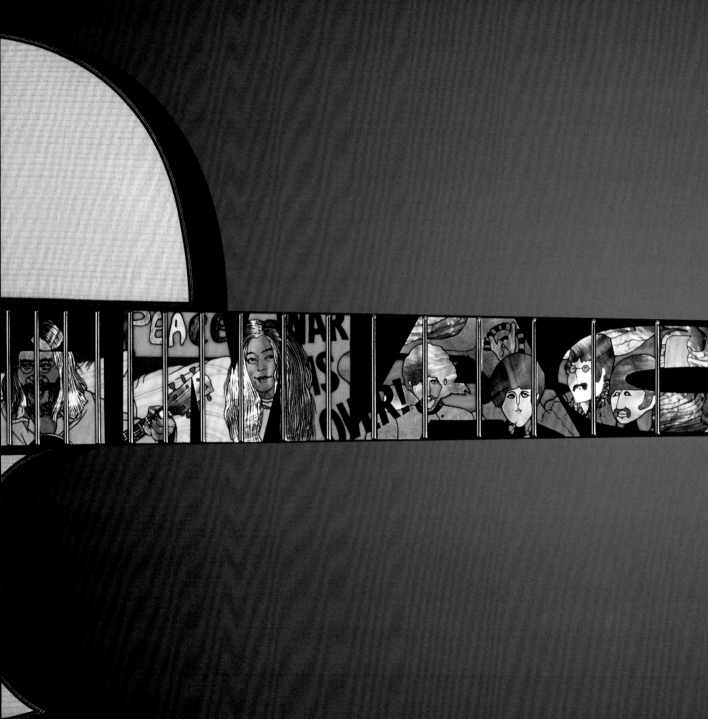

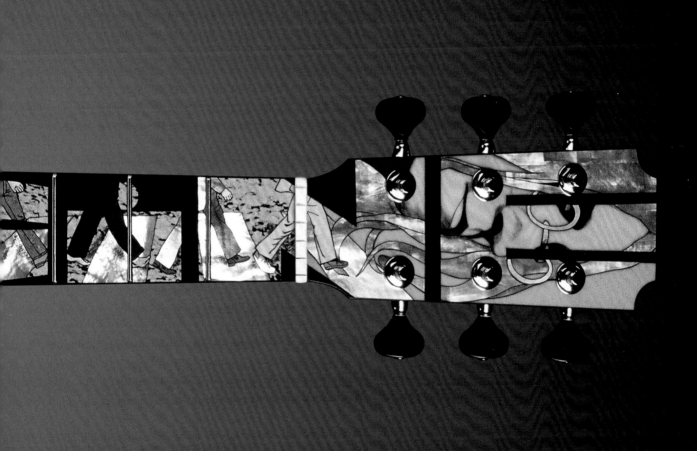

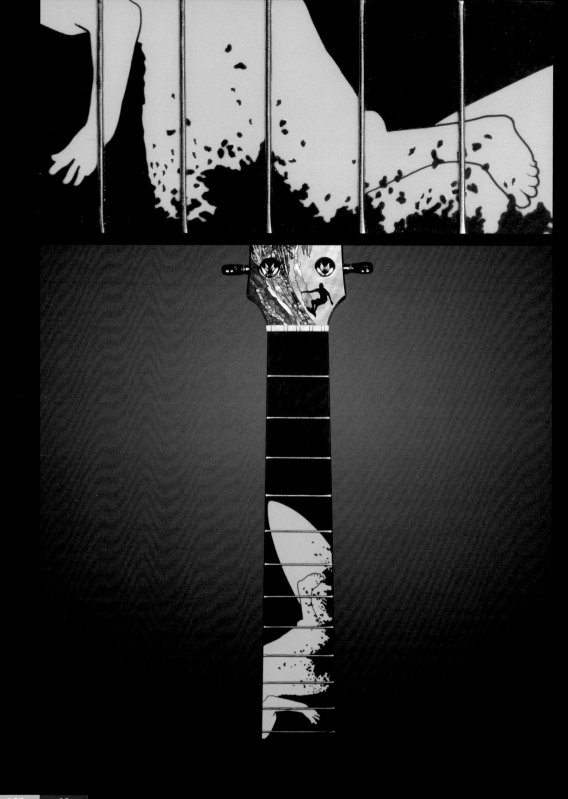

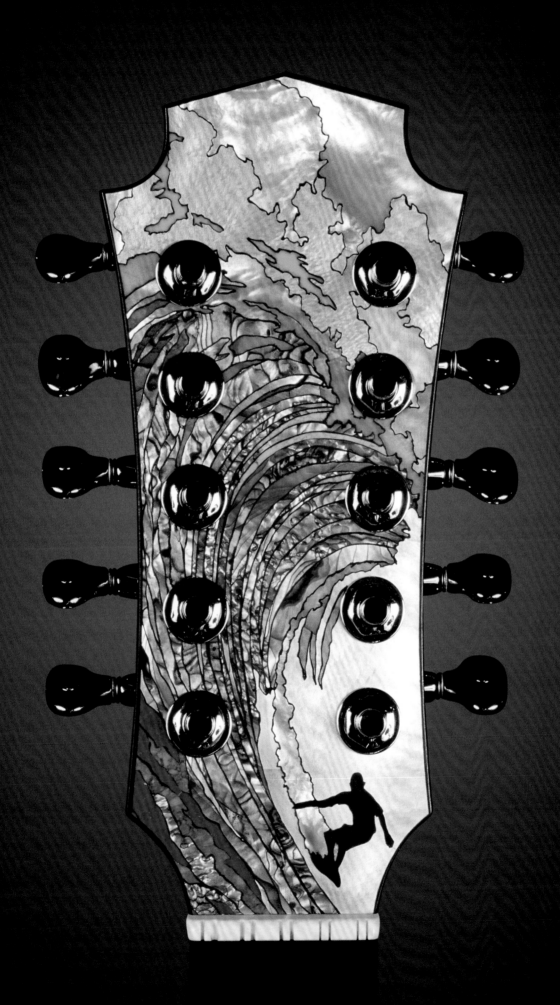

JATP 49

steel string guitar

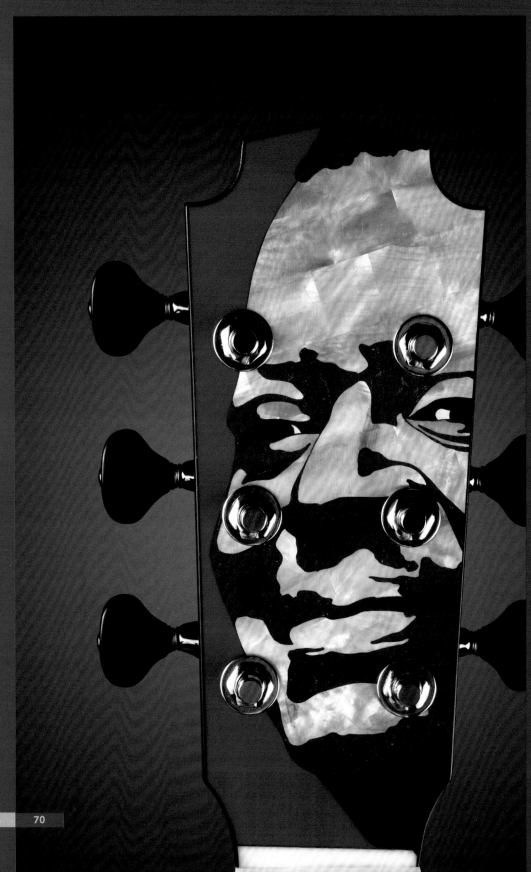

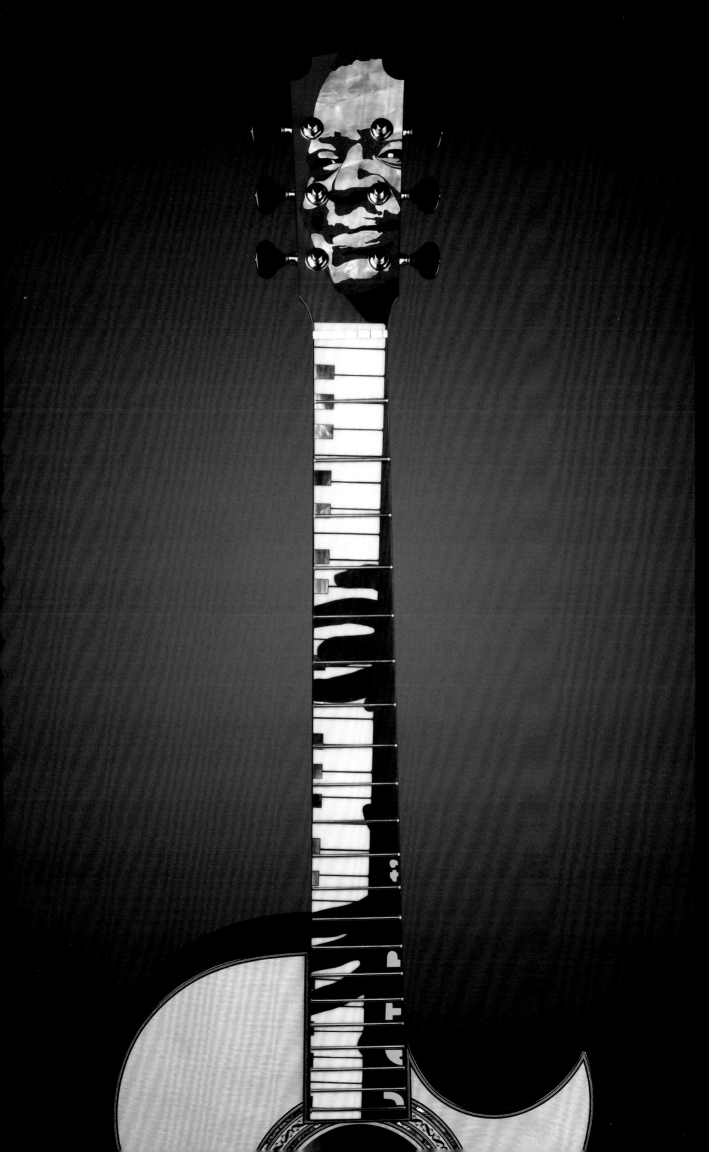

Haply I Think on Thee

steel string guitar

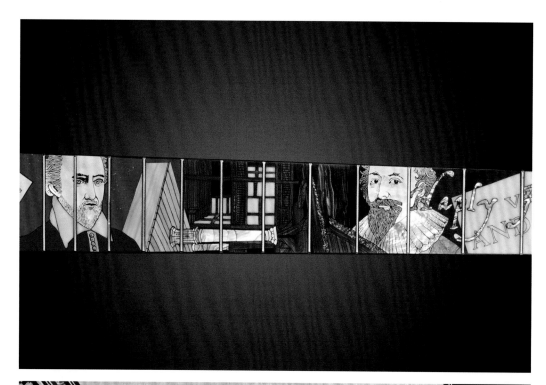

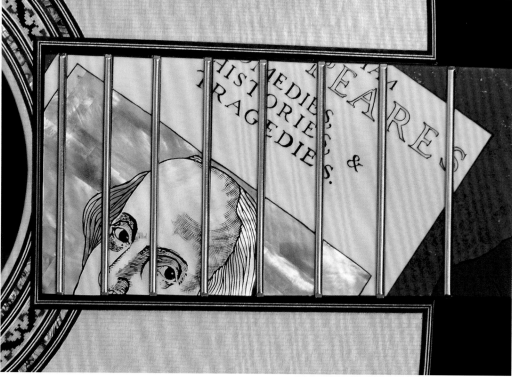

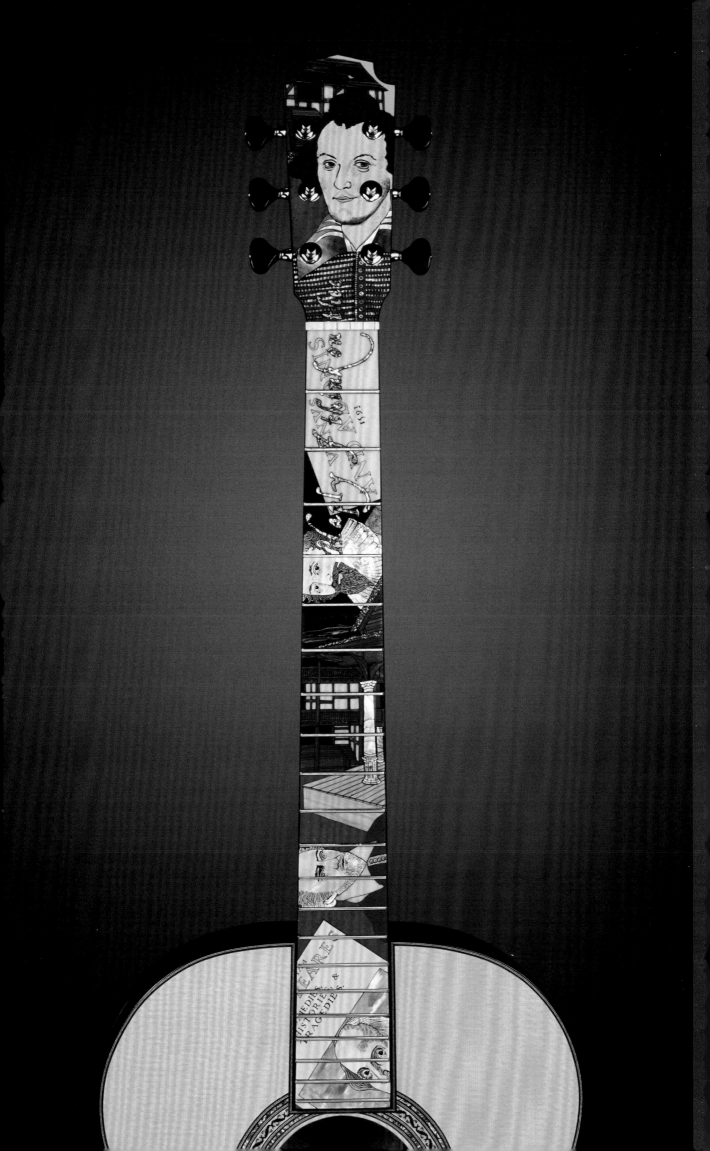

Music Never Dies

12-string steel string guitar

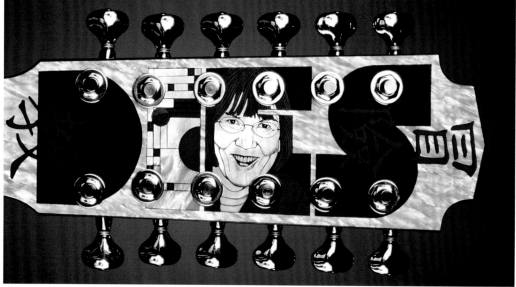

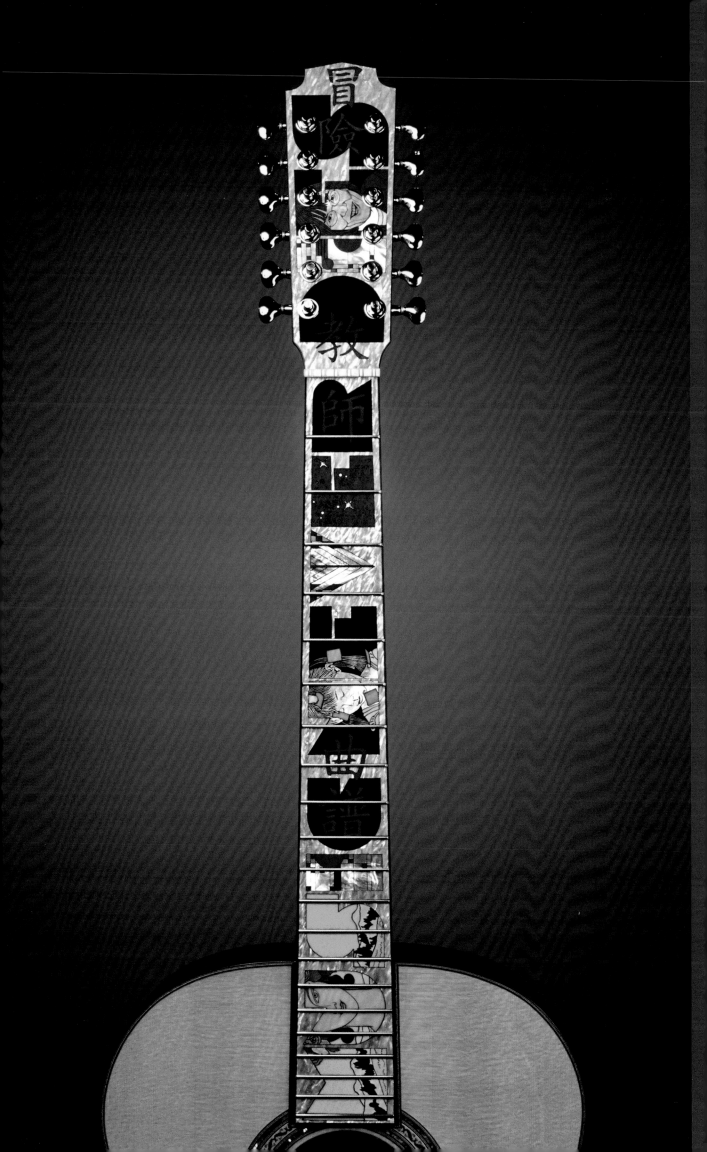

Three Wise Men

steel string guitar

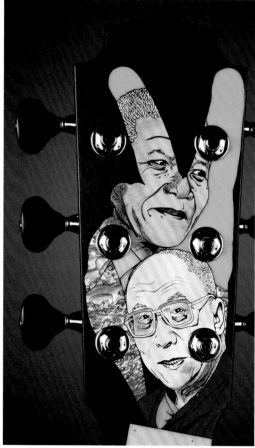

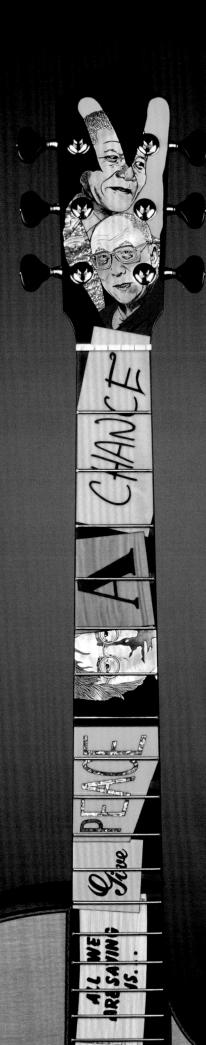

2010

Humpbacks

steel string guitar

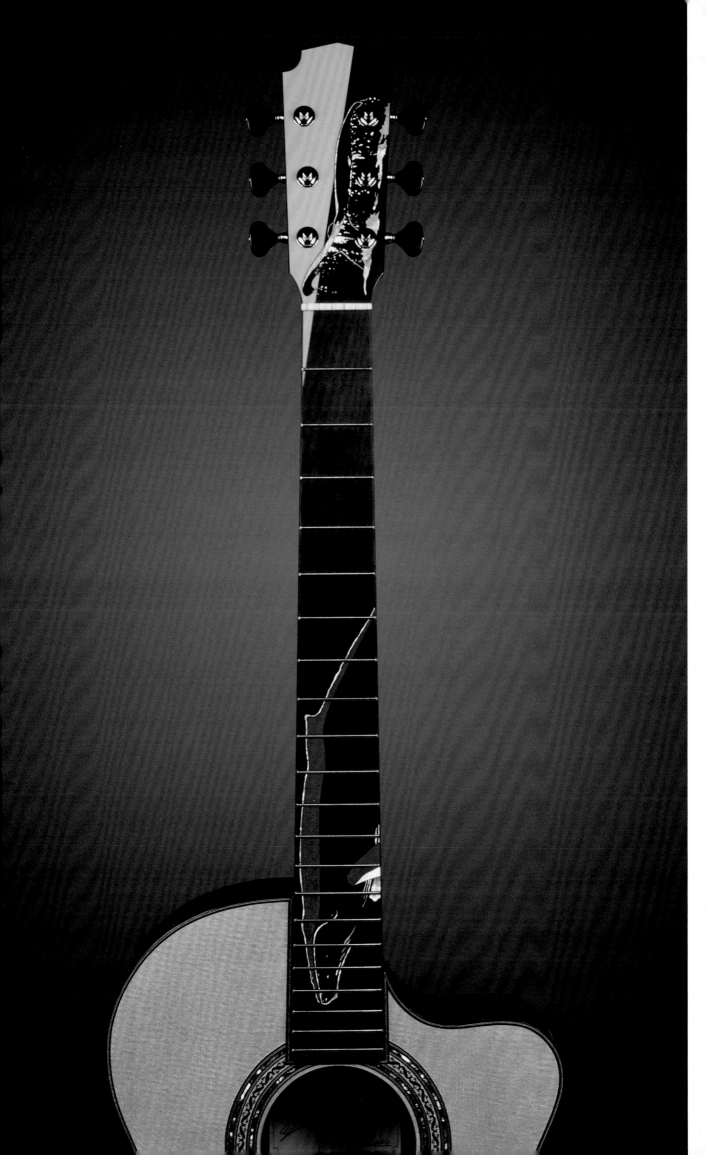

O'ahu Waterworld

steel string guitar

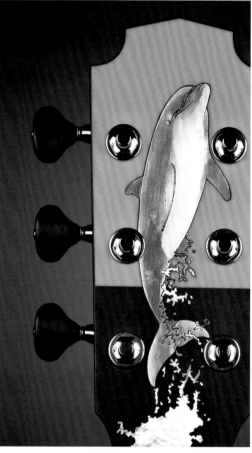

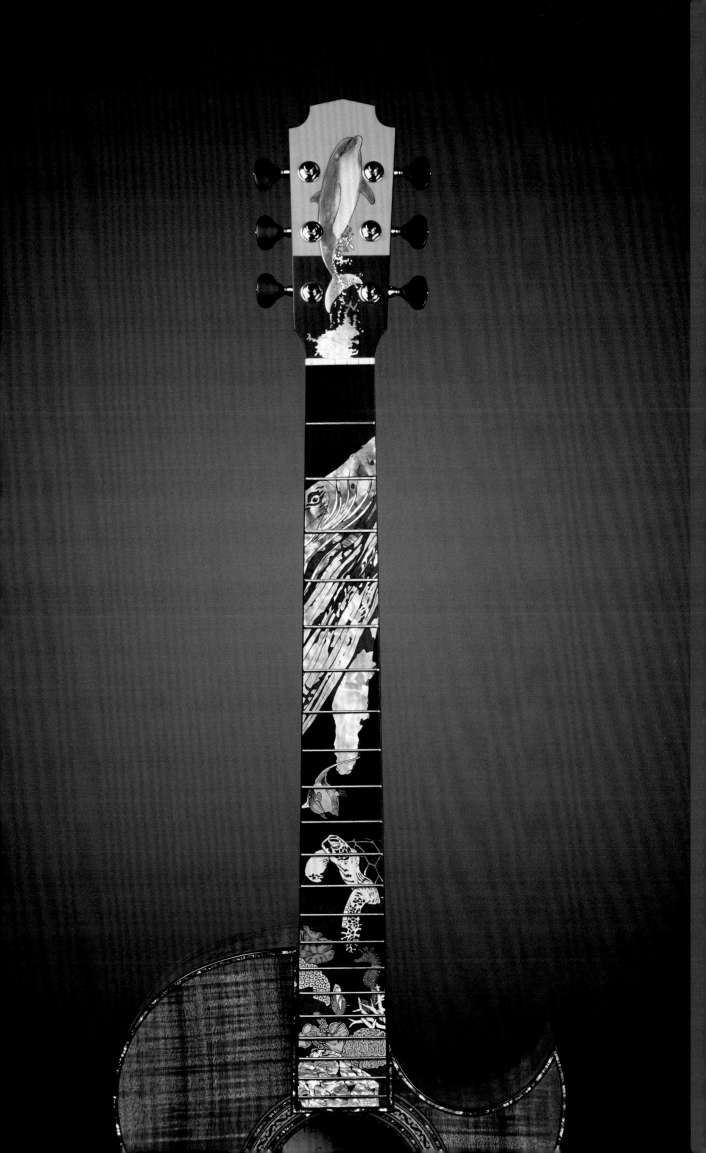

1964

steel string guitar

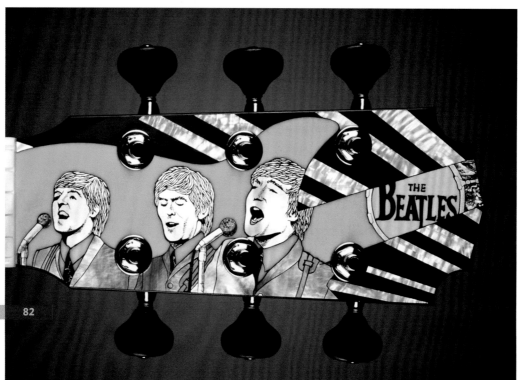

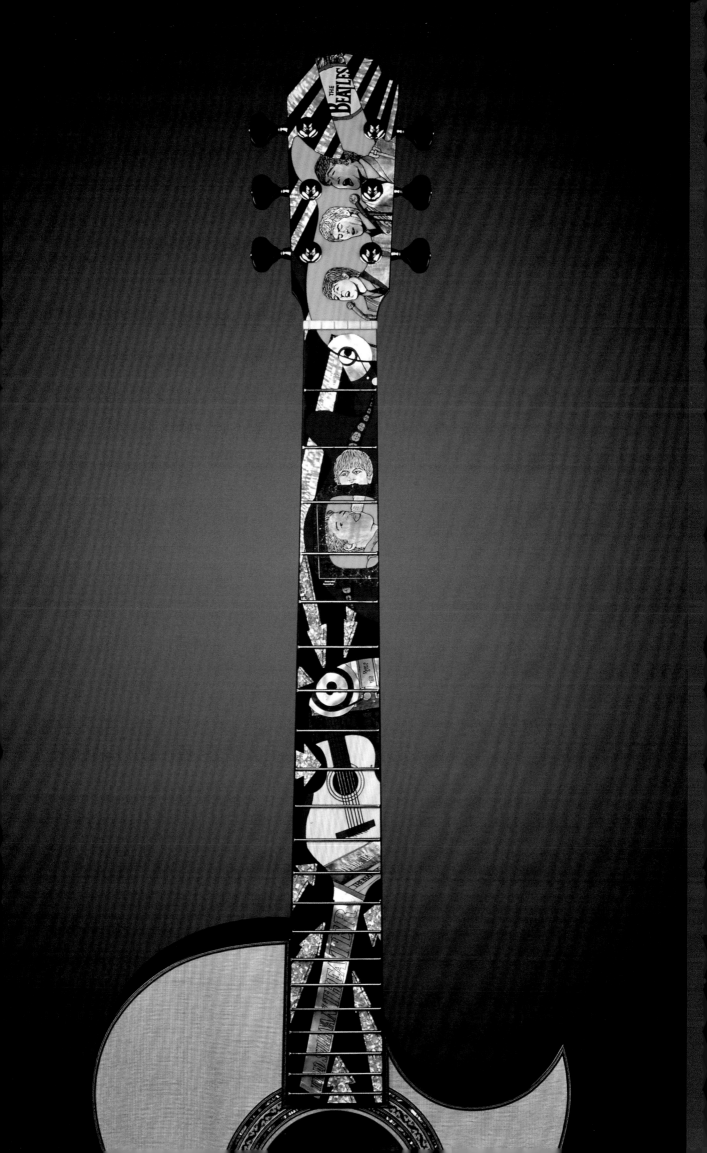

The Blue Trumpet

steel string guitar

The Impossible Dream

steel string guitar

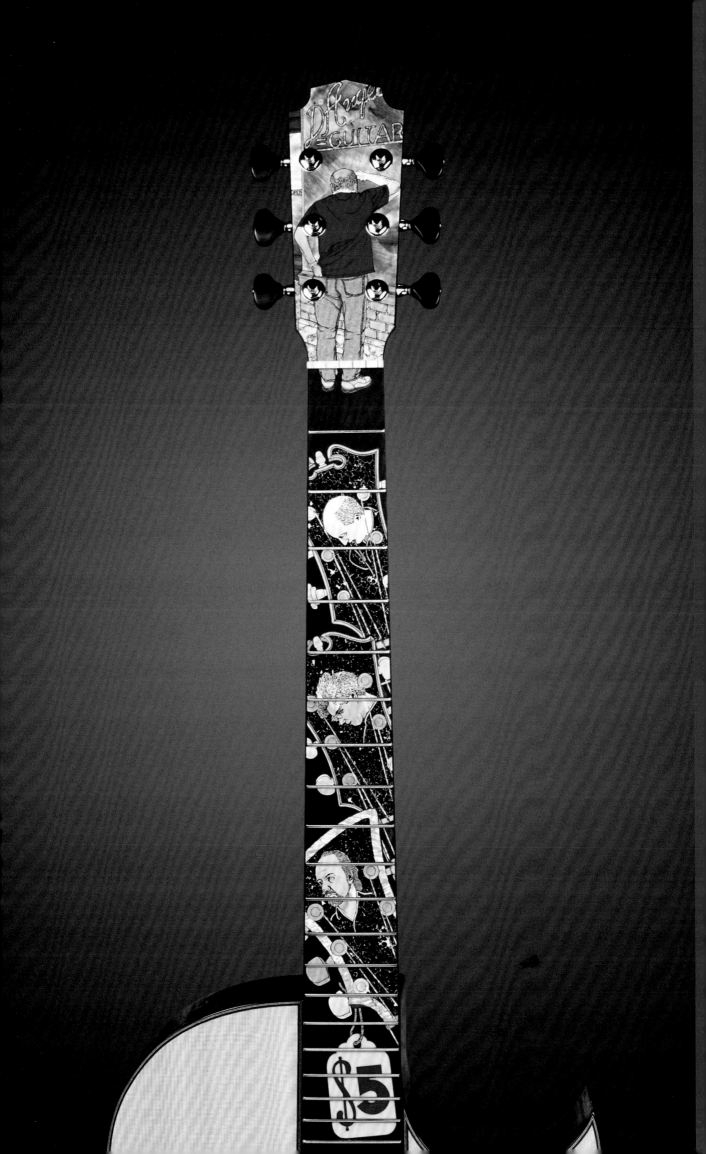

Blueprint for Curves

steel string guitar

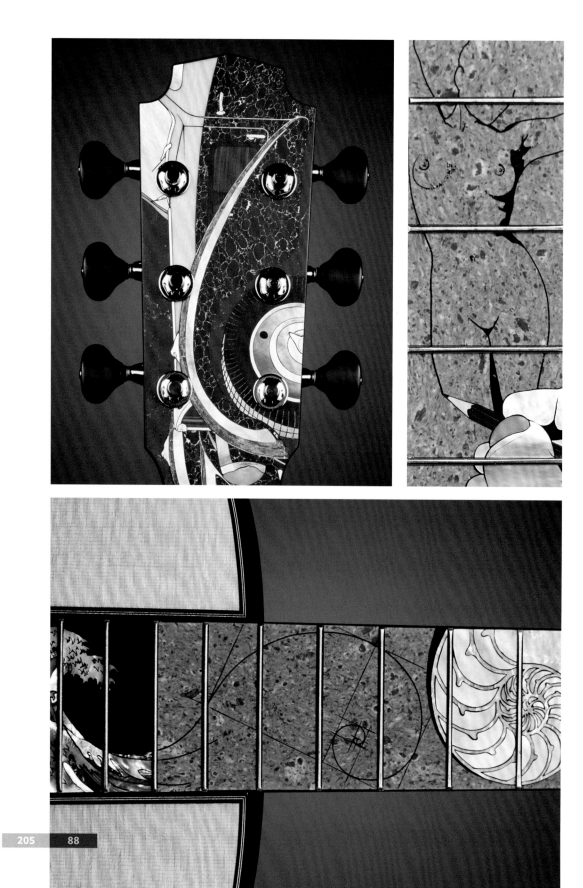

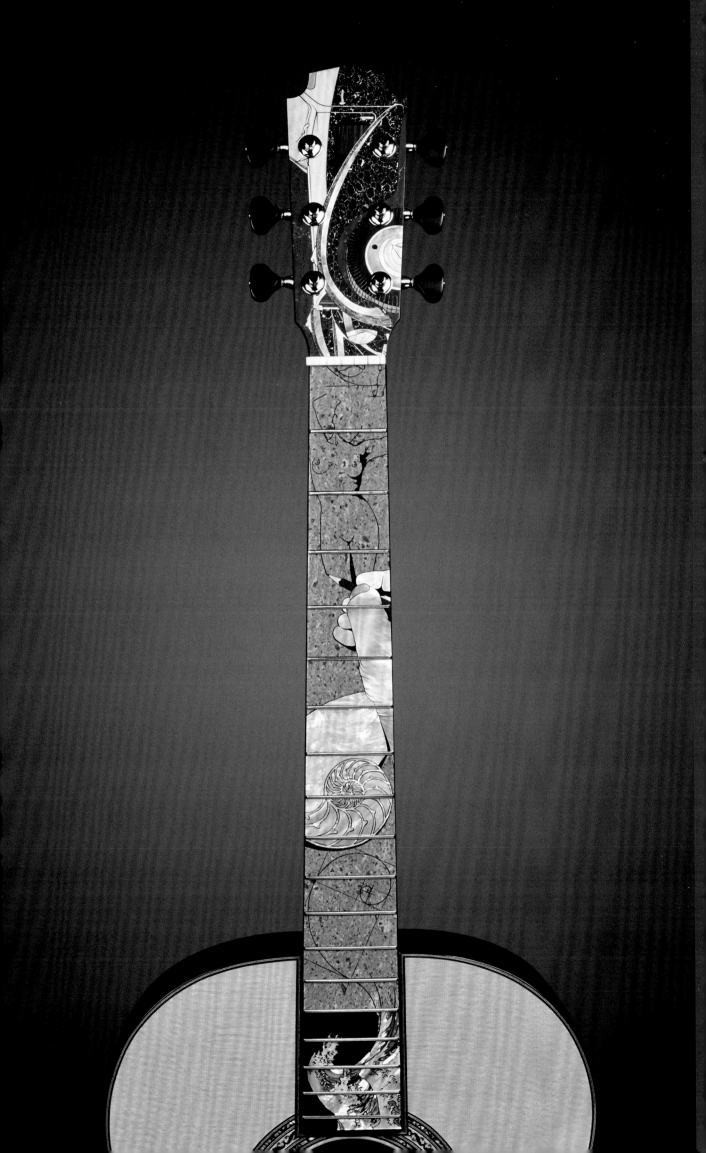

Playing with Light

steel string guitar

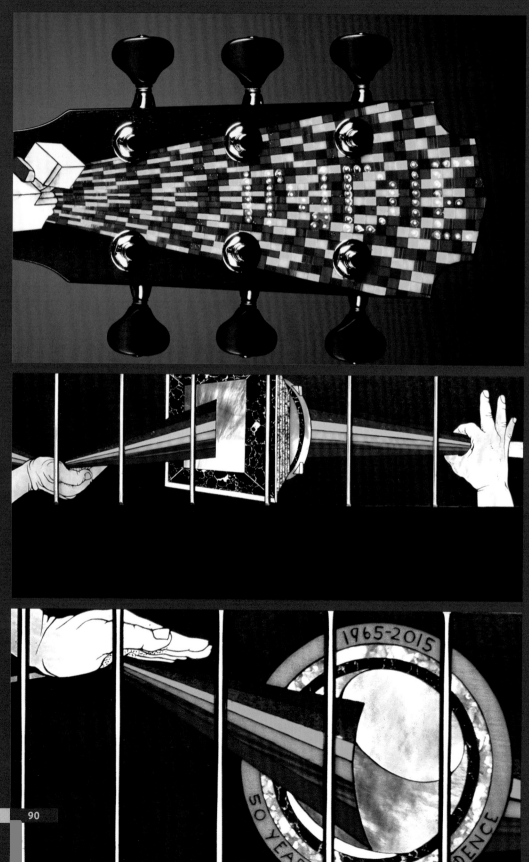

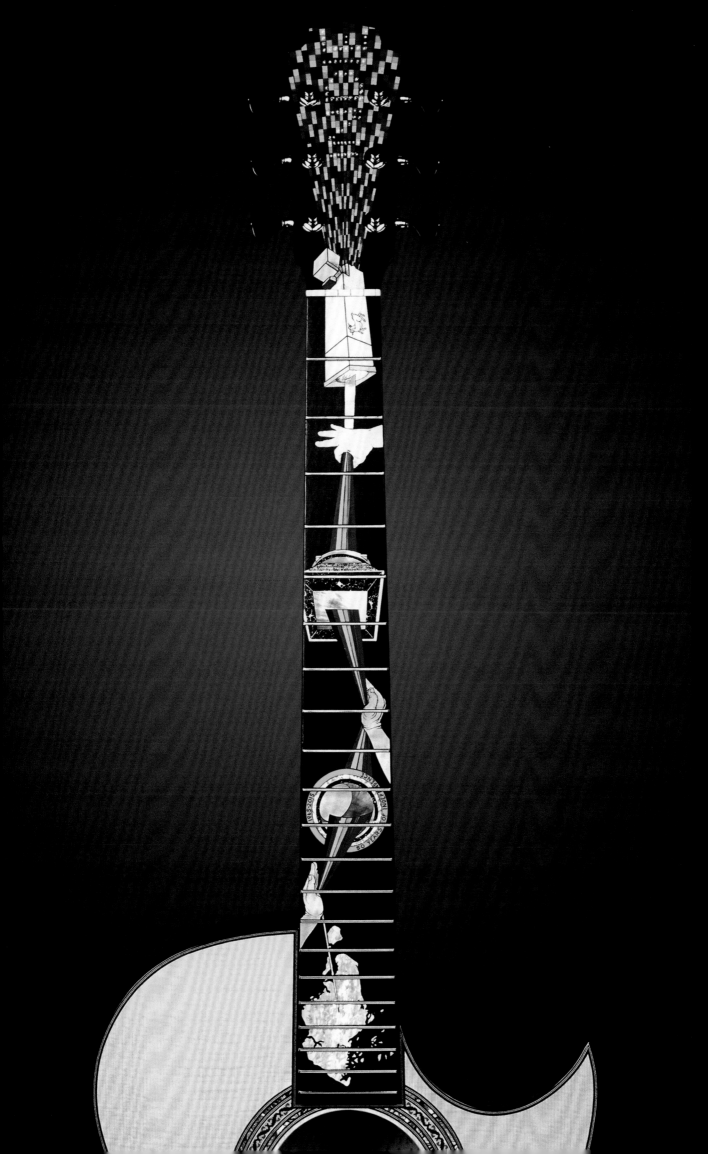

Water Music

steel string guitar

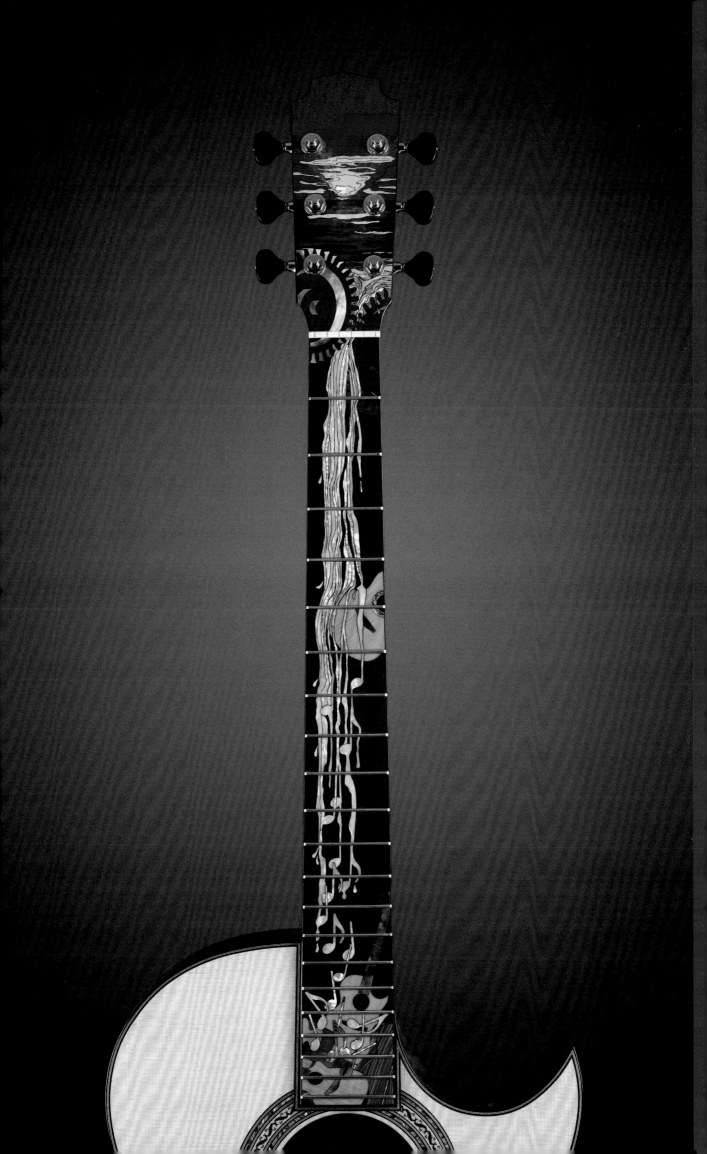

I Hope I Didn't Wake You

steel string guitar

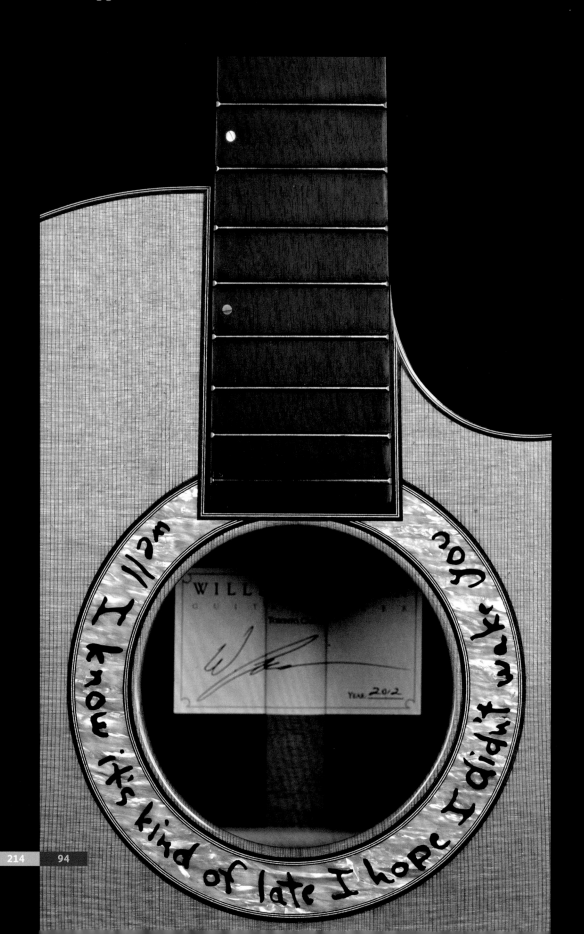

A Year of the Cherry

steel string guitar

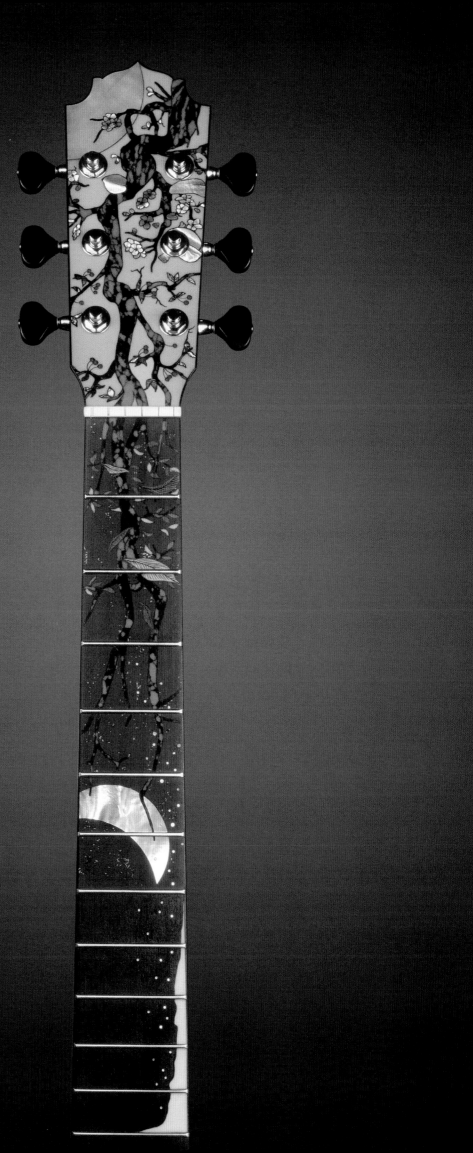

Courage in Sarajevo

steel string guitar

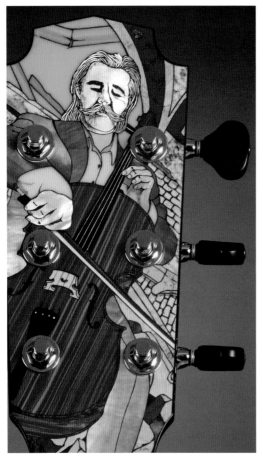
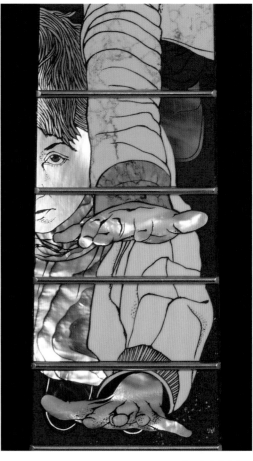

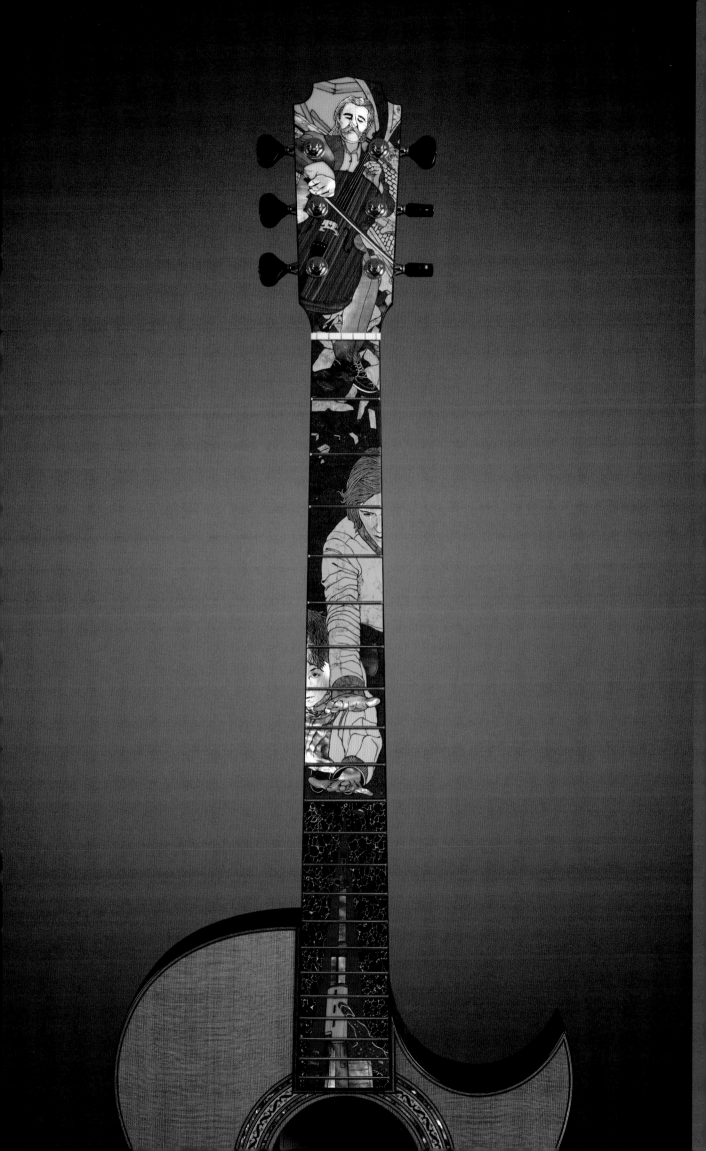

Southbound

steel string guitar

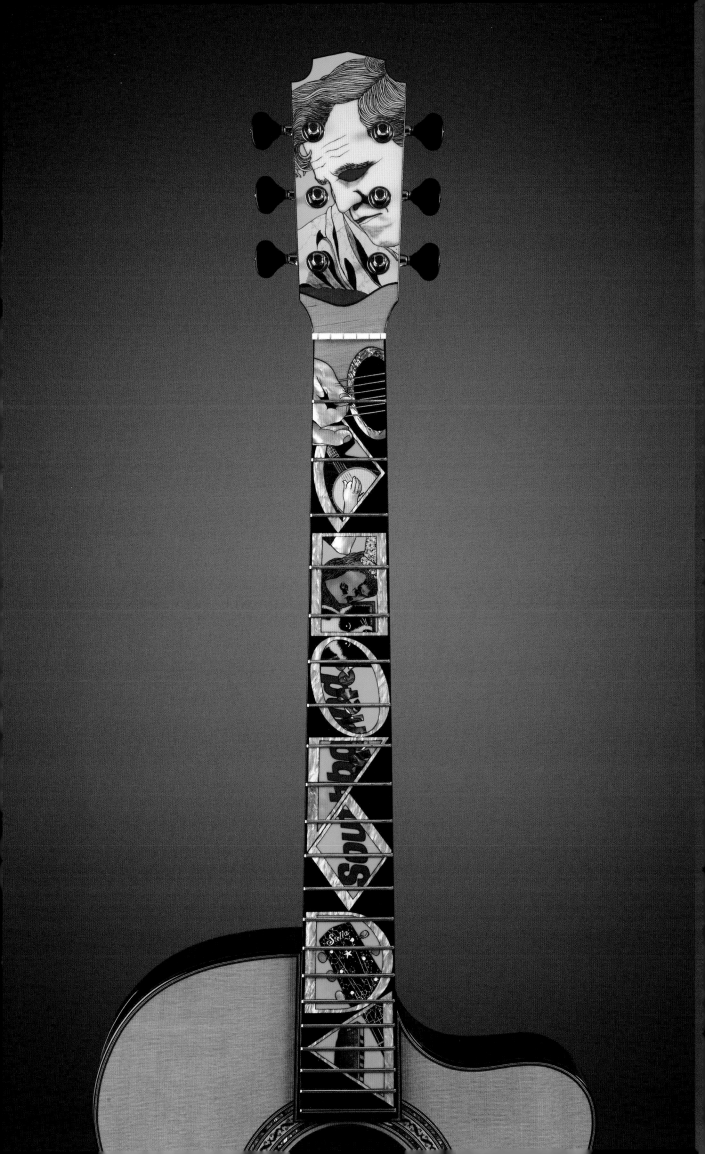

The Boxer

steel string guitar

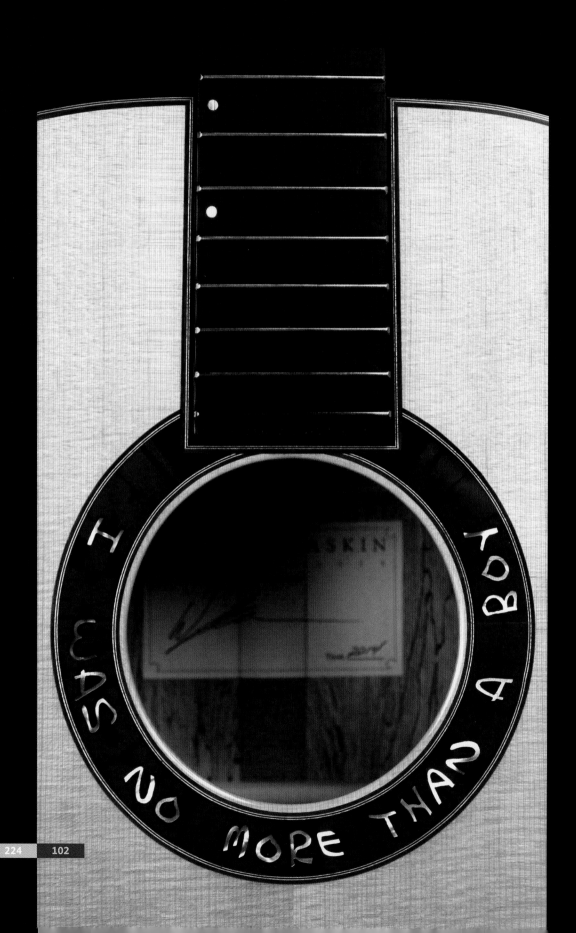

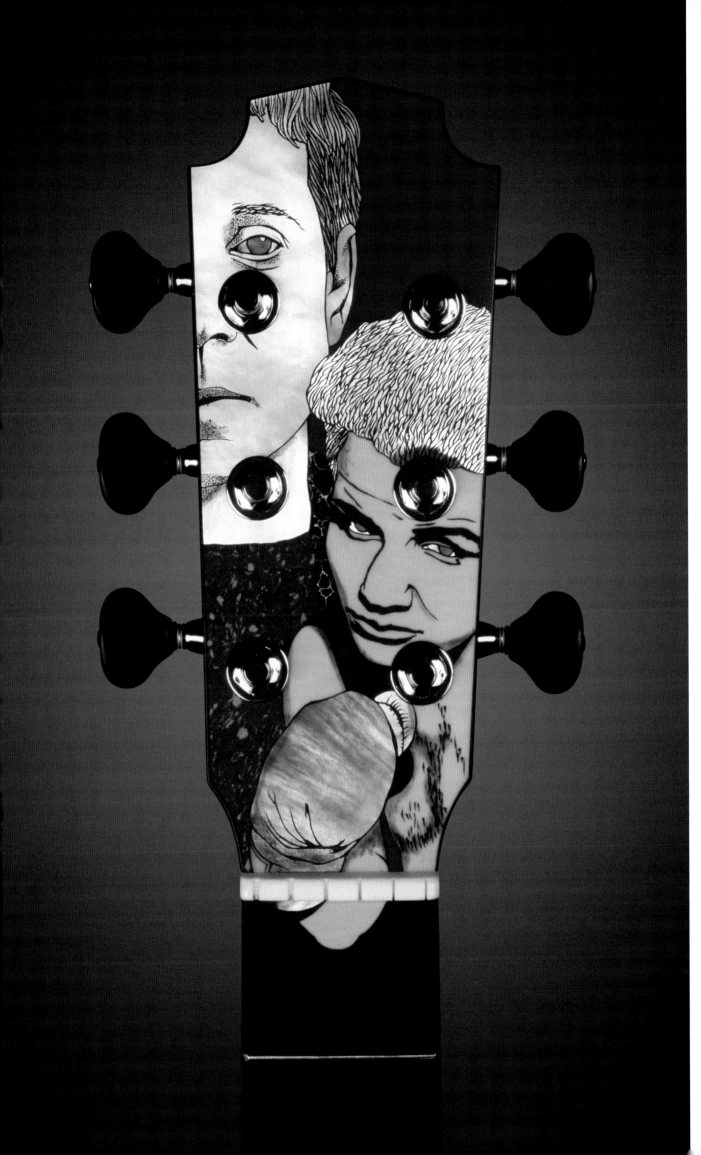

Darwin to DNA

steel string guitar

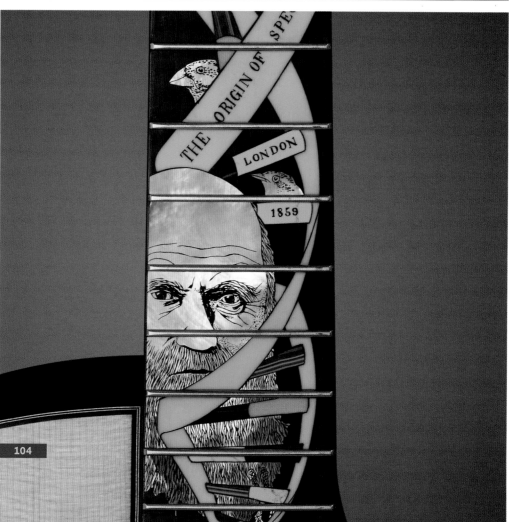

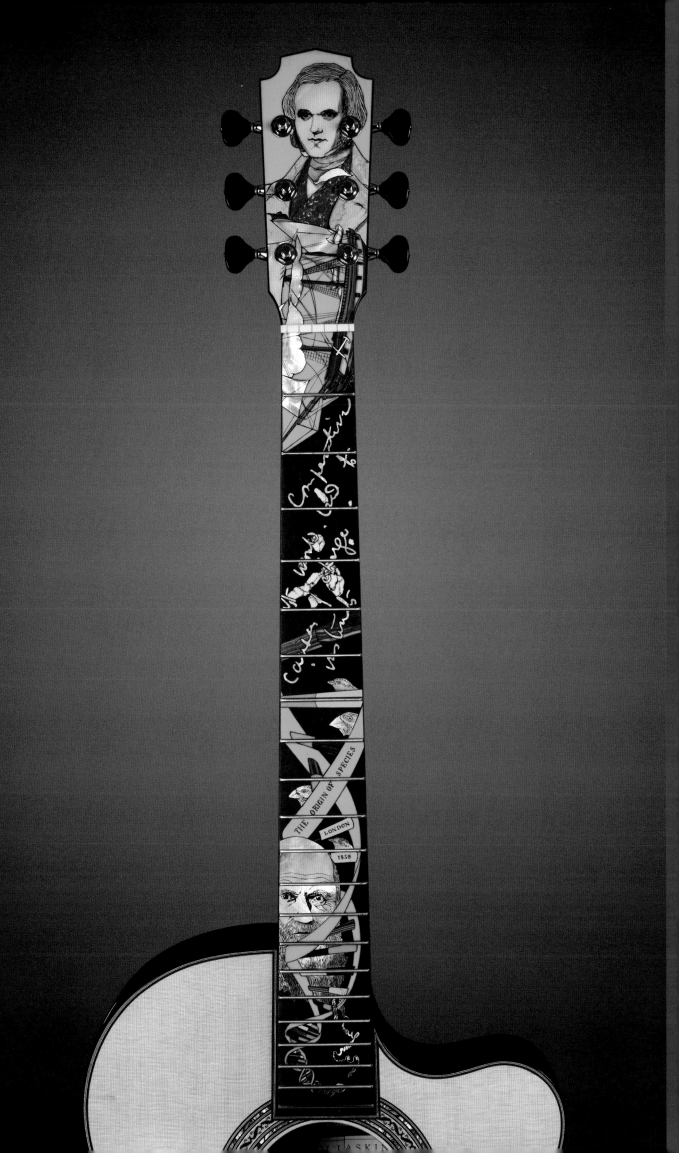

Wall

steel string guitar

God Natt Oslo

steel string guitar

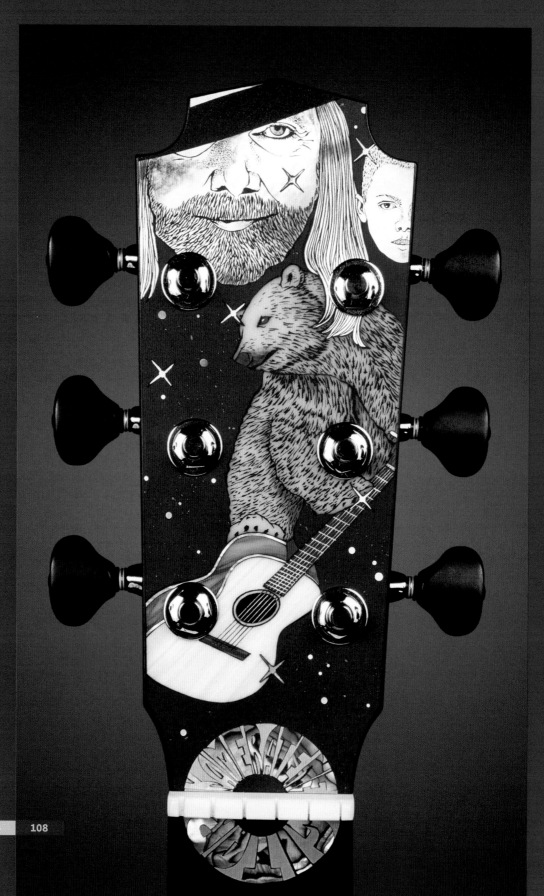

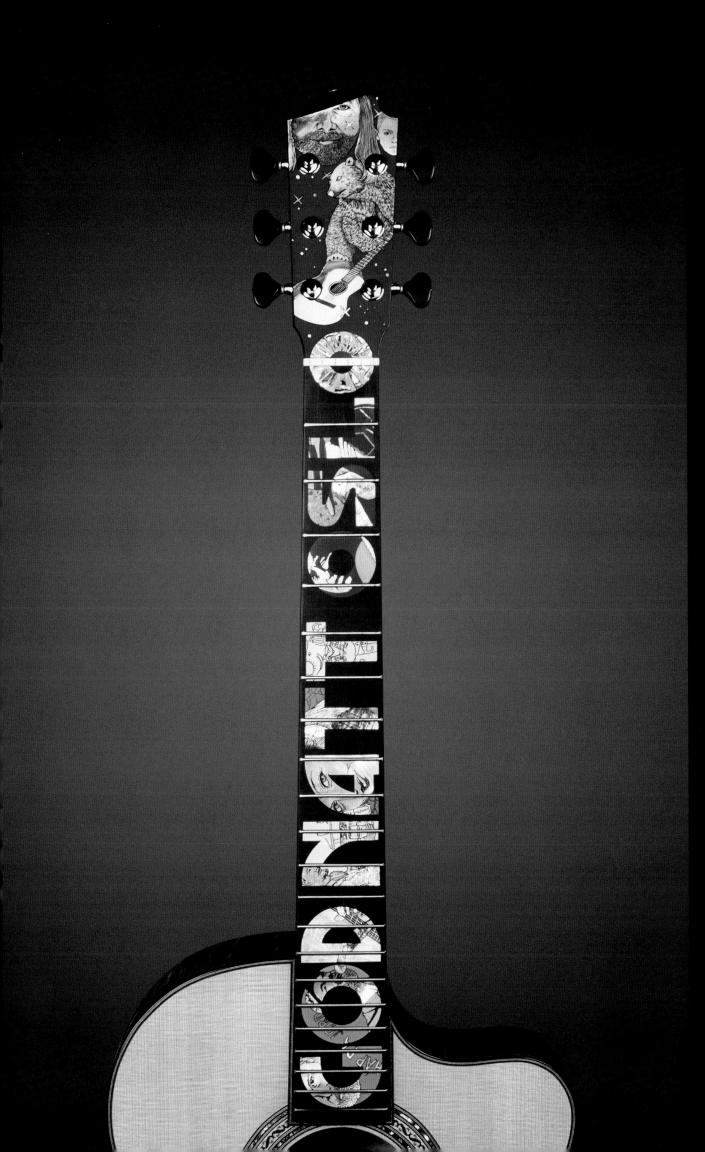

The Peruggia Caper

steel string guitar

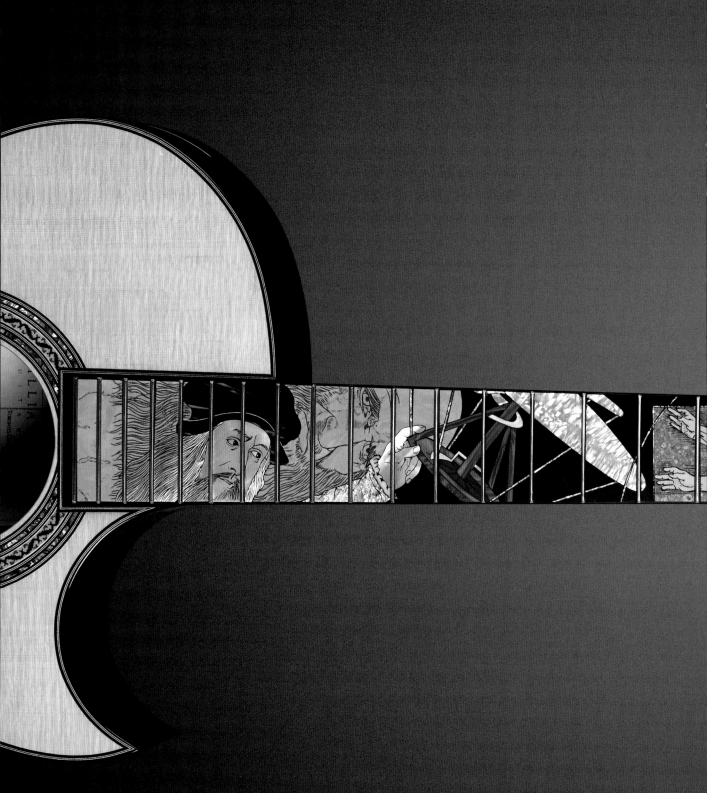

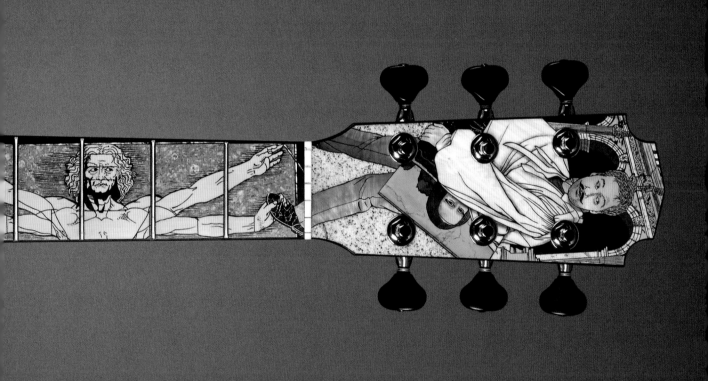

THE
STORIES

The Bridge 2003

I had been commissioned to build an instrument that is a hybrid of two members of the mandolin family, one that I call a tenor mandolin and that I build only on rare occasions. For the inlay art, my client wanted me to link the two very different facets of her musical life. She is a well-known fiddler and fiddle teacher who coordinates group classes through the ethnomusicology department of her local university and is focused on her regional fiddling traditions. At the same time, she teaches classical cello to private students using the Suzuki method. The Suzuki method is an approach that encourages younger children to learn music by using scaled-down instruments in a non-competitive, community-oriented environment.

As we began discussing this concept, she explained that she had studied with the method's founder himself, Shinichi Suzuki, in Japan. Simultaneously, she had become a protégé of her region's most influential fiddler and composer of fiddle tunes, a man named Émile Benoît. She was very clear that she wanted both of these elder statesmen of music depicted on the instrument since each has influenced her life's direction in profound ways and she holds them both in great esteem. A list of additional elements to include—always with the caveat "if possible"—began to grow. It included her husband, herself, their dog, something that spoke very distinctly of her home province, Newfoundland. Via the post she sent me a small package of photos. I now had numerous images of both of her mentors, her husband, and her dog. All going well I'd find a way to make these work together.

Over the next couple of weeks, my right brain was flashing image after image, concept idea after concept idea, as I tried to unite all

the items on my client's list. I started with her two teachers. There were some interesting dichotomies: folk music versus classical; two islands, Newfoundland and Japan, on almost opposite corners of the world. I tried to picture both of them playing music together, but that felt too contrived. Also, that concept would tell a complete tale on its own, leaving no space in the narrative for the other elements. I moved that image to the trash. But in the same moment, it struck me that if they couldn't and shouldn't be together, then perhaps I could and should place them at opposing ends of the design. Putting one at the top of the headstock and the other at the bottom of the fretboard would situate them as two disparate destinations. In turn, I would need images in between to represent a journey from one to the other, my client's journey.

Above **Shinichi Suzuki, on the left.**

200

Christina Smith & Jean Hewson

Like Ducks!

I was musing on the concept of the journey when I imagined my client travelling between the two men. Walking? Flying? Swimming? No, forget swimming—too silly. But could I have her walking? While I was pondering these questions, the phrase "bridge the gap" popped into my head. The word *bridge* in particular stood out. I started imagining a literal bridge that linked the men, with my client traversing it. But what type of bridge? From my own workshop library I pulled out a couple of books on historical Japanese prints. Many of the reproductions included bridges, and many of them were depicted with delicate filigree work on the railings. At one point I noticed that some of the filigree shapes had a passing resemblance to the cutouts of a violin bridge. Hello!

I pulled out some instrument catalogues and had a closer look at violin and cello bridges. The more I looked, the more I saw this concept working. If I stretched one of these bridges sideways—really stretched it—and gave it an arch, it could be my bridge. The symbolism of a bowed instrument bridge being the linkage between my client's bowed-instrument mentors simply confirmed the appropriateness of this idea. At this point I made the decision that the inlay art would have a horizontal orientation, with the instrument in playing position. The logic of the bridge and how it would have to appear pretty much made that choice necessary.

I was flipping through some promotional shots of my client, trying to picture not only how I could position her in the scene, but also if any of these images were usable. With the horizontal view, on an instrument with a fretboard narrower than a guitar's and with the

Facing, top **A homemade puppet horse, created for a mummers play.**

Below **I am often my own model.**

intended bridge running along one edge, I'd be lucky to have 4 centimetres of space left over to show a human walking. Clearly I needed a different approach.

Finally, an image of one of her CD covers popped into my head. On it, she and her musical partner were each depicted as rag dolls. I found the cover and immediately decided it would be more fun to show her as the doll. My client would know it was her, and I was certain she would enjoy the opportunity to explain the story to any interested viewer. But this still left me with the challenge of how the doll would traverse the bridge. And then I remembered her dog. Perhaps I could show the dog with the doll in its mouth?

I quickly realized I'd have to depict her dog far larger than I'd want in order for the doll to be of a recognizable size. Suddenly, in my mind I saw the doll, in flying position, moving horizontally that is, and being pulled along by her dog. The rag doll's hands had no fingers, though, so I couldn't have her doing the logical thing and grabbing the dog's hair. But if the dog's tail curled like a hook…? I turned my attention to her husband. I really didn't know yet how I'd include him, what role he'd play. I had the photos my client had sent, but nothing in the photos was giving me any constructive ideas. I was stumped. I called my client.

During our phone call, she mentioned that her husband, an established creator of radio documentaries, was currently at work on a show about Newfoundland's living tradition of mumming. I certainly knew all about the very old custom in which, typically at Christmastime, people would dress up in certain prescribed styles of costume, attempt to hide their identity from their neighbours, and then travel from house to house, performing a short play in return for free food and drink. (Yes, one can imagine the state of inebriation some people achieved after an evening's round of stops…) The plays traditionally had archetypal characters: knights doing battle with a foe, doctors who could revive the dead, wild horses, etc. Newfoundland was — and is — the only region of the continent where this age-old British tradition is still thriving. My client had just supplied me, I suddenly understood, not only with the solution to her husband's role, but also with a way to bring Newfoundland itself into the narrative.

She sent me more photos, this time showing herself and her husband in various mummer costumes. One shot depicted their version of a hobby horse: its homemade head was attached to a wooden pole, its lower jaw hinged, and a long stretch of canvas flowed out behind to be the body. This particular shot illustrated how a person hid beneath the canvas, grabbed the pole, and poked their head out from where the horse's neck would be. It didn't take me long to picture her husband in exactly that role.

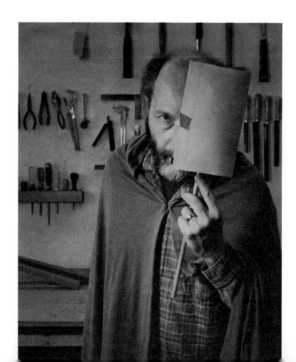

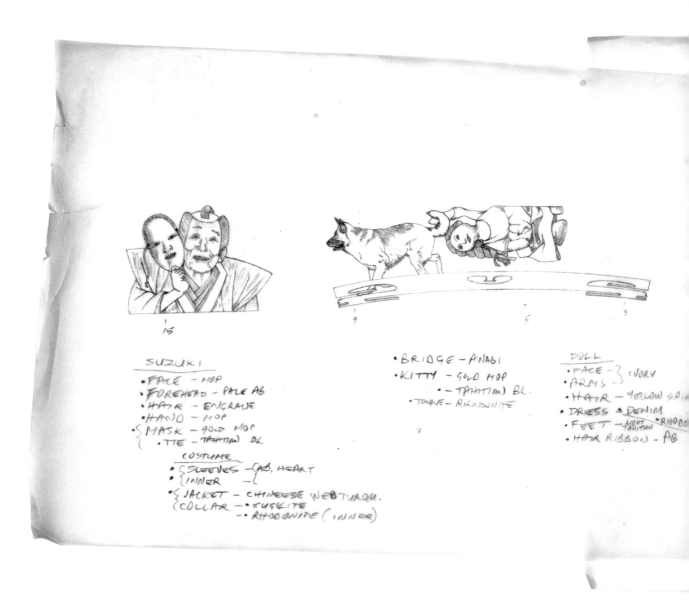

SUZUKI
- FACE – MOP
- FOREHEAD – PALE AB
- HAIR – ENGRAVE
- HAND – MOP
- {MASK – GOLD MOP
- {TIE – TAHITIAN BL

 COSTUME
- {SLEEVES –(AB, HEART
- {INNER –{
- {JACKET – CHINEESE WEB TURQU.
 (COLLAR –•SUGLITE
 –•RHODONITE (INNER)

- BRIDGE – ANABI
- KITTY – GOLD MOP
 •– TAHITIAN BL.
- TONGUE – RHODONITE

DOLL
- FACE –} IVORY
- ARMS –}
- HAIR – YELLOW SPIN
- DRESS •DENIM
- FEET –•TAHITIAN •RHODO
- HAIR RIBBON – AB

With mumming now incorporated into the story, it seemed logical that I would have Émile also in a mummer costume. He was a very playful man, I'd been assured, and I imagined it would not be out of character for him to have participated in mumming at some stage of his life. It was important to me to find a validity to the linkages in the narrative. Among the supplied shots, I found one of a caped character in a hat with cascading paper strips flowing down over its face. I loved that playful look, so I decided to clothe Émile in that costume.

I now turned my attention back to Suzuki. I certainly didn't want him dressed as a mummer.

He had no connection to that tradition. But with the idea of theatre in my head — even if it had been the amateur kind — it struck me that the logical step was to depict Suzuki as a character in a Noh play, Japan's traditional theatrical form. This approach provided symmetry to the design in more than one sense. The two distinct theatrical traditions mirrored the two different musical forms: the folk tradition for the fiddler, the classical form for the classical player. With the symmetry falling into place, I started to feel the design was in the home stretch and allowed myself a frisson of excitement.

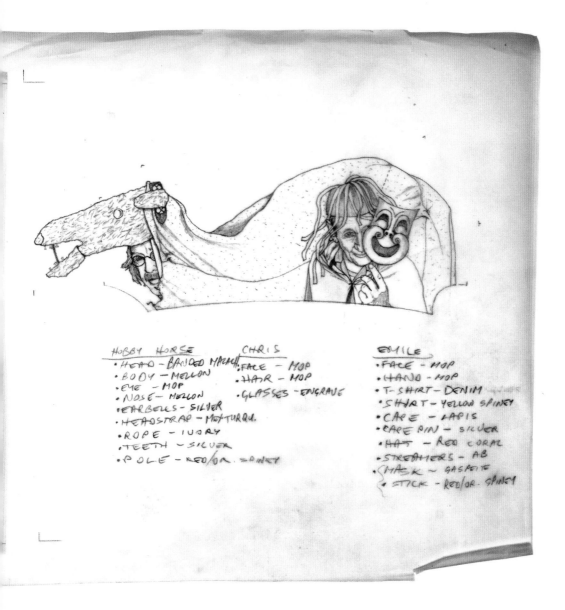

HOBBY HORSE
• HEAD - BANDED MALACH
• BODY - MELLON
• EYE - MOP
• NOSE - MELLON
• EARBELLS - SILVER
• HEADSTRAP - MEX.TURQU.
• ROPE - IVORY
• TEETH - SILVER
• POLE - RED/OR. SPINEY

CHRIS
• FACE - MOP
• HAIR - MOP
• GLASSES - ENGRAVE

EMILE
• FACE - MOP
• HAND - MOP
• T-SHIRT - DENIM
• SHIRT - YELLOW SPINEY
• CAPE - LAPIS
• CAPE PIN - SILVER
• HAT - RED CORAL
• STREAMERS - AB
• MASK - GASPEITE
• STICK - RED/OR. SPINEY

While doing my research into Noh costuming, I realized the players were frequently masked. It would make sense, then, for Suzuki to have a mask, but I would need to have him holding it away from his face so he could be recognized. This in turn sent me back to Émile and his costume. For further symmetry, I decided to have him holding a mask as well. There were no specific masks in the mumming tradition, especially when dressed as a non-specific character, so I chose to give him one of the two masks that commonly symbolize the theatre: Comedy and Tragedy. Thalia, the muse of comedy, suited Émile perfectly.

This completed the design concept. It would meet all of my client's requests and had its own narrative arc. I was satisfied. I reached for my pencil… **x**

The Willow Chair

One of my Scottish friends, an amateur woodworker, was building a full, stand-alone grandfather clock for a mutual friend. "It's in the style of Mackintosh," he explained. The only times I'd heard the word *mackintosh* were in reference to toffee or as common British parlance for a raincoat. I had no choice but to ask: "Who or what is Mackintosh?" After a momentary look of incredulity, my friend answered.

Charles Rennie Mackintosh was an architect, interior designer, furniture designer, painter, and graphic artist who lived from 1868 to 1928, primarily based in Glasgow, Scotland. His life span coincided with the flowering of Art Nouveau, a movement that he was influenced by — and that he influenced and superseded. In fact, all of Mackintosh's work — his buildings, interiors, furniture, wall coverings, paintings — were done in a style all his own, one that has been much imitated over the decades since his death. But he was certainly one of Scotland's most renowned talents of his era. And that is how, when my client said he wanted his inlay to be in the Art Nouveau style but very specifically inspired by Charles Rennie Mackintosh, I knew who he was talking about.

My starting point for a study of Mackintosh's work and style was, at my client's suggestion, his chairs. Some of his dining room chairs had distinctive painted designs on the fabric. The wooden back of another, one of a set created for The Willow Tea Rooms in Glasgow, formed a complex curved lattice. There was something about the geometry that struck me as intriguing. In addition, a very specific request from this client was that I find a way to include more than one of the very stylized roses — the "weeping rose," my client called it — that Mackintosh used as one design element on a number of wall coverings and decorated furniture pieces. Clearly, this way of depicting a rose was unique to Mackintosh, and it seemed to resonate with my client. He was particularly enamoured of its asymmetry.

As I delved into the multi-talented Mackintosh's world (poring through all the books on his life and work I could find), I soon realized that I was going to have to focus on just one or two aspects of his body of work. Including too many disciplines was going to dilute the composition and interfere with my ability to provide a clear narrative. With my client's request for the weeping roses fresh in my mind, I naturally gravitated, as my first stop, to how Mackintosh himself used them. In some of his paintings and wall-covering designs, the roses appeared as part of elliptically curving vines. I call them vines, but they are more like curvilinear graphics with roses than what one might imagine a vine looks like. They certainly had an Art Nouveau sensibility, but they were far from the artificial symmetry of Czech painter and decorative artist Alphonse Mucha; Mackintosh's were more natural-looking yet still very stylized. This was promising. I decided it would be fun to create my own vine but follow Mackintosh's style. That would get the roses in.

I returned to the furniture and again encountered what I was now referring to as "The Willow Chair," with its dense lattice. Could I put the Willow Chair on the headstock and create a vine on the fretboard, I wondered. I could, but I needed a connection. What was linking them? As I was staring at the back of the Willow Chair, initially to imagine how I could compress the dimensions to work on the narrow headstock, the word *lattice* nagged at me. Almost immediately, I began to picture wooden lattices, as one

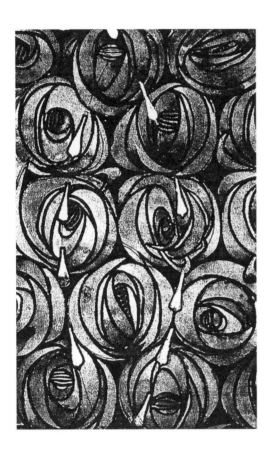

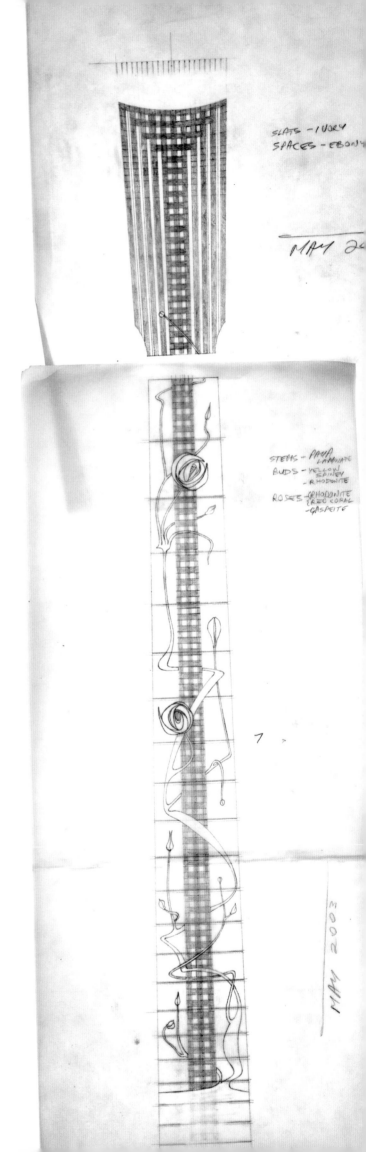

SLATS – IVORY
SPACES – EBONY

MAY 2?

STEMS – PAUA LAMINATE
BUDS – YELLOW SERPENTINE
– RHODONITE

ROSES – RHODONITE
– RED CORAL
– GASPEITE

7

MAY 2003

might find in private gardens for fencing or for clinging vines to weave through. And there it was — my solution to the connection problem. I could have the narrow centre lattice pattern, which carries the tapered lattice pattern down to the chair seat on the Willow Chair, cross the nut and run all the way down the fretboard. The rose vine I would weave around and through the lattice, as it might naturally do in a garden.

A final note. The elongated Willow Chairback on the headstock was cut from a single large piece of walrus tusk. Was it nerve-wracking making all the long cuts into this brittle material with my somewhat unwieldy, deep-throated jeweller's saw? Oh yeah. **x**

Cubists 2003

"Cubist guitars, that's what I want," he said. "But I don't want anything too big or too complicated. I want to see ebony all around."

I was scribbling notes, phone on my shoulder, talking long distance to my client in France.

"I'd like the guitars to mark the fret positions, but stop at the octave."

"This should be no problem," I replied, my mind attempting to form a picture. "Did you have specific paintings in mind? Specific artists?"

"Not really. Picasso, for sure. And Braque. See what you can find—there's lots."

Just as the conversation was winding down, I was asked one more question: "Could you do something different around the sound hole? I like your rosette, but I'd really love something original."

I explained that the rosette design I use around the sound hole is an identifying trademark of my guitars and that I was loath to vary it. I make exceptions only rarely—had done so less than a handful of times up to this point—and only if I think the suggested idea or concept I'm asked to pursue is particularly intriguing. I promised I'd consider it.

When I began looking at Cubist art I was surprised by how often a guitar was the focus, or certainly a dominant part, of the painting. Violins showed up as well, but not nearly as often as guitars. I was viewing work by Pablo Picasso and Georges Braque, as proposed by my client, and I also found myself attracted to the paintings of Juan Gris. What my client wanted me to do was to isolate the guitars from these Cubist paintings and reproduce them as inlays.

I picked up books on Cubism, I scoured the Net. (This was 2003. Search engines were fairly good at locating items on the Web but nowhere near as strong as they've become since then.)

From the nearly 100 paintings I found with a guitar in them, I selected five because of the vastly different styles they depicted. No two guitars remotely resembled one another. These would mark the fret positions. The five paintings, in the order in which they appear on the guitar, were:

— Georges Braque, *Woman with a Guitar*

— Pablo Picasso, *Guitar*

— Juan Gris, *View across the Bay*

— Pablo Picasso, *Guitar Player* (Strangely, I have been unable to relocate this painting. I've searched all sources, as I did at the time, but in vain. And for some odd reason there were no images in my files. For now at least, it's a mystery.)

— Juan Gris, *Guitar on a Chair*.

In Cubism, there are very often hard lines and hard edges to sections of the image. This made it fairly easy to extract the guitar from the whole. On some edges of some guitars, I certainly had to make arbitrary decisions about when and where the "exploded" image could appropriately end, but usually the painting itself suggested the manner. I would do my best to mimic that artist's style by observing how they treated other objects in the painting.

For the headstock I was pickier. It was a larger space, and I wanted something different again from the guitars I had selected for the fretboard. I also wanted it to be more immediately recognizable as a guitar while at the same time signalling the Cubist theme. I found what I wanted in Gris's painting *Harlequin with a Guitar*.

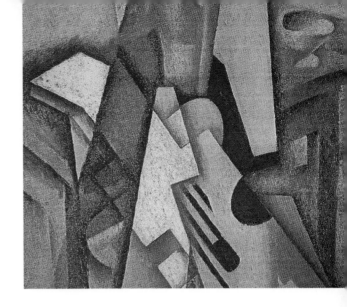

Right Detail of
Guitar on a Chair,
by Juan Gris.

But the rosette… What to do? My first instinct was to continue the Cubist theme and perhaps create something abstract that would work within the relatively narrow circle of the rosette. But almost as soon as that thought crossed my mind, I dismissed it. It felt arbitrary. I felt it had to connect to the theme, but, if possible, say something more about it. Perhaps the actual signatures of Picasso, Gris, and Braque done in ebony? Not bad, but it didn't feel like that nailed it.

As I was absent-mindedly flipping through images of Cubist paintings, the word *Cubism* itself flashed into my mind and I faintly recalled a docent describing the philosophy of Cubism as the artist's attempt to reduce shapes to their elemental forms. (Apologies if my memory has the concept wrong, but that's how it stayed with me.) Then I remembered the introductory chapter from a how-to book called *Drawing with a Pencil* that I had first encountered as a teenager. It described the three most basic shapes—the cube, the circle, the cone—and presented drawing them and accurately shading them as the kindergarten stage of drawing. This was what I should do, I decided: show the shapes that are not only elemental to art but that are also at the symbolic root of Cubism. My next thought was to enhance that theme, the roots of art, with another of the discipline's building blocks—the seven primary colours of the colour wheel: yellow, orange, red, purple, violet, blue, and green. This felt right. The sound hole would symbolize the base starting point for the Cubist images to come on the neck. I was done.

But… I stared at my rough sketch of the sound hole idea and wondered why my gut instinct was making me feel like I wasn't done.

WOMAN WITH A GUITAR.

GEORGES
BRAQUE.

5
PICASSO

VIEW ACROSS THE BAY

JUAN
GRIS

9
PICASSO

12
GRIS

What was I missing? It took me a little while to realize that the Cubist movement was shaking up established concepts of painting. They were revolutionaries. My rosette idea was a little too static, too representative of traditional art's symmetry. Should I try to draw the basic shapes as a Cubist would? I decided these basic shapes were the ones Cubists compose with and that there were valid reasons for them to remain as they were. At this point, my mind returned to *Drawing with a Pencil*, and I suddenly had my answer. I would interrupt the symmetry of the sound hole design with a pencil in the act of shading that would enter only one side of the circle. It was such a small change, but in my mind it quietly solved the "problem" and completed the story. **x**

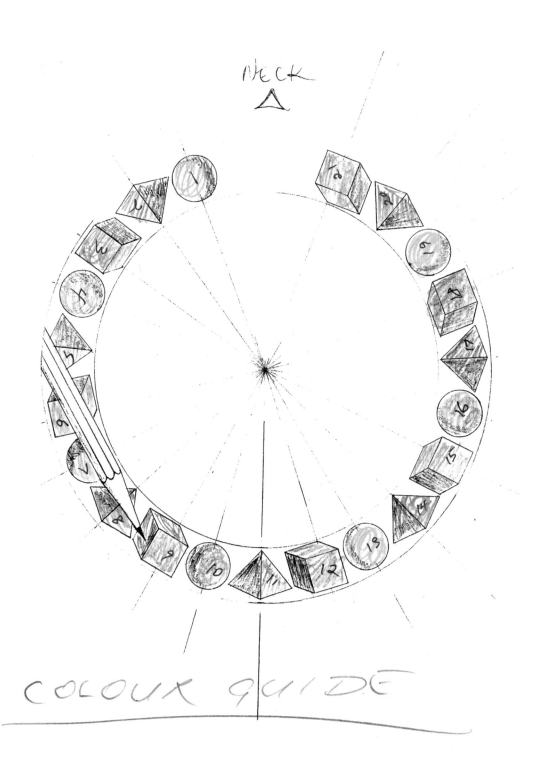

Four Short Stories

Sometimes I don't find it necessary to use the entire neck of the guitar to tell the story. The inlay may not be a full narrative, to use my own term for a design that occupies the entire neck, but it can still be a complete narrative. By that I mean it still tells the tale, just more compactly.

Here are four examples. In each case, though I think of them as solely headstock designs, they still each spill over the nut into the space of the first fret. To my way of thinking, as the guy who loves to "break the nut barrier," this still qualifies them as headstock designs.

Pursuit 2004

The subject of this inlay was entirely of my choosing. For some time it had been in the back of my mind to depict something about cycling, though I had few preconceived ideas other than the aim of somehow capturing the motion. I began looking through images of cyclists, and very soon I discovered numerous books on the greatest bicycle race of all, the Tour de France. The drama of the race—of the contest—could be seen in the intense body language, which in turn enhanced the sense of movement in the captured images.

As I made my way through hundreds of images, close-ups, distance shots, shots from high above, shots from ground level, a concept occurred to me. What better way to show movement and convey the intensity of the race than to have the cyclist coming right at the viewer? This orientation of a bike and rider also had the advantage of being able to fit within the narrow vertical frame of the headstock. I very quickly became wedded to this idea, but just as quickly began to despair of landing on a suitable image. I was preparing myself for the need to

photograph a model on a bike when I decided to flip once more through a book on the history of the Tour de France. This time, looking for a specific point of view, I managed to find the perfect shot, a black-and-white from the early 1980s (the cyclist was not identified).

As I began playing with the size of this image, attempting to keep the many important elements away from tuner washers, it struck me that something more needed to be going on in the story of this design. There was motion, but there was no narrative and there was certainly no drama.

By shifting my primary cyclist slightly to one side, I gave myself just barely enough space to insert a second cyclist, almost literally breathing down the neck of the other racer. The positioning was tricky, as I wanted to make certain I was providing at least a few visual hints of the second rider's bike and body language. But in the end I had my narrative, summed up in the title I gave this design: *Pursuit*.

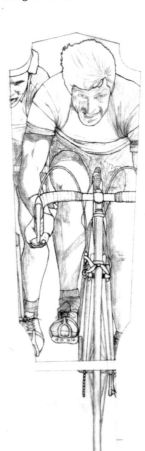

Ritmo Flamenco

On this flamenco guitar, I was asked, quite fittingly, to try to capture the essence of this style of music. At its heart, flamenco is about dance; secondarily, it is about song. The guitar was nothing more than a handy, portable accompaniment instrument. (It was only in the latter half of the twentieth century that solo flamenco guitar emerged as a stand-alone pursuit.) Knowing this history, I decided to stay true to the tradition of flamenco by trying to capture a guitarist accompanying a dancer.

To have the dancer's stance correct, and even the guitarist's pose ring true, I took myself to the rehearsal hall of a local flamenco dance company. I sat through most of a rehearsal, enjoying every minute of it. When it was over and the dancers had left the studio, I set up my camera and photographed a private performance by the dancer who led the troupe and her guitarist husband. I took numerous shots of her while she danced, and then focused on her husband.

Back at my workshop, I sifted through my shots and settled first on one of the dancer. It showed her in a pose very typical of flamenco,

with her arms crossed above her head, her back tightly arched, and one foot at a right angle to the other. It was an elongated pose, perfect for my narrow canvas. My next step was to select a shot of her husband and his guitar. He was seated, which worked well in reinforcing his role as secondary, as an accompanist.

Playing with the images, doing quick, cartoonish sketches in different sizes (the guitarist sits just behind the dancer, so I'd show him fractionally smaller) and shifting them around the headstock space, up and down, apart, overlapping, I stumbled onto a perfect juxtaposition. The dancer's tightly arched back opened up some space for me to perfectly fit the guitarist's left hand on his fretboard. As with the cyclists in *Pursuit*, bringing the dancer's feet across the nut gave the sense of forward movement I was looking for.

One final note of interest. I very deliberately made the dancer's skirt and under-top from a deep red stone (coral) while choosing a strongly yellow shell, agoya, for the background. I wanted these hot colours to further convey the intensity and passion that are the very root of flamenco.

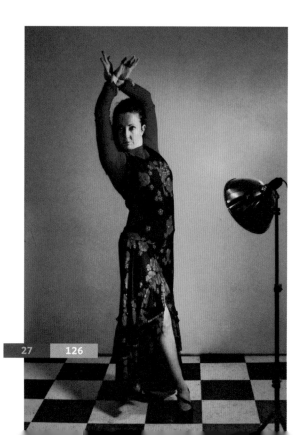

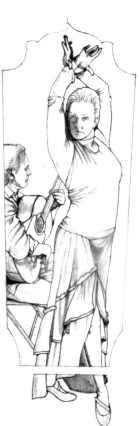

Toronto the Best 2004

A client from Malaysia very specifically requested that I depict myself working on his guitar, and that in the background I show two of Toronto's distinctive landmarks: the CN Tower (for non-Canadian readers, CN stands for Canadian National, the government-owned but privately run entity that administers the railways. Please do not refer to it as the CNN Tower!) and the SkyDome (now renamed Rogers Centre), our stadium with a retractable roof.

Neither of these structures is visible from my workshop window, so I accepted that I'd simply be inventing the scene. To assemble the elements of this design, I broke it down into three sequential steps:

1 Decide on how to depict myself creating his guitar — which task would visually satisfy?

2 Create a workshop bench, wall, and window orientation.

3 Situate the landmarks within the window frame.

I set my camera on its tripod, and used the self-timer to photograph myself doing various tasks related to creating the client's guitar body. I settled on two views where I was scraping down the wooden bindings, an action that brought both of my hands into the frame. One view had the guitar on its side, the other had it lying flat. I preferred the latter, which more clearly showed the curves of the sides. That view also required me to be leaning downward, which brought my head lower and freed up more real estate in the upper portion of the design to show the window view.

I settled on the sizing of my self-portrait, and the location — my hands, with the scraper, nicely in the foreground — and began to draw in the exposed brick wall and metal-framed, multi-paned windows of the workshop. In fact, what I was drawing looked nothing like my actual workshop, but I thought the industrial feel common to old warehouse buildings seemed appropriate on the guitar. This also allowed me to maximize the window size. I knew I'd need all the space I could get to capture what was still at that time the world's tallest freestanding structure.

In reality, the SkyDome and the CN Tower are within a block of each other. In my take, their relative sizes are fairly accurate but I juxtaposed them in ways that suited my own purpose. I needed them to be as clear of the tuner washers, not to mention my own head, as possible. I also needed to make certain that key identifiable aspects, such as the SkyDome's distinctive roof or the Tower's observation deck, were not obscured. In the end, these considerations largely determined the size of the windowpanes, which were the last element I drew in. They needed to be big enough for their frames to allow a clear view of anything important.

A final note. I kept small offcuts from the rosewood I used for the back and sides of this client's actual guitar and used them to create the guitar body depicted in the inlay.

Forever David 2004

"**I am such a fanatic for guitars**—we should capture that," said my client during a phone call. "How about a guitar player repeating endlessly into the distance, like in one of those Renaissance paintings that shows a reflection of a reflection of a reflection…?"

This was going to be fun, I thought. Step one was to go in search of one of those paintings my client and I were both certain we'd seen. I needed to review how this conceit was accomplished. I flipped through art books, I Googled endlessly. I was as convinced as my client that I too had seen this in a painting somewhere, but I wasn't finding it. I phoned two different art history professors of my acquaintance, certain they would be able to help. But they too had no answers. Surely both my client and I hadn't imagined this—or had we? He said "Renaissance," but maybe he was simply guessing. After further research still unearthed nothing, I realized I would have to figure this out myself. I would need to create my own infinity mirror and photograph the reflection.

I badgered my old pal David Wren, another luthier, to act as my model. I arrived at his house with two tall, narrow mirrors. Prior to my rendezvous with David, I had stood in my workshop bathroom, in front of the medicine cabinet mirror, with a second small mirror in one hand. I held the second mirror in various positions relative to me and my reflection in the main mirror. I kept shifting it from side to side, tilting it more left or more right, hoping to

see the desired effect. I recall an aha! moment when I caught a flash of myself repeating endlessly. I was ready for the main show.

At David's place, I brought the mirrors and my guitar into his dining room. We cleared a space, I handed him my guitar (it simply had to be a Laskin!), and he sat down. I then duct-taped the tallest of my mirrors to the backside of one of his dining room chairs, placed the mirror opposite David, and walked around behind him to take a look. I could see his reflection—so far, so good. I taped the second mirror to another chair and began shifting it to different locations behind him, this time aligning it about ninety degrees to the first mirror. At first, that didn't show me what I wanted. When I shifted it slightly to one side, however, an effect that positioned the first mirror just shy of one o'clock relative to David's front and my second mirror a bit more than five o'clock relative to David's back, it happened. The second mirror caught David's main reflection and reflected it back to the first one, and on and on. I rested my camera on top of the second mirror and took the perfect shot.

When completing the design, I made sure to include a number of visual clues to help the viewer sense the logic of the scene: the back of David's head and shoulder; a hand gripping the second mirror, shown from the back and the front as well as, in its own reflection, gripping a distinct edge to the second mirror. The resulting inlay was used as the cover for the August 2004 issue of *Acoustic Guitar* magazine. **x**

Facing **Photographing fellow guitarmaker David Wren in his living room. I can be seen in the mirror, camera in hand.**

6.0, 6.0 2004

A few years ago, it became time for me to build a new guitar for myself. My primary need for a new guitar was to showcase some recent innovations in the construction, and so, when I began building it, I didn't have any particular inlay theme in mind. Truth be told, nor did I have any particular theme waiting in the wings. Trolling for an idea, I began asking myself a question I pose to clients who need prodding: what is (or has been) important in your life? That question frequently elicits very personal stories, which lead to very personalized inlay designs. In my case, knowing that my guitar would often be displayed and played purely as an example of my work, I wanted a more general theme. I settled, quite appropriately one might say, on music itself. In past years I had depicted jazz and blues players, various famous musicians, even an archtop guitar. I needed a fresh angle.

Four years earlier, on a tenor mandolin I'd made for myself, I had explored the politics of trending styles in painting, specifically how an older "movement" is overshadowed by a new one. With this idea in mind, I began to wonder whether there wasn't some equivalent issue in the music world that would lend itself to illustration. I didn't want the theme to be "dark." I was welcoming the chance to make a valid point on some issue, but I wanted to do it with an element of playfulness.

It was while weighing these considerations that I recalled a conversation I'd had with my musical neighbours, one a classically trained violinist; the other, a cellist. The part that came to mind was when they were painstakingly explaining that though the bowed instruments as a group are considered the heart of a classical orchestra, the violin is at the top,

is king, and all other bowed instruments are varying degrees of lesser mortals. Was I staring at my theme?

Entirely separate from this line of thought was another concept that had been lurking in my mind for some time. Pole vaulting. I could visualize the linear scene filling up the tall, narrow canvas of my guitar neck: the vaulter rising above the height of the fully extended pole, just about to let go of it as she begins to arc her legs upward over the bar. I would want to depict the moment when it appears almost impossible that the vaulter will make it over the bar. I'd want the goal to seem insurmountable.

Why the pole-vaulting scene occurred to me just then I can't explain. Perhaps my subconscious had already made a connection between one difficult task and another, and suddenly I saw the cellist as the vaulter, "cello-vaulting" up to the bar. Up on the bar, sitting on it in fact, I saw the violinist. He was already there—goal achieved. This would become a visual metaphor for the classical orchestra's hierarchy: the violinist at the physical top, the cellist resorting to Herculean extremes to attain a similar status.

I phoned my musician friends, who had modelled for me once before, and booked them for a photo session. I explained their roles, starting with the cellist. I explained that she will have vaulted upward, have just let go of her cello, and be depicted at that moment, upside down, aiming her feet toward the bar. I also assured her that I had no intention of requiring her to actually pole vault. My plan was to simulate the body positions and later insert the cellist and the violinist into the scene, or more truthfully build the scene around them. The cellist asked what I meant when I said "letting go of the cello." Good question.

I'd decided that the cello itself would be the uppermost portion of the pole, with the neck of the cello being the place she would have gripped. That seemed the most natural orientation. I asked the cellist to wear a more formal dress, the kind she would wear for an orchestra performance.

On the day of the photo shoot, we walked into their back garden and spread a blanket on the grass. The cellist lay down on it, facing skyward. I rumpled up her gown around her knees, simulating what would likely occur if she were actually upside down. As well, game friend that she is, she allowed me to brush her short hair straight out from her scalp, again to visually confirm her inverted body. I then went up on their back porch, leaned over the handrail until I was directly above her, and began photographing her. Next, we very gently placed her old and valuable cello in the same spot where she had lain on the blanket, and, as quickly as possible (before the shifting sunlight reached that spot), I took shots of it as well.

For the violinist, we went indoors. We moved aside their dining room furniture (I have such understanding friends!) and, with the ever-reliable duct tape, secured a sturdy broom handle between the upright backs of two dining room chairs. My first shots had the violinist sitting on the broom handle, holding his violin. The shots seemed basically fine: his body position was going to work well on the headstock.

But something wasn't right. It took me a few moments of silently staring at him and at the image in my viewfinder before I realized that I needed to connect him to the story, to the cellist vaulting toward him. With the next shot, I instructed him to look downward, as if he had just noticed what was heading his way. Better. Still, what was he doing just sitting there on the bar? What else could he be doing? Since both of these friends are espresso lovers, I asked him to grab a small mug (we went for a cappuccino size; the miniature espresso cup wouldn't be as noticeable) as if he were on a coffee break. As well, when he looked downward, I told him he should look slightly miffed, as if his moment of relaxation was being rudely interrupted. And he did.

If you look at the photographs of this inlay, you'll notice that I too am participating. Yes, that's me in the upper right-hand corner of the headstock, eyes aimed down the fretboard. To be honest, I had been searching for a way to join my friends in this design and so decided to make myself the observer of the cellist's jump. As the observer, I am outside the main action, which I indicate by placing myself at a hard right angle. In my judgement, the cellist is having a perfect jump, so, like a sympathetic competition judge, I scored her 6.0 out of 6.0 for technical merit and the same again for artistic merit. Thus the title: *6.0, 6.0*. (Rating a performance out of six was how figure skating used to be scored, and I borrowed it as my scoring system largely because of the appealing curves in the numbers six and zero.) By making the numbers large, they formed the backdrop. And by using two types of turquoise — Mexican for the numbers, North American for the remaining background — I made them visible without having them compete with the foreground scene. **x**

The Big Bang

For many guitarists, a few mother-of-pearl dots on the fretboard to mark the regular positions are perfectly satisfactory. For others, something very simple—a flower, a family crest, a favourite constellation—is all the custom inlay they desire. Then there are clients like this one. Over a nine-month period, documented by over sixty printed pages and numerous phone calls to and from his home in Europe, was one of the most wide-ranging and in-depth client conversations of my career. And that's saying something. I am lucky enough to deal quite regularly with wonderfully thoughtful clients who become deeply engaged in the process.

This story begins with the first phone call. My client made it quite clear that he was going to want every square centimetre of the neck covered with art. He was telling me I had permission to fill the canvas. But with what? Key phrases such as "possibilities in combining the real and the surreal, the figurative and the abstract" began to fill our lengthy and fascinating discussion. The word *deconstruction* made its appearance in the early emails, as did *pointillism* and *pixellation,* the digital bitmaps visible in an image. Also at this early point, he described some of his favourite inlays of mine and why they appealed to him. Words like *self-referential* and *playfulness* started to show up. Thankfully, this use of language helped me determine some of his sensibilities, which certainly comes in handy for knowing how to approach a subject as a design emerges.

As our discussion progressed, it became clear that this was a person capable of being profoundly moved by art, someone who seemed to crave the task of finding the type of symbolism and meaning in art that communicates successfully. I learned that he had favourite painters (René Magritte, Roy Lichtenstein) and a favourite photographer (Andreas Gursky). He even had favourite works by these three, which I duly noted. We agreed that I would make an appearance in the design. At length we explored how I might "flow" the story, his wish to "evoke the primary materials," and the importance of humour and irony.

At times our emails veered off into philosophy. At other times we compared impressions about the layered meanings in a certain artist's work. We spoke of colour balance and movement and story structure and perspective angles. Clearly I am providing you with a highly truncated version of our deep and lengthy conversations. What ultimately emerged from those many months and many pages of emails was a clear picture of how my client thinks, how he views and analyzes the world, and how that fuels his music and his appreciation of art.

Was this a cumbersome and time-consuming process for me? Absolutely not. This is one of the great pleasures of my very personalized approach to guitar inlay. I'm allowed into my client's world, their life, their mind. Then, knowing them to this degree, I can more easily create something they will feel deeply committed to. At least, that's my goal, every time, with every client. And with every suggestion or idea this particular client offered, he also offered assurance that ultimately he wanted me to have complete creative freedom in encapsulating his/our ideas. In fact, he very specifically asked that I layer into the design meaning and symbolism that would require time and contemplation to understand.

My mind was spinning with ideas and concepts. For days I allowed anything and

everything that occurred to me mental space to breathe. I reviewed our emails and my scribbled notes, underlining key words and phrases, especially those that were repeated. Still, the concepts were too broad, too open-ended. I had too many options. I needed to focus. I began by drinking in all I could find about my client's two favourite painters. I was already well acquainted with Magritte, as I too had long been fascinated by his enigmatic Surrealist images. I was not as familiar with Lichtenstein's Pop art, but for a couple of famous exceptions. In both instances it was pure pleasure for me to have the required task of exploring art.

One particular Magritte work was my client's standout favourite: *L'Empire des lumières*. I placed that scene of a nighttime street lit by a single light under a daytime sky as the first item on the list of likely elements. Lichtenstein wasn't so easy. I was certainly intrigued by his giant canvasses of tearful 1950s comic-strip women and cartoonish explosions, but I had no immediate idea about how I'd incorporate any of them. "Symbolism," "self-referential," "playful," "pixellation," "figurative," "surreal," these were the guidelines, the descriptive links that I was mentally clicking, but so far they weren't connecting me to anything tangible. I added some other possibilities:

— Myself — but what's my role?

— Magritte himself?

— Lichtenstein himself?

— One of my own inlays as a framed work of art? (I liked this concept and underlined it.)

Well, that was a bit of progress.

I was idly flipping through a book on Lichtenstein that I'd purchased, looking at paintings he'd titled *Explosion* and *Whaam!* and *Varoom!*, when a phrase jumped into my head: "soup of ideas." These were words my client had used, and though it wasn't a usable concept per se, it did start a chain of connections in my thoughts that went something like this: soup of ideas, primordial soup, beginnings of the earth, beginnings of the universe, the Big Bang. And when I landed on that last thought, the general term for the origin of our universe (and everything it contains, obviously), I saw in my mind's eye a Lichtenstein-style exploding BANG! At that moment, the words "Oh! This is interesting" popped into my head.

In an instant, I had a vision of a Lichtenstein-inspired explosion, somewhere near the centre of the inlay, with things flowing out of it — emerging from the Big Bang — to the left and right. Carrying that thought to the next logical step, I naturally asked myself what should be emerging. In the accepted theory, the universe's Big Bang was the source of all matter, all the building blocks of any object or substance with mass. (This kind of information fascinates me. I've been an astronomy nut since at least age ten, and when my parents offered me the choice of a telescope or a guitar for my thirteenth birthday, I agonized over the decision, alternating visits to the science store and the music shop for weeks. In the end I chose a guitar, but I often wonder what might have happened, where life would have led me, if I'd chosen the telescope.) So, what should be emerging from the Big Bang was pretty obvious: I create stories out of stone and shell. I could show these materials flowing out of the BANG and ultimately transitioning to scenes at each end of the neck. Yes.

But I have dozens of varieties of these materials. How was I to show them all—a rainbow-like mix of colours? Alternating vertical bands, like the printout of a spectrograph? (A spectrograph is a device that separates light by its wavelength and records this data, enabling astronomers to determine the material substance of distant stars.) At that moment, I recognized an association with another set of building blocks: the binary code. When that message was conveyed to my conscious brain, barely a fraction of a second passed before I was seated at my computer Googling the binary code for the alphabet. In no time at all, I found what I was after:

```
S - 01010011
H - 01001000
E - 01000101
L - 01001100
L - 01001100

S - 01010011
T - 01010100
O - 01001111
N - 01001110
E - 01000101
```

I would have the binary representations of these materials flowing out of the BANG. To represent the zero, I would use a light shell; to represent the one, a darker stone.

My attention now turned to the scenes that would occur at either end. As is my habit, I considered the headstock area first. At this point, I knew I would somehow incorporate Magritte's *L'Empire des lumières*. Also, at my client's request, I would be making a personal appearance and perhaps so would one of the other artists. If I were viewing a painting, I thought, most often it would be at a gallery. So the Magritte could be on a gallery wall. What kind of wall? A gallery's standard plain white wall would make for a boring inlay. Perhaps I could make it a brick or a stone wall. Check. Continuing with the gallery concept, I wondered whether there was a way to show another room. If so, it would provide the space to add more characters and more elements.

Since all this designing and playing with options was occurring in my head, it made manipulating the elements supremely simple. I moved myself and the painting in various directions within the space. And while playing in this way, I hit on an interesting idea. If I moved myself downward into the fretboard, I would have the space to create an upper opening in the wall. The opening would offer a view into the next gallery.

Who or what to put there? Almost as soon as I began picturing Magritte or Lichtenstein, an amusing idea took shape. If I depicted myself looking at the Magritte, why not have Magritte viewing one of my works? That made me smile. I very quickly realized that for this to work, for the viewed work to be visible, Magritte would have to be shown from behind. I found photos of him dressed almost exactly like the bowler-hatted men he often painted. In the end, I borrowed one of these iconic men and inserted him into the story. To add another subtle element to this scene, I decided to have Magritte's character admiring an inlay drawing of mine that was the preparatory work to a design that itself depicted other artists: Egon Schiele and Jackson Pollock. I imagined my client enjoying the challenge of working that out.

ME
- HEAD - MOP
- ARM - MOP
- SHIRT - RED CORAL
- JEANS - DENIM STONE
 SHOE
 - UPPER - TAHITIAN BL.
 - SOLE - EBONY
 - LACES - (ENGRAVE)
 MAN
 - HAT - TAHITIAN BL.
 - COAT - ~~EBONY~~ TAHITIAN BL.
 - ~~HEAD~~ - GOLD MOP

- WALL BRICK - "LEOPARD SKIN" STONE
- FLOOR BOARDS - RED/OR. SPINEY
- BACK WALL - PINK CONCH STONE

EMPIRE OF LIGHTS
- SKY - MEXICAN TURQUOISE
- CLOUDS - IVORY
- TREES - EBONY
- HOUSE - BEIGE MELON STONE
- WINDOW SHUTTERS - GOLD MOP
- ROOF - EBONY/
- GROUND - OBSIDIAN
- WATER - TAHITIAN BL. (DARK)
UT - EDGE OF CANVAS - MELON STONE
 SCHIELE MEETS POLLOCK
- DRAWING - MOP
 - CANVAS - IVORY
CUT - FRAME - AZURITE/MALACHITE
 (BANDED)

UNTITLED
- FACE - MOP
- CANVAS - BEIGE MELON
- FRAME - ABALONE HEART
- TITLE - PLATE - GOLD MOP
- BACKGROUND - BIANCO NERO STONE

BANG
LETTERING - MALACHITE
 - EBONY (SHADOW)
EXPLOSION CLOUD
 - MOP (FIGURED)
 - RED CORAL
 - GOLD MOP
 - ASIAN PINK CORAL

BINARY CODE
 - GOLD MOP ⎫ S.H.E.L.L.
 - TURQUOISE ⎭
 - MOP ⎫ S.T.O.N.E
 - GASPEITE ⎭
- BACKGROUND
 (~~FRET~~ 1 - 11)
 - LAPIS

- CURSOR - NICKEL SILVER

At this point, I felt that I'd thought out all the preliminary work this scene needed. But just as I was preparing to turn my attention to the scene at the opposite end of the neck, my gut signalled that the story in this section needed to be more interesting. At first I was stumped. What else, after all, could someone be doing with a painting in a gallery but looking at it? I had no immediate answer, so I sat down for lunch and pondered. When I finally stumbled on the solution — or at least the road to it — it struck me that it had been staring me in the face, so to speak, the whole time. I was being entirely fantastical with my Big Bang concept, so why was I so tied to reality in the headstock scene? Why couldn't something impossible be occurring?

I portrayed myself as seen from behind, beginning to fall into the painting. My head was disappearing into the canvas, which I hoped my client would interpret as I intended — a visual metaphor for an effort to deeply understand the creative process. This conceit had the added benefit of giving me the perfect solution for the scene at the opposite end. I would show a blank canvas with the front of my face beginning to emerge. This would be the completed story arc: a deep understanding of art becoming the inspiration behind one's own creative efforts. I also imagined the explosion, the BANG, as the physical centre of the concept. If I had lifted up the inlay design like a large piece of paper and folded it down the middle, the place where my face was appearing in the blank, untitled

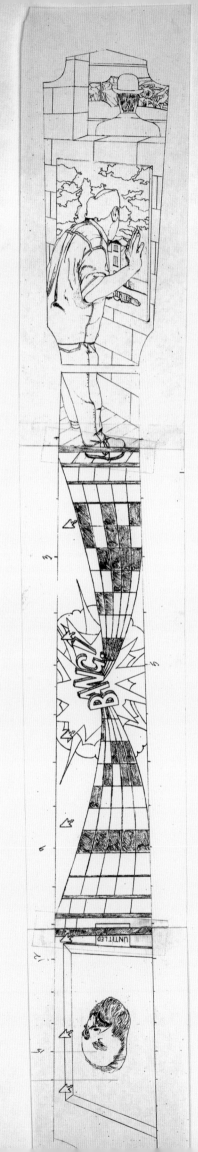

Facing **Me,**
miming the role.

canvas would perfectly align with where my head
was disappearing into Magritte's canvas. Details
like that are a major source of satisfaction for me
and confirm that there is internal logic to the layout,
even if no one else notices.

My client, you'll recall, asked me to imbue the
design with layers of symbolism he would have to
decipher. None of what I have written here was
conveyed to him at the time. One day I will have
to ask him for his own interpretations. I wonder
how close they'll be to my own.

A parting note. I marked the fret positions with
enlarged computer cursors cut from nickel silver.
To confirm the cursor's particular pixellated shape,
I simply kept enlarging the image on my screen.
Borrowing a computer symbol felt like the most
appropriate echo of the illustrated binary code. **x**

Bettie on Red 2005

"The singer? Patti Page?"

"No, Bettie Page. She was the prime pinup girl in the 1950s."

"Oh," was my one-word response. I'd never heard of her.

"I'll send you some pictures."

And my client did send me pictures of Ms. Page. He also sent along very specific directions for his design. He asked that all of the inlay occur only on the fretboard. He insisted that I do a portrait of Bettie based on one very specific image. He asked that her signature be seen on the twelfth fret. He also asked me to do something with the background, behind and around her, to create "distance" between her image and the ebony fretboard.

There were further instructions. Though the image of Bettie that he supplied did not show most of her legs, he asked that I draw them in and complete the image. In addition, I had to put her in fishnet stockings and patent leather boots and gloves. "And be sure to capture her blue-grey eyes and red lipstick," he warned.

Here was a client who knew precisely what he wanted. It's rare that I have a client who has thought out the inlay art to such a degree. On the plus side, it means very little design effort will be required on my part. But on the minus side, it means that very little design effort will be required on my part. Usually, being challenged, and meeting that challenge, is the source of a creative high for me. But I could still foresee challenges with this one …

My first step, despite being supplied with images of Bettie, was to learn more about her. To my amazement, I found a number of books on her life and collected images from her time in the spotlight. As a further surprise, the only Toronto location that stocked these books happened to be a store that specializes in graphic novels and comics. The guy behind the counter had no explanation as to why they carried books about Bettie Page, other than to suppose people had asked for them.

Probably the most useful thing I learned from my reading about her life—and yes, looking at the pictures, although they weren't much racier than some of today's perfume ads—was about her attitude. She managed to always look cheerful and playful. She appeared to be enjoying what she was doing and exuded a positive, confident, and healthy attitude about it. I could understand her appeal, especially in the '50s. I was determined to capture that expression.

My first task was to draw in her legs. As bad luck would have it, no images in the books showed her standing, fully in view, precisely as she was standing in the image I was instructed to use. I had actually stumbled upon a different image of her that I thought would work even better in an inlay and wouldn't require imagining the missing parts. I called my client and told him so. He was surprisingly adamant that I use the specific image he sent. His mind was set. So be it.

In search of a stand-in for Bettie's legs, I turned to one of my *Illustrator's Figure Reference Manuals*. These books provide nude and clothed female and male models, from a variety of angles, all for ready use by artists who don't have a live model to draw from. In the one I picked up, I found views of a model with a comparable figure, whose body position was very close to Bettie's and whose legs from mid-thigh down I could borrow.

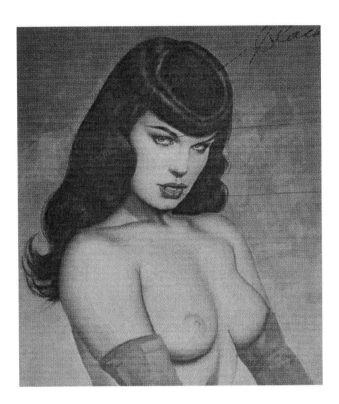

As a background, behind and around Bettie, I planned to use red coral, with its dense blue-red hue. The idea of a "hot" colour made sense with this type of image. And in an attempt to capture her eye colour, another of my client's instructions, I would cut her irises from the richly blue section of some pau shell.

Ultimately, the most amusing event took place when I was delivering the completed guitar to my client. He lived in a small town only a short drive out of the city, and as he spent most of his days in a wheelchair, I offered to bring the guitar to him. I arrived, he invited me in, and he excitedly opened the case and picked up his new Laskin with Bettie on the neck.

"Did you wonder why I wanted you to inlay only this particular photo?" he asked. I nodded, at which point he put down his new guitar and rolled up the shirtsleeve of his right arm. Tattooed on his forearm, with perfect detailing, was the identical image. ✖

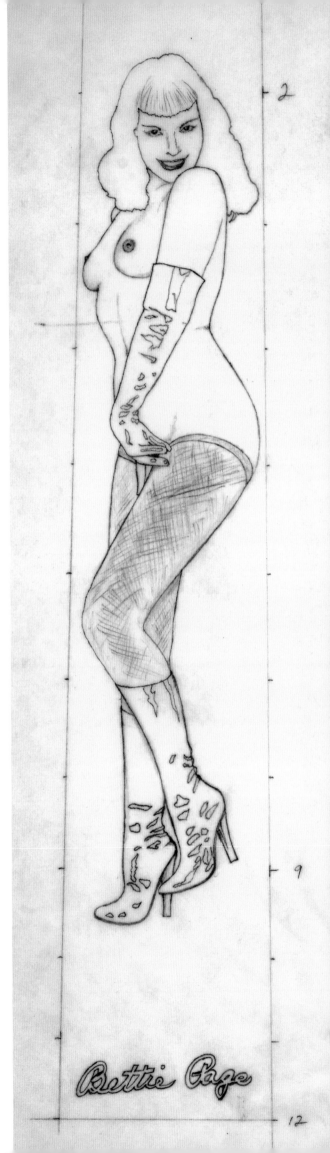

The Red Canoe

From time to time, a client challenges me to capture an atmosphere or a mood. That, at least, is the starting point. Once mood is acknowledged as a priority, as it was with this client, my next question will be something like: "Where, when, or how do you find that mood?" There is a reason I ask such a wide-open question: it's to better elicit an answer with tangible content to help me find a direction to explore.

This particular young client asked for a design that would evoke calm, tranquility, and peacefulness. For her, the source of this mood was the family cottage and the relaxed pace of life there, which led to a discussion of which aspects of the cottage and its environs would best capture the atmosphere. Not surprisingly, a list emerged that included calm water, a red canoe, the beach, the hillside stairs, the cottage itself, a glow from the lakeside window. Other possibilities we discussed were including her in the design (though she'd only accept a minor role) and showing a sunset on the lake (yes, a hackneyed image, but I left it on the list—we were still brainstorming, and nothing was excluded).

Very soon after our conversation, a ream of printed photos arrived. They were views of the cottage and its lakefront as seen from the land and the water. There were canoeing scenes, sunsets, and other random details of the property and its waterfront. By this point, through the progression of our email and phone conversations, my client concluded that she wanted me to show only nature and the cottage. She'd changed her mind about playing a role herself.

My first concrete step was to spread out all the photos on my workbench. There were twenty or so. I sat and stared at them, letting my subconscious alert me to any interesting features, any potential angles, any particularly evocative scenes that I could work from—anything at all, really, that might help me to capture and evoke my client's tranquil mood. I scanned them over and over. When I decided one image had something I could use—and might successfully capture with inlay—I'd set it aside and look anew at all the others, seeking perhaps an even better version of the aspect I felt would work. And so it went, for several hours.

This particular cottage was situated atop a low ridge. To access the water's edge, the dock, and the beach, it was necessary to walk down an angled set of stairs built, not unattractively, into the hill. It became clear to me that if I wanted to show both the cottage and the lake, and not have the cottage so distant that it became superfluous, I would have to adopt a less realistic approach. I decided to use the "nut barrier," the natural division of sections on the guitar, to my advantage this time. I would create two separate scenes: one on the headstock, another on the fretboard. I imagined the effect might be as if I were viewing one scene through, say, binoculars, then shifting the view slightly and increasing the magnification to pull me closer into the second scene. I knew I was going to depict becalmed water, and I knew also that the cottage would appear, so the two scenes naturally positioned themselves: the cottage would be "above" (moving "up" the neck to the headstock); the lake would be "below," in the fretboard.

I began roughly drawing out a tranquil lake surface leading up to my client's beach and the bottom portion of the steps. I positioned this scene so that the steps led upward to the nut. I next started placing the cottage into the headstock, keeping it in the upper region so that the uppermost portion of the steps would remain visible in the scene. Although, as first envisioned,

Climbing up to the family
cottage from the lakeshore.

First steps up from the beach.

the cottage scene was closer to the viewer than
the lake scene, the natural barrier of the nut
created the acceptable notion of the shifting
view, much like a film edit that simply, suddenly,
jumps us nearer to the action. (I'm thankful
we've become a film- and video-literate society!)

While staring at the large lakeside window
of the cottage, I recalled my client informing
me that this window was westward facing.
The sun sets in the west, so I was puzzling over
how, given the view of the building I had, I could
logically include a sunset. The sky above the
cottage was the east. Thankfully, within a few
more minutes I spotted the perfect solution.
I'd been staring at it all along. I would show the
sunset reflected in the window.

I then turned my attention to one nagging
problem that I'd been ignoring. Where and how
to end the water? The lake surface was beginning
very near the first fret. How far down the neck
should I go? I didn't need to show too much for
the calm mood to be conveyed. Should I just have
the water ripples slowly thin and fade out into
the ebony of the fretboard, I wondered. Maybe.
Or, should I arbitrarily stop the water at a logical
fret, such as the third (the outer edge of first
position for chords) or the fifth or the seventh?
A hard finish like that didn't feel right. It would jar.

While I was mulling over this question,
I realized with a start that I hadn't yet inserted
the requested red canoe into the scene. When
I began sketching it in, and playing with location
and position, one particular foreground location
allowed it to quietly form a natural border to
the scene. My water problem was solved. And,
almost as an afterthought once I'd finished the
overall design, on impulse I named the canoe
after my client. In the subtlest way, she made
an appearance after all. ✖

Matt & Jody & Hieronymus 2005

A young couple, in their early thirties, was squeezed onto the small couch in my office. "We just got married," they explained. "This pearl necklace," said Jody, pointing to her neck, "was Matt's wedding gift to me. A guitar from you will be my gift to him."

After discussing general construction options for the guitar, the conversation worked its way around, ultimately, to the inlay art. They began: "We had a great wedding. It was exactly how we wanted it. We want you to depict our wedding, but with one big difference: we want you to show scenes that could have happened, but didn't."

I was still digesting that instruction when they explained further.

"We want the scenes to show our wedding as if all of the things that we feared actually occurred."

There was a moment of silence.

"Oh, and we'd like you to incorporate the art of Hieronymus Bosch."

"Uh, well," I said, buying myself time to form a response to how I was going to incorporate the fifteenth-century works of a fantastical Dutch painter. "I wouldn't normally associate Bosch's art with a happy occasion like a wedding," I began. "He painted pretty dark stuff—and weird, even for his time. Are you sure about this?"

They were adamant.

"And we see you taking a somewhat medieval approach to the art, or at least to the way it's shown."

They explained how they imagined it. They saw themselves on the headstock with me there as well, gesturing for them to view the triptych of panels (hence the medieval approach to the display) that I have created for them and that span the length of the fretboard.

Where to begin?

While I had them at my shop, I asked them the key question: "What would have upset you had it happened at your wedding?"

As they brainstormed, I began a list. Some of their answers were predictable: invitations with the wrong date and no one comes, the garden reception is rained out, the best man loses the ring, etc. But then more personal dislikes and concerns emerged. To jump forward in the story, these became some of the elements I incorporated:

- Jody's intense dislike of carnations.

- Matt's dislike of flashy tuxedo colours.

- Their worry that their dog would show up at the dinner reception and cause trouble.

They promised to send me photos from the wedding. What arrived some days later was a dozen CDs with close to a thousand images. They contained the entire photo shoot from the hired photographer as well as images from the cameras of eleven friends. My first thought was to peruse them all on my desktop and print any that might potentially prove useful. Instead, to save ink, I took myself to the local copy shop, sat in front of one of their computers, and spent the better part of an afternoon selecting and printing twenty-five images— and using up *their* ink.

Now it was time to look at Bosch's paintings. I immersed myself in his imagined demons, panel after panel of them, his scenes of *The Last Judgment*, even his marginally cheerier *The Garden of Earthly Delights*. Ultimately, I found myself scanning for creatures that I could extract for my own purposes and that were more benign in appearance. With Bosch that wasn't easy. But I did, finally, earmark

Matt and Jody at the altar.

Matt and Jody at their reception.

Their pet bulldog.

an inventory of possible characters I could incorporate into my narrative, depending still on where that narrative took me.

Aside from the headstock scene, which my clients were quite specific about, I knew I'd be creating three additional scenes — a triptych. While reviewing the list of wedding "wrongs," the obvious occurred to me: the three panels should follow the sequence of a wedding, of their wedding, as closely as possible. It made sense to begin with the ceremony. That should be the first panel. My clients confirmed that the afternoon ceremony was followed by a dinner reception, and the reception was followed by a more raucous celebration at a pub. There were my themes for panels two and three.

For Jody and Matt's headstock portrait, I decided it would be fitting to depict them clinking champagne glasses, both in their wedding finery. I was able to assemble a composite of that image from three different photos. To complete this section, I took photos of myself looking their way and with one arm gesturing down the neck, as requested. I made sure one hand would extend far enough to cross into the first fret.

On to panel #1, the ceremony. I had decided that in place of the priest/minister/rabbi conducting the ceremony, I would incorporate a Bosch character. One of my inventory of creatures was a hooded, blue-green being of sorts with a relatively benign expression. He/she/it would be conducting the ceremony. To show this character, however, required Jody and Matt to have their backs to the viewer. I remembered seeing some shots like that, but hadn't deemed them worthy of printing, so I went searching through the CDs again to find them.

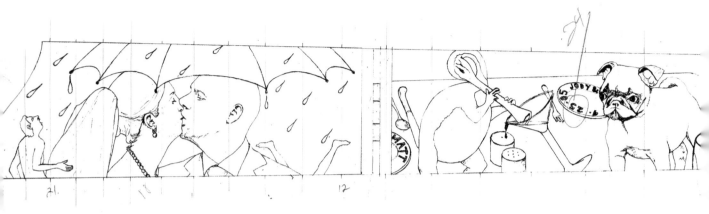

While I played with the layout of the bride, groom, and creature within the space I'd mapped out for the panel, I also began to think about how I could incorporate some of the wedding-gone-bad elements. For this scene, those aspects seemed to suggest themselves almost immediately. Jody hated carnations, so I drew in an oversized one as part of her hairpiece. Matt hated ostentatiously coloured tuxedos, so I gave his jacket clown-like purple and green stripes.

While I was staring at this panel's layout as its elements fell into place, I decided to get the wedding ring into the story somehow. There was no room for another major creature, but there was some available real estate between the bride and groom... I skimmed through my Bosch creature inventory with an open mind, not certain what I was really looking for. I had weird fish with human legs, lizards with bearded heads, dragons, flying creatures... Flying creatures! I stared at a flying fish with some sort of mer-creature on its back, holding what resembled a fishing rod but with a small red ball dangling from the end of the line. I immediately pictured an equally circular

Detail from *The Last Judgment*
by Hieronymus Bosch.

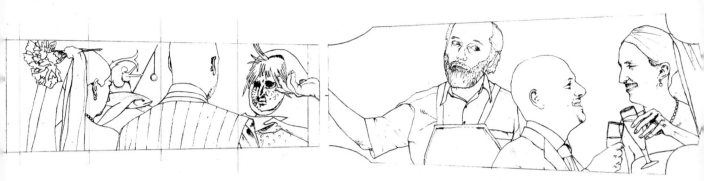

object at the end of that line—the wedding ring. I had found my ring bearer.

On to panel #2, the dinner reception. It seemed logical to me to show a table set for the meal, with wine glasses, cutlery, etc. I had printed many photos of guests at the tables, so I knew I'd be able to duplicate the precise place settings. Since my clients' fears had been that their pet bulldog might disrupt the reception, it was an easy decision to try to place him in this scene. I first visualized him up on the table, digging into someone's dinner, but this didn't leave much room for a Bosch character. Why didn't I have a Bosch creature stealing food and let their dog be protectively confronting it?

Once again, I scanned the various Bosch creatures I'd collected. None seemed to be just right. The only one that was showing any possibility was a fowl-type thing that was playing its elongated nose as if it were a whistle or a recorder. While staring at this animal, attempting to visualize a suitable role for it, the image of an elephant drinking through its trunk came to mind. There was my solution—with its elongated nose, this creature would be getting into the wine. And I'd have the dog eyeing it

with some suspicion (at least as much as one can depict that in an inlaid dog). The use of the table setting also allowed me to meet the clients' request that the date of their wedding appear. I engraved their names and the wedding date on the edges of the bread plates, as if they were souvenirs for the guests.

Lastly, panel #3, the afterparty. The actual event took place at The Red Pump Inn, but there were few usable images from this venue among the photos I'd been sent. I allowed myself to think less literally about this final panel. To conclude the narrative arc, a shot of Jody and Matt kissing would serve, seeing as the kiss is the symbolic capping event of most wedding ceremonies. I wanted the couple and their kiss to dominate the panel, so I decided to bring The Red Pump Inn into the scene only symbolically. The entire background colour is red coral, and to hint at the Pump, most often a device for moving liquid, I set the newlyweds in the rain. To prevent their fine clothes, and Jody's hairpiece, from getting soaked, I gave them an umbrella. As for the two simple characters from Bosch I used in that scene just to be playful? Well, I didn't care if *they* got wet. ✘

This Machine Prevents Wars 2006

I've never forgotten this sentence, one of only three in a very short email inquiry about my guitars: "I need a beautiful marijuana and peace themed axe."

I soon learned that the sender was a former lawyer and a politically active advocate for the legalization of marijuana. It wasn't a surprise that someone with strong views in the public sphere would also have very definite ideas about what he'd want in an inlay theme. He had conceived a design that combined three key elements: Bob Marley, marijuana, and the written phrase "This machine prevents world wars," which was inspired by the message the US folk singer Woody Guthrie had painted on the face of *his* guitar: "This machine kills fascists."

Over the course of our discussions, primarily by phone, the inlay concept became more defined. My client wanted a portrait of reggae singer and Rastafari Bob Marley, showing him holding/smoking a large marijuana cigarette. Marley's Lion of Judah ring needed to be prominent. (Note that the Lion of Judah symbol is taken from the flag of Ethiopia as it appeared during the reign of Haile Selassie, the spiritual leader of the Rastafari ideology.) Of equal importance to this client was that the anti-war phrase emerge from the marijuana smoke. His final request was that I have a ganja leaf (the word is Sanskrit for "hemp") emerging from Marley's dreadlocks.

An early suggestion from my client was to have the smoke being blown out of Marley's mouth. I accepted that as my starting point. However, once the search for a suitable image of Marley—one that would work successfully around the tuner washers—was underway, I changed my mind about that. For that image

I was limited to stock photos, dozens of which can be found online. Finally, I chose an unattributed but commonly known shot that captured him with a brilliant smile and also clearly showed his long dreadlocks. It was large enough that I'd be able to easily reproduce the detail in his face and on his ring. Clearly, it had many advantages. What Marley's engaging smile didn't provide was the logic of smoke emerging from his mouth. That forced me to turn instead to the source, the marijuana cigarette itself.

Being a non-smoker, and therefore unfamiliar with the specific smoke patterns that might emerge from a marijuana cigarette—or any cigarette, for that matter—I decided to do some homework. No, I didn't cruise the street, hoping to score some weed. But I did go to the nearest convenience store and buy a cheap package of no-name cigarettes. Back in my shop I lit one, rested it on a makeshift ashtray, and watched how the smoke emerged. To witness a variety of patterns, I blew on the air, alternating my angle and force. I quickly sketched some of the patterns and shapes this one cigarette provided.

My next task was to look at the font style of the anti-war phrase that would stretch across the fretboard. By this point we had tightened the phrase to "This machine prevents wars." I tried various formal fonts, including the stencil font often seen on the crates of armament or food aid shipments. I first sketched in each font and then began to redraw each letter, progressively morphing it into a wispy smoke-like shape. After trying a third font, I found that the transition from a formal letter shape to smoke wasn't working. The lettering had to be more fluid to begin with.

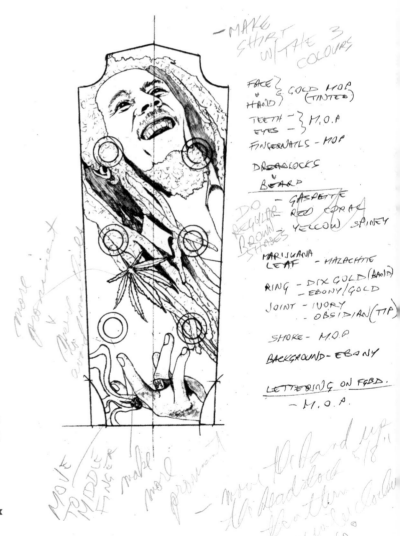

this

this machine

prevents ware

this this this this this

mass machine prevents

this this this this

Above **Selecting word shapes from my own writing.**

I decided to write out the phrase myself, in my regular haphazard cursive. I used a medium-sized Sharpie and wrote out each word over twenty times. I then selected the best version of each word, looking to retain the natural shaping while being sure it was readable. I placed those on a fretboard-long sketch and found that this approach very easily enabled the transition from fully readable through smoky wispiness to the smoke of the cigarette.

When a client has very specific design ideas, as was the case here, it might seem that the execution of the concept is a less satisfying endeavour than when all the creative conception is up to me. Ultimately, I derive satisfaction from the degree to which I have successfully interpreted and illustrated a client's idea. In a case like this one, the elements may have been dictated, but every aspect of the specific "what" to include and the "how" to make it work was still up to me. x

The Hill in Autumn 2006

Tom Thomson died in 1917, at only twenty-nine years old, in what are still considered mysterious circumstances. He had been part of the collective of painters that became known, after his death, as the Group of Seven. They are the iconic masters of early Canadian painting and their influence continues unabated. Despite having died shortly before the group coalesced (and likely would have borne the name the Group of Eight), Thomson is considered a member, and by some reckoning remains perhaps the most celebrated of the Group.

My client for this inlay was an admirer of Thomson's work who owns a small cottage, more of a cabin, near the sprawling wilderness of Algonquin Provincial Park in Ontario. The beautifully framed view from the cabin's kitchen window is almost precisely the view Thomson depicted in his painting *The Hill in Autumn*. The coincidence was uncanny, and the link between my client and his family's life and this painting became something tangible. It naturally followed that my client wanted me not only to duplicate the painting but, more importantly, also to depict Thomson in the act of painting it.

Tom Thomson died on a canoe trip in Algonquin Park. Given his short life, and the fact that he lived almost a full century before YouTube and cell phone cameras, visual documentation of his life is extremely limited. As I went searching for images of him, I soon realized I had a problem. The few photos showing him in painting mode, not to mention the few formal headshots I found, were all unsuitable for my narrow canvas.

I decided I would have to pose a model, dress him in a hat and the casual clothes of the period, and then sketch in Thomson's head, based on as many of the existing portraits as I could find.

Before doing that, I began flipping through my books about Thomson and the Group of Seven, making mental notes about clothing styles. I was trusting that a theatrical costume supplier would have what was needed and was mentally assembling the elements: hat on page *x*, wool pants on page *y*, likely a tie, etc., when I stumbled upon a loose, sketchy, somewhat impressionistic ink line drawing of Thomson. It was by Arthur Lismer, another member of the Group of Seven. I stared at this drawing, which showed Thomson very relaxed, sitting on the ground. He wasn't at all in the act of painting, but the more I stared at the drawing, at the angle of his head, at his body language from the waist up, the more I saw that this sketch could be the foundation for my scenario.

I already knew that to duplicate even a narrow section of the original painting would require a horizontal orientation. With that as my starting point, I could see that this sketch of Thomson would work for me — I would only be showing him from chest height. I modelled my own arm, brush in hand, and sketched it in, doing my best to mimic the raw style of the original. Then I placed in the scene an older-style easel holding a canvas, largely blank but for the earliest sketch lines indicating the contours of the hill. My goal was to depict Thomson's very first brushstroke on the canvas.

Usually I inlay shell and stone of various hues into black ebony. However, to duplicate the effect of the Lismer ink sketch, I had little choice but to do the opposite: inlay ebony into shell. A laminated sheet of awabi shell, with its seamless appearance, became the background. Beginning directly behind the canvas being painted, I placed my version of the actual painting. With my narrow vertical space limitation I

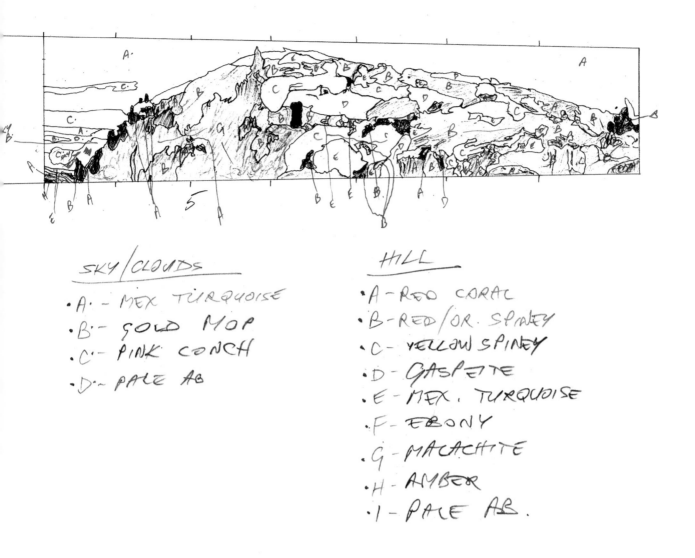

SKY/CLOUDS

- A. – MEX TURQUOISE
- B. – GOLD MOP
- C. – PINK CONCH
- D. – PALE AB

HILL

- A – RED CORAL
- B – RED/OR. SPINEY
- C – YELLOW SPINEY
- D – GASPEITE
- E – MEX. TURQUOISE
- F – EBONY
- G – MALACHITE
- H – AMBER
- I – PALE AB.

couldn't reproduce the entire painting, so I chose to focus on the hill itself, given that this was the title of the painting.

In Thomson's painting, the foliage on the distant hill is displaying its fall colours, with spots of green (from pine and fir trees, one assumes). His impressionistic brushstrokes were obvious and intentional. To duplicate the colours as well as the effect of the visual brushwork, I selected stone that naturally showed fine graining. After sizing my selected view of the hill nicely within the borders of the fretboard, I managed to locate the natural left edge of the painting at the octave fret (the twelfth), which served to mark a key musical location. However, it also created a visual imbalance of dense inlay for much of the neck followed by a largish region of "empty" ebony. I stared at the layout for some time, puzzling over how to add something to balance the design. I tried, then rejected, the idea of enlarging the hill. I considered artificially extending the

painting, but imagined my customer's negative reaction to this presumption. I paced my shop. And then I took a break for lunch.

Away from my workshop, my brain was juggling words like *symmetry* and *balance* and *narrative arc*. It struck me that perhaps there could be more to the story than I had shown. Yes, it was true that the design already satisfied my client's wishes by showing Thomson at work, and as faithfully as possible reproducing the painting. But it struck me then that I had begun a story — the story — with Thomson's first brushstroke on the canvas. Perhaps what would more definitively complete the narrative would be showing his final brushstroke as well. And it would, of course, provide me with the opportunity to extend and balance the design. Now, taking us all the way to the fifteenth fret — one fret past where the neck joins the body — is a proportionally sized brush, having just layered on the final stroke of sky blue. x

What Is Your Desire? 2006

I was almost entirely ignorant of Japanese animation when I was asked by this Japanese client to use that subject as a basis for an inlay. I had a vague awareness of some feature-length Japanese animated films that had occasionally attracted notice at film festivals, but that was all. I had definitely never encountered the terms *anime* or *manga*. Manga, I thought, isn't that Italian for "eat"? When it comes to inlay themes, however, I cherish my ignorance. It forces me to learn something new.

My client had indicated, minimally at least, a direction for me. He'd sent images from a variety of Japanese graphic novels that depicted young women, all with impossibly long hair, and drawn stylistically, as if the artist had taken Czech painter and decorative artist Alphonse Mucha's distinctive Art Nouveau style and simplified its lines. To supplement what my client had sent, I made my way to a comic book store in Toronto called The Beguiling, where I thought I'd have a good chance of finding more examples of Japanese animation. My education began at the front counter. The proprietor patiently explained that motion animation in Japanese film is referred to as *anime*. The same drawing approach in graphic novels and comics is called *manga* (the Japanese word for "comics" or "cartooning"). Manga was what I was after, and, yes, they had an extensive collection.

I soon discovered that at least one of the images my client had sent came from a series titled *Oh My Goddess!* by Fujishima Kosuke, first published in 1988. The series ran for twenty-six years, until 2014, when the forty-eighth and final volume was released. I picked up the earliest six volumes of the series, along with books by a few other artists, made my way back to my workshop, and started reading.

Yes, reading. The text in these editions had all been translated into English. Of course, while I was reading I was also looking, examining every page of every story in every book for potential elements to include in the inlay.

Perhaps because the world of manga was new to me, perhaps because the first story I read had the sheen of novelty—whatever the reason—I couldn't get the images from Kosuke's story "Wrong Number" out of my head. Partway through that story we are introduced, for the very first time, to one of the enduring Goddesses of manga. Here is a summary, taken from the published blurb, of the pivotal moment in the story that kept pulling me back:

> Keiichi Morisato is a good-natured yet hapless and girlfriend-less college sophomore whose life takes a turn to the unexpected when he accidentally calls the Goddess Technical Help Line and a beautiful Goddess named Belldandy materializes in his room.

Trusting my instincts, I chose to depict this scene. My primary challenge was simply to capture the essence of the Goddess's arrival and Keiichi's surprise within my limited headstock canvas. I also liked the idea of a dialogue balloon, as had appeared in the book, with the first words the Goddess speaks: "What is your desire?"

For the fretboard portion of the design, I stayed on theme but chose to represent what I came to understand were archetypal features that indicated a magical Goddess: a petite face with huge, oversized eyes and hair so long that it often curled and flowed around her entire body as she moved.

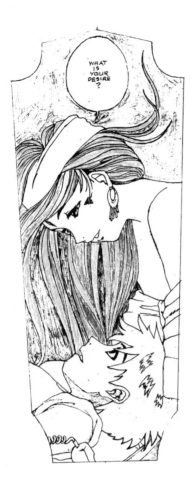

HAIR - AWABI SHELL
 - RED CORAL
 - YELLOW SPINEY
FACE - IVORY
FORHEAD)
CHEEK } - LAPIS
MARKS)
EARING - DIX GOLD
EYES
 - M. O. P
 - TAHITIAN BLACK
 - EBONY

At his first viewing, my client was happy with the overall concept but had concerns about the scene in the headstock. Given his familiarity with the two characters over the decades, he requested that I insert a later image of the Goddess's face, which I did, and an earlier, younger-looking version of Keiichi's face, which I also did. And I have to admit, I like the revised version better. **x**

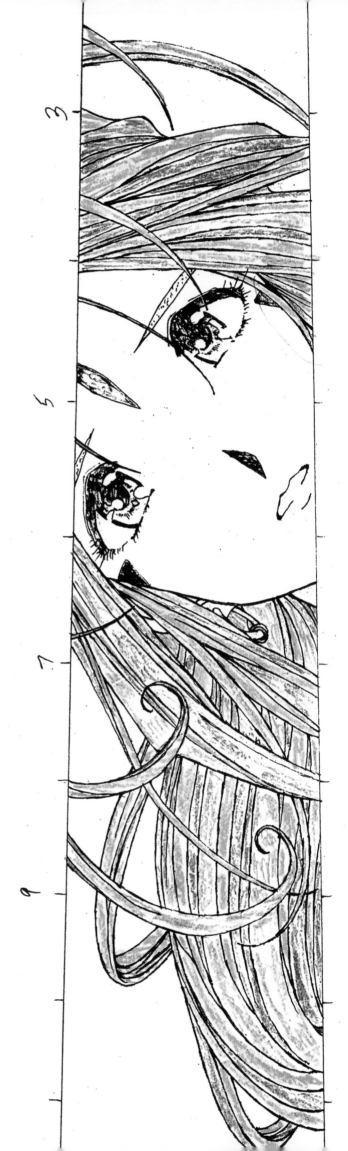

The Kiss 2006

Here is another complete story told in a small space: it's another Short Story. I was building this guitar to take it to the Newport Guitar Festival, one of a small handful of festivals that take place around the world, combining live performances with a trade show of only handmade guitars. (The show originated in Newport, Rhode Island, and later moved to Miami Beach, Florida, but has been dormant since 2010.) Since my guitar didn't yet have a buyer, the inlay art could be my choice.

Mentally skimming through general topics like sports themes, music, and musicians ultimately brought me 'round to the greatest theme of all: love. Contemplating how I might illustrate love very soon took me to its adjective, *loving*. I might have depicted a couple in the act of making love, but that approach was likely to turn off as many prospective buyers as it might turn on. Too risky, I decided. When I moved to the idea of a simple affectionate kiss, Gustav Klimt's iconic painting of the same name immediately came to mind. Could I use that somehow? And what about Auguste Rodin's sculpture also titled *The Kiss*? Thinking of these recognizably famous artworks quite naturally led me to imagine viewing them in a gallery or an art museum. That's fine so far as it goes, but as an image it's fairly static. I had to find the story.

To spur my imagination, I began asking myself the question employed by writers throughout the ages: "What if?"

— What if I depicted Rodin and Klimt admiring each other's work? Boring. And it took me away from my theme.

— What if the depicted lovers came to life — leapt off the canvas; walked off their marble base? Okay, but why? What was their intent? Where was I going with this? Rejected. I was getting off topic again.

— What if I showed gallery-goers admiring these works? Perhaps.

— And what if a couple of gallery-goers, seen from behind as they view the sculpture and painting, secretively reach for each other's hand? Interesting.

— But what if the couple that is viewing the works gets really inspired and embraces and kisses? Ah. Yes. Now I had a story.

Two postscripts to this design. The particular version of Rodin's *The Kiss* that I referenced was carved from white marble. In my design, white was not going to work. I needed something that would give greater contrast between Klimt's earth tones and the light shell of my young couple's heads and hair. I chose Mexican turquoise, not just because of its colour but also because of its "web" graining, which visually implied stone.

I was late getting this guitar completed before travelling to the show and had no time to coordinate with my usual photographer. The image of the strung guitar reproduced here — the only one I have — was captured by my friend and fellow luthier David Wren. **x**

Facing, top left
David Wren's photo.

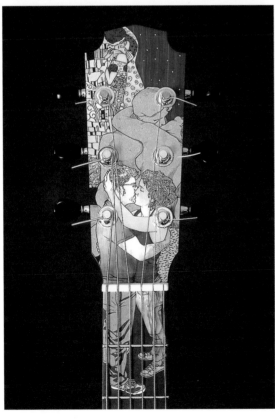

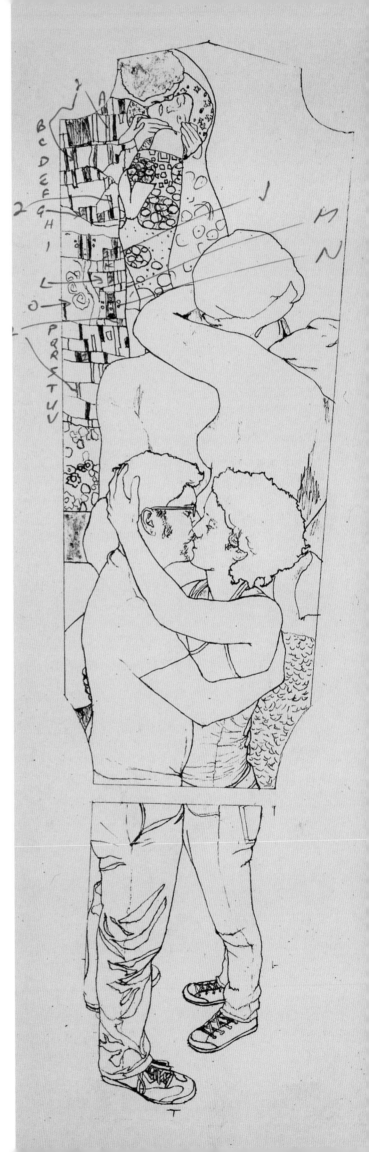

Yosemite 2007

There I was, flipping through stunning panoramic photographs of California's majestic Yosemite National Park, wondering how on earth I was ever going to capture that majesty on my restricted, narrow canvas. Despite the fact that my client had unequivocally stated, "you have my permission to be creative," I was still despairing of being able to pull this one off. Page after page in my book showed wide-angle shots, the breadth seemingly necessary to successfully capture the scenes of impressive natural beauty. But my client was firm on this theme, leaving me no choice but to devise a way to make my narrow vertical or horizontal slice of the scene convey the equivalent grandeur.

From my research, I came to understand that Yosemite is most famous for its granite peaks, ancient giant sequoia trees, waterfalls, and valleys. Somehow, some of those features would have to be in the design. My first instinct was to consider a horizontal orientation, creating the design to be viewed with the guitar in playing position. That is certainly an easy way to capture the width of a scene, but… the height wouldn't be there. And the height of the mountains and sequoias is the key aspect of their majesty.

Again and again I searched for something that would spark an idea. "Think vertical," I kept reminding myself as I revisited each image for a fourth or fifth time. No concrete ideas were coming, and so I rose from my stool and began pacing the shop, visualizing some of the photographed scenes superimposed onto the fretboard. Still nothing useful was emerging. I needed to allow all the images to roll around in my head for longer than they had so far. It was time for lunch. (When in doubt, procrastinate!)

After lunch, I sat on my couch with my feet up and my eyes closed. In my imagination, against the clean darkness of my closed eyelids, I began to play with the images. Vertical orientation, I thought. Valleys, water (lake? waterfall?), mountains, trees entered my mind. I looked at them in my mind's eye, moved them around, allowed them to percolate.

A question rose to the surface: how to indicate scale? Well, scale is always relative. The size of one thing is always relative to another, so perhaps I could show distant trees set against… waterfalls? Mountains? I remembered a shot of distant fir trees near a shoreline with mountains in the background. I jumped off the couch, returned to the books, and found the photograph I had remembered. If the fir trees were on a shoreline, perhaps I could indicate a lake by having them reflected in its surface. Perhaps the scene could be split somehow between the real and the reflected. I tucked that idea into my back pocket and returned to thinking about the mountains I would need to include if my fir trees/scale relationship idea was to succeed.

From my reading, I'd learned that there were a few particularly famous mountain peaks in Yosemite. Two that impressed me with their starkness were the well-known Half Dome and El Capitan. My initial thought, given that these mountains are certainly not adjacent to each other in the park, was to choose one and have its edge slide into the vertical scene behind the silhouetted fir trees. And yes, that seemed like it could work. I was playing with the outline of Half Dome, and then of El Capitan, searching for the profile that would best serve my purpose, when I was reminded of my customer's permission to be creative. So, while these two iconic peaks may not be near each other in reality, in my inlay they became kissing cousins. By bringing one in from

the left side and the other from the right, making certain to reveal enough of their distinctive profiles to be recognizable, the scene felt like it was taking shape at last.

After this step, I returned to my lake/reflection idea. I decided to see how the design would be affected if the natural dividing point on the fretboard, the octave at the twelfth fret, also served as the line that divided the real from the reflected. A very quick roughed-in sketch showed me I was lucky; this approach would indeed work well. It gave me a smaller area to depict the reflection but still enough room to build the conceit convincingly.

Next I needed to figure out how to get a sequoia into the scene. I stared at the rough sketch that I had so far: the two mountain peaks, the fir trees, the reflection of the scene in a lake surface. After some time, I came to realize that I had unconsciously created a viewpoint as if I were standing on the opposite shore of the lake. If I stayed with that point of view, in the foreground—on the implied shore where I stood—could rest the base of a sequoia. And if it were in the foreground, I could draw it suitably large and impressive. So I did that: sketched it in, off to one side so as not to obscure the main scene, but rising up the full length of the fretboard.

While I settled in to begin the finished drawing, a new email arrived from my client. The gist of its message was that his wife was insisting on seeing a butterfly in the scene. I sighed—or if I'm honest, groaned—when I read that, but I responded, of course, that I'd find a way. Having just worked out a way to capture the large-scale nature of the scene, I now had to insert a very tiny object. Re-insert sigh.

To make the butterfly large enough to show some of its attractive colouring (otherwise, what was the point?), it clearly had to be part of the most immediate foreground. And the only clear foreground space available was in the air space well above the mountains. When I started sketching it in, however, I realized that by jutting one wing upward I could depict the butterfly breaking the nut barrier, but crossing up into the headstock rather than onto the fretboard.

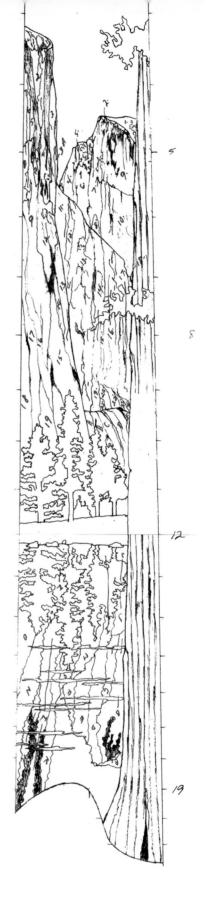

That little triumph mollified me somewhat. My client's wife got her butterfly. (And my client's overall reaction to the inlay, happily, was: "Simply amazing. You did capture the majesty of Yosemite. Wonderful balance.") **x**

Ibis Redux

For this guitar, my instructions were succinct: "Make the tale about the birds which inhabit the southern island." The location my client was referring to was Kyushu, the most southerly of Japan's four main islands. Surprisingly, the inlay design often begins that simply, with a single sentence.

I couldn't identify most of the birds in my own backyard, never mind the species that inhabit Kyushu. There began the learning curve… I soon found images of twenty different species of birds. No doubt there were many more, but this amount seemed plenty for my purposes. I found varieties of cranes, pheasants, thrushes, buntings, spoonbills, woodpeckers, storks, eagles, etc., in an array of sizes, shapes, and types. There was plenty to work with.

I also came across a few local species that had become extinct. One in particular, the crested ibis, was intriguing because of the shape of its long bill especially, but also because of its name. It sounded like something out of Greek mythology rather than a real bird. (Though, ironically, being that it's extinct, it is not that far from being mythological.) For all these reasons, the ibis stayed in my mind. If I could find a way to incorporate this bird into the artwork, its state of extinction might help create a deeper narrative than solely "the birds of the southern island."

I now recalled that my client had mentioned particularly liking an earlier design of mine, titled *Rainforest*, that he'd seen in my book *A Guitarmaker's Canvas*. That inlay featured bird and tree species from tropical rain forests, and one linking device I'd used there was a giant tree that rose up the entire fretboard and headstock. Recalling this design from twenty years ago sent me in search of the trees of Kyushu. I reasoned that incorporating a tree would provide me with a tree trunk and branches, which might prove useful. It didn't take long to find local species of cedar, stewartia, and beech. When I saw pictures of the beech trees, I realized that a particular stone amalgam I have in my materials palette, nicknamed Dalmatian, would quite accurately replicate the grey-white bark. In short, I'd found my tree.

My subsequent realization was that I had examples of cranes, large birds that perch in shallow water; woodpeckers, which ideally would be gripping the trunk of the beech; and a variety of other species that I could perch on its branches. What I didn't yet have was something more dramatic for the dominant space of the headstock.

By this point I was already imagining my beech tree climbing up the fretboard. If I continued with a vertical orientation and placed the base of the tree at the sound hole end of the fretboard, then I could logically have the tree emerging from a wetland and set a crane in the pond. I was thinking this through, rough-sketching the tree and the crane, when an idea so obvious I was amazed I hadn't thought of it earlier finally entered my consciousness. I had water, I had a tree, but I hadn't thought of showing what a bird is built to do: fly. Immediately, I understood that showing birds flying would offer me more dramatic visuals for the headstock, and it created a logical story arc of land-to-air, from the bottom to the top of the inlay.

I returned to the bird species I'd collected and sought images of each of them in flight. I went on the hunt for dramatic body positions and/or splayed wings that revealed the feather structure. As the most perfect image of a black-faced spoonbill with its full wingspan opened in the first phase of having launched itself in flight popped onto my screen, I suddenly went still. The bird's feathered wing was impressively long and complex, and even its face and bill were

unusual. My body had realized a fraction of a second before my mind chimed in that I'd found my headstock image. With that and the bottom image determined, I needed only to begin playing with the layout of these two birds and the beech tree before looking for the best location for a woodpecker and any other species I could fit in. Ah, but what about the ibis?

Simply depicting the ibis wouldn't say anything special, certainly not that it's an extinct species. Really, if I wanted to make a point about extinction, it shouldn't be there at all! I could just leave a blank space and tell my client that it represented where the ibis once was. But that was a cop out. And unless my client was ready and willing to explain the concept, anyone looking at the guitar might assume the unfilled gap was a design flaw. What I really needed was to have it there, but not there; shown, but not shown. My first thought was to make it entirely from Tahitian blacklip pearl, and the darkest pieces of that shell I could find. When the material reflects darkly, it almost disappears into the ebony, which would solve my problem. However, when blacklip reflects from its opposite angle, it flashes deep greens and purples. That wouldn't serve my purpose.

Perhaps, I thought, I would only do the bird in outline, not fully realize it. Yes, that felt right. Next, I mentally reviewed all the materials I routinely avoid butting against ebony because of their tendency to largely disappear from lack of contrast. At the top of the list was lapis stone. I did a little test piece, and as I expected, from some angles the lapis disappeared, and from others it just quietly showed itself. So that's what I did. I had the ibis span the guitar from the sixth to the thirteenth fret, solely outlined in lapis. Sure enough, when you're close to the guitar you see it, but when you pull away from the instrument it disappears, mimicking its real fate. ✖

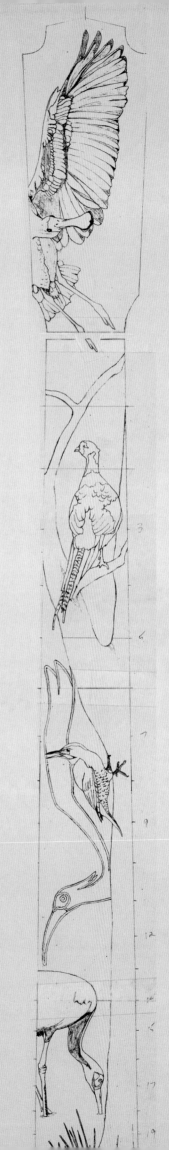

Acoustic vs. Electric 2007

"You wanted a courtroom scene," I wrote in reply to a client who had sent an email request for an inlay design, "but as you can easily imagine, that could be shown from many different perspectives and in many ways. I need to hear from you:

— Which aspects within a courtroom are important to you?

— Which roles in a courtroom are important?

— Which country's courtroom?

— How much freedom do I have in such things as perspectives, visual point of view, percent of the headstock and neck I can cover with art, etc.?"

In a follow-up phone call, I learned that my client was a barrister, and other than a request that he appear in the inlaid scene, he had no other wishes or instructions. The scene, the setting, whatever story emerged were all at my discretion.

My first task was to remind myself how a courtroom is laid out, which is not hard to do in the era of Google. The judge sits higher than everyone else in the room: check. The witness box seems most often to be to the judge's left: check. I noticed that the distance from the judge's bench to the witness box is quite a span. That might present a problem on my narrow canvas. Over and above the physical setting, the actors — a judge, a witness, a lawyer — create the critical triangle of any courtroom trial, so they had to form the basis of my scene. Thus, the judge, the witness, and the interrogating lawyer would all have to be in view and logically situated for the scene to appear realistic.

This was the point at which I realized that if my client, a person I'd never met or seen, was to play the role of the lawyer in this scene, I would need photos of him. At this early stage, I was simply assembling the scene in my mind and couldn't say precisely how I'd want my client to model for me. And given that he lived on a different continent, I couldn't do the photography myself. His wife became our photographer, and both she and my client followed these instructions:

— Dress yourself in your courtroom robes, and wig if at all possible.

— Your "action" is: you are gesturing to the witness, who is sitting to your right. (I want the gesture to look natural, so it could take whatever form you feel right about — pointing, hands up in an "I give up" gesture, etc.). You are either frustrated by the responses you are receiving — or annoyed — and while your right arm gestures to the witness, your eyes are pleading with the judge, who will be in front of you, over to your left, and slightly above you in his seat.

— I want a series of photos (as many as possible), starting with your left side profile and moving gradually toward your front, until I am directly in front of you. I'll probably be using a three-quarter face view but I'd like that view bracketed with other possibilities. You should hold your body position while the camera moves.

— The shots should be in two series: a full body view (do not cut off the feet!) as well as a close-up view of your head and shoulders.

— Make sure you are well lit. If there are parts of you, especially your face, in deep shadow, I will not be able to draw and engrave accurately enough to have the inlay look like you. But a small amount of shadow is fine; I would like the light to come strongest from the spot where the judge would be.

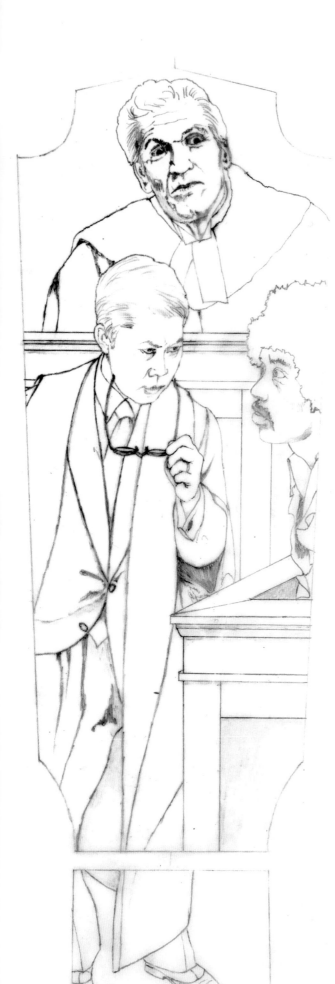

LASKIN
- FACE/HAIR - MOP
- SHIRT - IVORY
- COLLAR - BANDED MELON
- GOWN - RED CORAL
- BACKGROUND - OBSIDIAN

- FACE - MOP
- HAND - MOP
- GLASSES - DIX GOLD FRAMES
 - MOP LENSES
- SHIRT - IVORY
- TIE - MALACHITE
- JACKET - TAHITIAN BL.
- PANTS -
- SHOES - BROWN TAHITIAN
 " " " "
- GOWN - LAPIS
BUTTONS - EBONY

HENDRIX
- FACE - GOLD MOP
- HAIR - EBONY
- SHIRT - MEX. TURQU

WOOD PANELLING
 - YELLOW SPINEY
 - RED/OR SPINEY
 (PANELS)

I concluded the email with: "I'm sorry to get so picky with these instructions, but when I have to depict a real person playing a fictional role, and I cannot model and photograph them myself, I have little choice."

Some weeks later, my email inbox slowly downloaded a series of photos. My client was in robes only, since wigs, he told me, were no longer in use. He also informed me that when he was seriously questioning a witness he would often remove his glasses and aim a penetrating look their way. That, then, became the view I used. One unexpected image that he slipped into the email on a whim was a view of his music room, in which numerous acoustic guitar cases rested against one wall. It was this afterthought of an image that ultimately gave me my theme for the inlay. My client was clearly very serious about his love for acoustic guitars. What if he was required to defend that passion, to argue the case of Acoustic Guitars vs. Electric Guitars in court? At the very moment that concept struck me, I recalled an early comment that a tongue-in-cheek approach would absolutely appeal to him.

A storyline was taking shape, but who would I place in the witness box? It needed to be a player, someone who would be instantly recognized as an iconic electric guitarist. At the top of my list was Jimi Hendrix, so I was determined to see if I could make that work. I searched through photos of Hendrix, and found four views of him that offered some potential. I printed those and set them aside. And who would I use for the judge? There are countless pictures of generic sitting judges,

both real and fictional. I was casually skimming through some of them, earmarking a few for a second look, when a much better idea came to me. My paternal grandfather's cousin, Bora Laskin, rose through the ranks of the legal profession and concluded his career as the Chief Justice of the Supreme Court of Canada. He was a highly respected Chief Justice, responsible for numerous progressive decisions. Bora would be my judge. A direct connection to me, as well as to Canada, became my little inside joke.

With my characters' roles settled, I needed to return to my problem of a courtroom's standard layout. My familiar constraints—the narrow view as well as the location of the tuner washers—were making this layout trickier than most. I had a lot of visual information, not to mention three portraits, to arrange around these limitations. I was left with no choice but to rearrange the furniture, so to speak. With the judge sitting top and centre, which seemed most appropriate, I brought the witness box around to the front, though still on the judge's left, and jutting only far enough into the scene to enable me to show a recognizable amount of Hendrix while leaving lots of space for me to position my client.

When my client ultimately saw the finished inlay and learned that I was a relative of Chief Justice Laskin (however distant), he expressed surprise and explained that he was very aware of Bora, having studied some of his decisions. Small world, indeed.

This inlay remains one of my favourites because it successfully and succinctly tells its story in little more than the headstock area. **x**

Swimming in Cape Dorset ₂₀₀₇

During our phone call, my client had tossed out a wide-ranging list of themes: the rain forest, Inuit art, Art Deco, William Shakespeare. Clearly, they were all over the map, but that's not a bad way to start. He had done some acting, so exploring Shakespeare was a natural choice, and we gradually zeroed in on that. My client began conveying to me how he was visualizing a Shakespearian theme. On the upper portion of the head-stock would be the Bard's portrait, depicted in monotones; on the lower portion, the Comedy and Tragedy masks, done colour-fully; down the fretboard a creamy-shaded parchment scroll filled with text from one of Shakespeare's sonnets. I was dutifully noting all these details, saving any of my own reactions until I'd heard him out. His own creative vision was growing more detailed the longer we talked. On the parchment, he'd want me to engrave the words "When in disgrace with fortune... Haply I think on thee." That's where we left it.

A couple of weeks later, when I called my client again to secure approval for some of my own amendments to his ideas, everything changed.

"I collect Inuit sculpture and Cape Dorset prints," he said. "Did I mention this?"

163

"Not specifically…" I replied. Unspoken was my immediate fear that he was about to ask me to depict Shakespearian scenes in the style of Inuit art. But he didn't.

He explained that each year the Inuit artists of Cape Dorset (a hamlet of 1,236, mostly artists, situated at 63° north latitude on the southern tip of Baffin Island, Nunavut) release new lithographic prints for sale. He had just purchased one from that year's collection via a Toronto gallery. He now wanted his inlay to be my version of a Cape Dorset print.

While we were on the phone, each of us in front of our computer screens, he had me view a variety of prints that had been catalogued online. He named his favourites and commented on what he liked about each one. I scribbled notes during this virtual tour, trying to capture his comments and listening closely for the qualities he emphasized. He remarked on the vibrant colours, the emphasis on animals over people, a specific drawing of a rainbow trout that depicted a loon within the trout's body—a fusion of the two species. By the time this conversation concluded, almost two hours later, I had my revised marching orders. He'd settled on the very specific prints that he wanted me to interpret. One was the beautifully detailed rainbow

trout/loon. The others simply depicted large schools of fish moving across the lithograph. This sure wasn't Shakespeare, but I actually found it a more interesting challenge.

The trout/loon image was a self-contained view of the fused animals, a single creature colourfully depicted on a white background. To fit on the guitar neck, it would have to be entirely redrawn. And its body was too bulgy and too tightly curved to work even on the wider surface area of the headstock. Despite that, given its strong colouring and fine detail, the headstock made the most sense as its natural habitat. So I redrew and reproportioned the image to fit into that frame. My task for this section was similar to the one students or amateur painters take on while copying a famous work. In my case, however, I had to recalibrate more than just the overall dimensions; I also had to reshape the art itself.

My preference, whenever the customer allows for it, is to pour myself into another artist's work, life, and time, and then create an original in their style that might, if I'm successful, have been in their body of work. Moving into the fretboard portion of this design, I felt I could come closer to that approach. Inspired by the way the Cape Dorset artists depicted

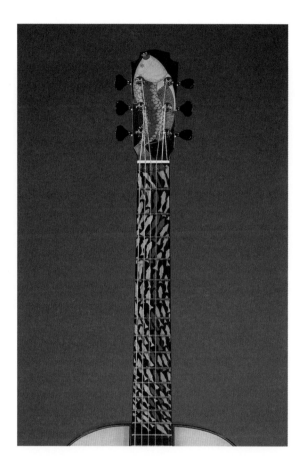

the curving motion of schools of fish, as well as
by the more simplified shapes they gave them,
I set out to create my own version of their style.
The strong elements of indicated movement
and the shifting colours became my guiding
principle. I played with the overall gently
curved path of the fish simply by drawing
directional lines across the fretboard layout.
When I felt the shape of the flow looked
natural, and when I was happy with where
I had placed the school's entry into the fret-
board frame, I began to draw in the fish. When
completed, 105 fish, in four primary colours
and in tight formation, made up my school.
All in all, it wasn't Shakespearian in any way,
but in every way Cape Dorset-ian. x

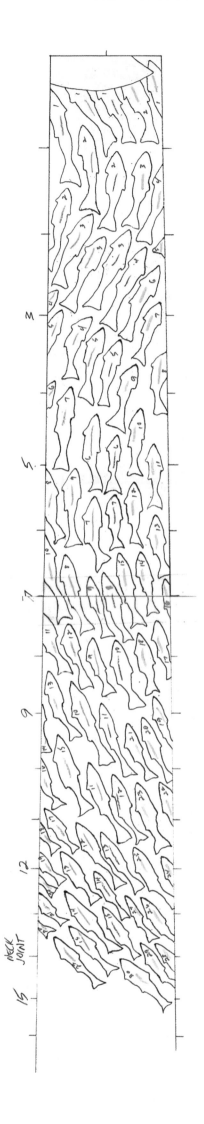

The Blue Fiddle 2008

It's always a delightful moment of anticipated
pleasure when a client asks me to pay tribute
to a visual artist. I can count on the fact that no
matter who the artist is, I'll have great fun feed-
ing my natural curiosity. In this instance, my
commission was to create an homage to Marc
Chagall, an artist who has always intrigued me.

Chagall's fantastic and colourful realism
followed no particular art movement. His was
a brilliantly unique style of painting, inspired by
his early life in the Russian (now Belarus) town
of Vitebsk and his periods in Paris. Even if you
know nothing of Chagall's work, you're likely
aware of the famous Broadway musical *Fiddler on
the Roof*, which is based on the late-nineteenth-
century short stories by the Yiddish author
Sholem Aleichem. His humour-laced tales
describe people and situations from the Russian
villages and towns of his own upbringing, not
unlike Chagall's Vitebsk. To create the 1964
musical, playwright Joseph Stein, composer Jerry
Bock, and lyricist Sheldon Harnick admit they
took much inspiration from a number of Chagall's
paintings that depicted a village fiddler, often on
a rooftop (for example, *The Fiddler*, painted in
1912–13, and *Green Violinist*, painted in 1924).

It so happens that my client was the great-
grandson of Sholem Aleichem. And his grand-
parents had known Chagall. My client's direct
connections to his theme remained front and
centre in my mind as I began my research.
I pored over reproductions of Chagall's paintings —
mentally noting repeating motifs — read about his
life, searched for pivotal events. I certainly knew
that a fiddler was going to make an appearance,
but otherwise I came to the task with no precon-
ceptions. It wasn't long before I had a growing
list of potential elements I could incorporate,
including several motifs that occurred repeatedly
in Chagall's work:

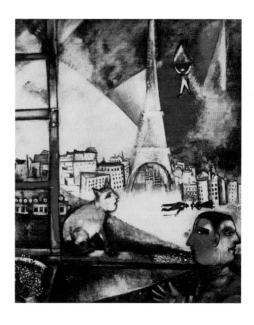

— Dreamlike images of poor Russian villages.
 Chagall only depicted these scenes after he
 had left Vitebsk, so they really were drawn as
 much from his imagination as from remem-
 bered reality.

— A goat or a rooster — or both. No explanation
 exists for their frequent appearance, accord-
 ing to scholars, other than that these animals
 are a common aspect of village life.

— Paris, frequently represented by a stylized
 Eiffel Tower. The city played a huge role in
 establishing his international reputation.

— A portrait of Chagall. He made a number of
 self-portraits.

— People floating or flying.

— Lovers embracing.

— Cubism. This style shows up in Chagall's work
 in general, but especially near the end of his
 first Paris period (1910–14).

— His vibrant, surreal colour palette.

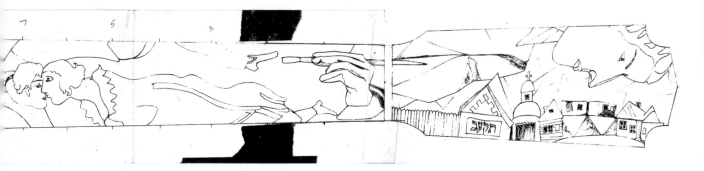

There was clearly no lack of material to work from. Still, full as this list was, it had no narrative form. I still needed the story that would bind these elements together on my canvas.

As is my habit at this point in the process, I walked away from my workbench, away from the books and printed images spread across its surface, and poured myself a coffee. I sat on my couch and focused inward, letting the images I'd stared at for the last few hours scroll through my mind. I finished my coffee, lay back, closed my eyes, and let my thoughts drift. I was imagining what it must have been like to be a struggling artist in Paris shortly after the turn of the twentieth century. Poverty would've been the shared lot of all artists, so of only fleeting concern. And outweighing that hardship would have been the creative excitement of being in Paris alongside Pablo Picasso, Henri Matisse, and countless other groundbreaking Modernists. It was just past the period of the Impressionists, but Paris was still the place to be. I was enjoying this moment of fantasy when my brain went off on a tangent and showed me the solution to my storyline, which, of course, had been in front of me all along. I would depict Chagall's journey from his obscure Russian village to Paris. And I could assemble my narrative from borrowed bits and pieces of Chagall's own work.

The fact that Chagall frequently depicted people floating or flying above the ground opened up the possibility of creating a horizontal design that would still allow for larger figures. My first use of that orientation was in the headstock. I began my theme there, floating one of Chagall's early self-portraits above his own village. I chose this particular portrait because it

served my narrative: his eyes look over the village of his past, but his left hand, symbolically holding a paintbrush, takes us down the neck and into the future.

Just before Chagall left for Paris, he met the love of his life, Bella, whom he would later marry. I wanted to use one of his embracing couples to represent his new love. Ultimately, the pair that fit perfectly into the horizontal perspective was from a heart-warming painting titled *Birthday,* painted in 1915. These lovers, whom I have purposely placed in the epicentre of the design, overlap one side of his very stylized base of the Eiffel Tower. On the opposite side of the tower we see one of the wooden houses of Vitebsk with a fiddler on the roof. I placed them here to represent the fact that wherever Chagall travelled in his life, he always carried Vitebsk with him. His early life experiences, both real and imagined, never disappeared from his art. At the very bottom of the fretboard, I situated one of his many portraits of Bella, making his portrait and hers the bookends to the storyline.

At this point in my layout I had left a space, between the fiddler and Bella, for one last element. This stumped me for a while. I reviewed all my materials, sketched in other isolated objects from his paintings, but none helped the theme. In fact, they all felt superfluous. But I had this space... That was when my attention was drawn to Chagall's *The Bridal Pair with the Eiffel Tower,* which felt like a variant of what I had assembled. Most intriguing was a human-sized rooster-like being in close sync with the bride and groom. It reminded me of goats and roosters making appearances in Chagall's works for no known reason. I decided then and there to put in my own rooster, also for no known reason. **x**

Marc's Menagerie 2008

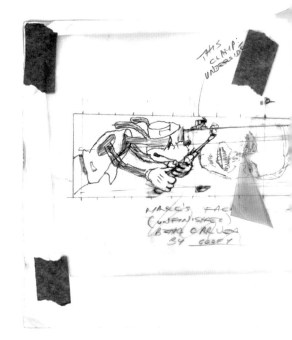

Over the past decade I have occasionally taught a week-long session on inlay and engraving at the Marc Adams School of Woodworking in Indiana. Marc's school is considered one of the top private woodworking schools in North America, and for good reason. He brings in the most skilled people he can find, from all areas of the field, to a superbly equipped facility. I may only teach there for a week, once every year or two (or three!), but it's still an honour and a pleasure to be among the talented faculty. Marc is a terrific woodworker, as you'd expect, and is equally well known for his popular instruction videos.

Much to my surprise, during one of my visits Marc commissioned a guitar. When we arrived at the point of discussing inlay themes, he listed a few general concepts. At the top of his list was "woodworking." To him that meant woodworking tools — hand tools, especially — and the process of milling a rough tree from log form to planed lumber. Number two on his list was early Disney cartoon characters. His fascination for them was obvious: the cabinetry he'd built for his children's bedrooms was decorated with carved and painted Disney characters, and his collection of Disney figurines was displayed in one of the large workrooms of the school for everyone to see.

I assured Marc I'd find a way to blend his first two choices, although as the words left my mouth, I realized I had no idea how I'd do that. A bunch of tools and cartoon characters don't in themselves create a narrative. I realized that to get a handle on this, I needed to begin at the beginning, to look for images of lumberjacks cutting down trees, especially the historic technique of using those giant two-man saws. That might spark an idea.

I easily found books on the history of logging, and there were plenty of images to be found online, especially in the photo archives of regional historical societies. Skimming through the blurry old photos was certainly instructive, but not necessarily productive. I didn't feel I was seeing anything I could directly use. I decided to let all these logging images slip off to one side of my mind while I went in search of Disney cartoon characters.

Reading about the history of Disney's early cartoons and the artists who drew them (Walt Disney was one) turned into a fascinating journey through the early days of animation. While reading, I was listing characters I might try to use: Mickey Mouse (of course), Minnie Mouse, Pluto, Donald Duck, Goofy, Jiminy Cricket, Lady and the Tramp. And then I stumbled onto something very surprising. One of the first animated characters that Disney and his partner, Ubbe Iwerks, created was Oswald the Lucky Rabbit, who made his film debut in 1927, in *Trolley Troubles*. Less than a year later, a dispute with his film distributor, who technically owned the rights to Oswald, caused Disney to walk away from his popular creation. Before the year was out, Disney and Iwerks had created their own new character,

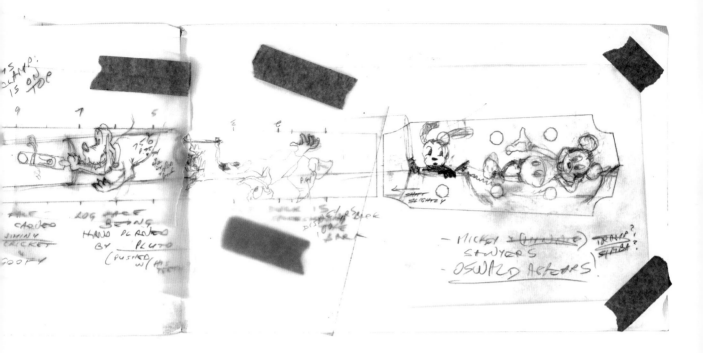

a mouse this time, whom they named Mickey. Thus, it was a copyright dispute that seeded the Disney empire.

I was musing on all this when an image came to me of Mickey confronting Oswald with a smug: "So there!" Which led to a parallel thought: what if Oswald made an unexpected appearance in Mickey's life? Talk about awkward. I visualized Mickey sawing through the base of a tree, only to find (as could only happen in a cartoon) Oswald popping out of the stump. And if a tree were just cut down, revealing the stump, then the main trunk of the tree would have to be lying on the ground somewhere, extending away from the stump. I immediately saw that for what it was: a perfect linear image, ideal for the long narrow area of the fretboard. The tree would be the backbone of my narrative.

It wasn't much of a leap to the next logical thought: as the log made its way down the length of the fretboard, I could have the Disney characters processing it. First, the bark would need to be scraped off; next, a portion would be planed to a flat board… Then what? I reminded myself about Marc's wish to see woodworking tools. I started listing a few that I could logically show: a saw, a de-barking tool, a plane. A chisel? Maybe. Though using a plain flat chisel on a

large board didn't feel right. A carving chisel? What would Disney's characters carve if they had a choice? In my imagination, the answer came quickly. They'd pay tribute to their creator. I had my storyline. Next I made a series of very arbitrary decisions about which cartoon character would be doing what task. Of course, Mickey had to be at the start of the story, near the stump, so that Oswald could encounter him as he emerged. Therefore, Mickey did the sawing.

As I was drawing in the characters, having already positioned the tree, I began doubting that I was including enough woodworking tools. I stared at the partially completed sketch and spotted some unfilled space near where I'd placed Goofy carving Walt's portrait. Thinking about the cartoon characters and their lack of woodworking experience (to the best of my knowledge), I wondered what would happen if they made a mistake in their work, or miscalculated a measurement. I looked at Goofy, whom I'd just given a carving chisel, and imagined that he was the one who miscalculated and that his work wasn't centred on the board. How would he fix that? He'd have to glue on an extension piece—which meant clamping. And that idea gave me more woodworking tools. **x**

43

Every so often a client requests an inlay theme that is deeply personal. And 43 is one of them. With this inlay, a number of lengthy but delightful phone conversations took me on a privileged journey that enabled me to better understand my client's major passions and the reasons for them. Among those passions, cycling topped the list. He was so dedicated to the sport that despite his nearing middle age, he frequently competed in long-distance races, day-long and multi-day events in which he traversed a couple of hundred kilometres or more each day.

The longer we talked, the clearer it became to both of us that rooted in this particular passion was something inseparable from his nature: the relentless drive to achieve a goal. It was a quality that had brought him success in many aspects of his life, so it was truly inherent to who he was as a person. And as we talked still further, confirming that cycling would, of course, form a key part of the design, my client described how this relentless drive sometimes makes him feel like he's being chased. He knows it's all in his mind, this perception, and he accepts it as one side of his nature pushing the other. But the image of being chased jumped out for me. I began to see it as a possible direction from which to illustrate his inner drive, and to sense that it would help me tell a story.

At another point in the conversation, one of us (and I truly can't recall which) referenced *Horse and Train*, the 1954 painting by the Canadian realist painter Alex Colville, in which a moving train is depicted only moments away from colliding with a horse that is running directly toward it. It is a brilliant and unsettling painting. (Bruce Cockburn used it as the cover

art on his *Night Vision* album.) Inspired by this image, my client thought perhaps I could picture him being chased by a horse while cycling. I proposed instead that we make it the train that is chasing him, using the larger muscularity of a moving locomotive as the metaphor for his strong inner drive. He agreed.

Later, we were batting around possible details to include (for example: "I'm training for the Paris-Brest-Paris race four years from now, a distance of 1,200 kilometres. Maybe we could include that somehow, perhaps with a signpost…?"), when my client returned to our very earliest discussion about his nature. He described the attitude he brings to any pursuit as not feeling hampered by any challenges, that the sky — the universe — is the limit. That description stayed with me, and it became particularly significant as the design took form.

To get started, I required views of my client on his bike. He dressed in his racing clothes, slid his bike into a rack, and had his wife snap photos from various angles as he mimed racing. That sounded fine, but when I printed them I could see they weren't showing me what I needed. I reminded him that he's being chased by a train, so I wanted his face turned as far back as possible, over his right shoulder, acknowledging the train on his tail. "Remove the bike helmet," I insisted, so that I could see his features, "but keep the sunglasses." I then instructed: "I'd like one set of shots from a bit above (someone could stand on a chair) and then from a bit behind you as well as directly beside you. I mean from a five o'clock position, then four o'clock, then three o'clock. Then repeat the same sequence but from a standing position on the floor." When these photos arrived, they were shot perfectly. I knew that

Vintage poster from 1901.

My client on his bike.

A steam engine from the 1940s.

I now had all I needed to work from for my client's role.

As for the train, I gravitated to engines from the late nineteenth and early twentieth centuries. These were big, hulking contraptions, the antithesis of a sleek modern design. Not only did the more ominous, steam-punky engine feel more interesting to inlay, but it also went some way to symbolizing the agelessness of human motivation to succeed. Maybe I was overthinking it. The truth is, in my gut it felt right, and I always respect my gut.

I now had my two primary elements, the train and my client on his bike, but I still needed to set them onto the bones of a narrative, and I didn't yet have those bones. Certainly there would be train tracks—had to be—running along the neck, but where to position my client? Riding his bike along the tracks? Bumping across the ties? Impossibly balanced on one of the rails? The phrase "riding the rail" stuck in my head. At the same time, I found myself musing on the internal nature of my client's drive, the nature that I was trying to illustrate. Something so connected to his psychological makeup that it almost felt like it wasn't just shaped by nurturing but was actually programmed directly into his DNA. Of course! These human building blocks are most commonly depicted by a stylized double helix, two twisting polynucleotide strands with alternating sugar/phosphate linkages between them, very much resembling—*yes!*—twisted train rails and cross ties. My heart raced as I realized I was on to something. I was impatient to get sketching.

Simultaneously, my client's earlier comment about "the sky—the universe—is the limit" returned to me, and I immediately pictured the completed bones of my narrative. The railroad

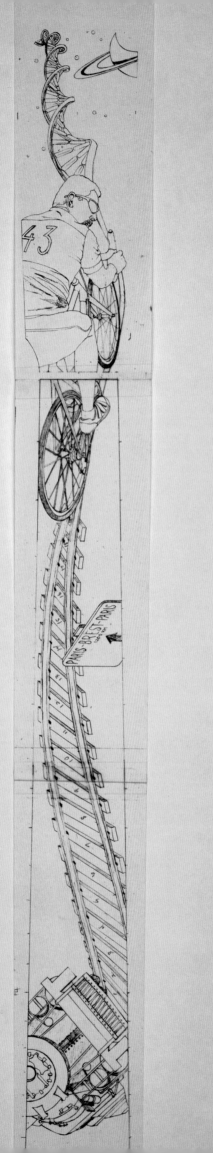

tracks would converge into a single line that would separate farther along into the DNA double helix, which would itself twist up and away into the universe. My client and his bike would be riding on the single rail, midway between that which drives him — pursues him — and the very essence of his nature, represented by the DNA, taking him limitlessly forward. And I purposely removed the brake pads from the bike. There had to be nothing that prevented him from moving toward his goal.

In one of our phone conversations, my client and I had shared a chuckle over the famous quote from the late Douglas Adams's *Hitchhiker's Guide to the Galaxy* series: "The answer to the ultimate question of life, the universe, and everything is 42." My client casually asked if perhaps we should push beyond forty-two as the meaning of everything, if I could possibly find a way of working that in. And, with *43*, I did. ✖

The Blue Notes 2008

Dream guitars. It sounds like an instruction, or a promise: when you sleep you will dream guitars. Thankfully for me and my fellow luthiers, many people do indeed dream guitars. In this instance, however, I am referring to one of the premier guitar dealers in the United States, Dream Guitars. I feel quite certain that the name was meant to imply they're a source for the guitars of players' dreams.

When Dream Guitars commissioned a guitar from me, the phrase "dream guitars" became the inspiration for the inlay theme, the jumping-off point for our broad discussion. What began with my client's loose concept of "dreaming about guitars, music" began to solidify over time as a concept when he had this thought: "Images of musical notes floating out of the sound hole, interacting with people shuffling to work, but a few of them turning and smiling at the music." Immediately, a slideshow of images started to flash through my mind's eye. And to my delight, my client gave me no further direction except to take the idea from there.

I let my client's final thought simmer in my head. I pictured city streets, hurried pedestrians, some not so hurried, musical notes floating through the air or embedded in the pavement, and on and on. I understood that the core of his idea was that some people connect with music in their daily lives and others don't. The location of a busy city street, with some pedestrians focused on their workday and others more relaxed, was simply a backdrop that would add emphasis to the differing sensibilities. I needed to show that for some people the music was irrelevant, it was beyond their awareness. I had to render visible a disconnect from sounds, which are generally invisible. Then, of course,

I also needed to depict that for other people, the music was everywhere, all the time, almost tangible. How to do that? Facial expression? Body language? At this point I really wasn't sure. I went to run some errands.

I had just left my car when I noticed that one corner of the parking lot I was in rose like a cliff over the street. Out of curiosity, I leaned over the nearby railing and found myself looking down at the sidewalk, which sat at least twenty feet below me. As pedestrians walked by, I could watch them unobserved. I was transfixed, fascinated by the bird's-eye view and the surprising similarities of bodies in motion, yet all of these people were oblivious to me. And with that last thought an image came to me of pedestrians literally walking over musical notes, their trajectories and body motion indicating their complete disregard for the music. Soon I had abandoned my errand, driven back to my shop to grab my camera, and returned to my spot at the railing. As discreetly as possible, I began photographing a wide variety of pedestrians as they passed directly beneath me.

I still had to figure out how to indicate the people *not* oblivious to the music. I knew I needed to stay with the bird's-eye perspective, and realized that a way to set these other people apart would be to have them looking upward. With their faces visible, they would contrast perfectly with my pedestrians: only the tops of their heads were visible. To have people look upward, I needed models. It occurred to me that if they were young people, or better yet children, the natural curiosity we associate with childhood would emphasize their connectedness to the music. I begged a favour from a neighbour-friend with two young

daughters, and luckily the girls agreed to be my models. We cleared space in their living room, I climbed an eight-foot ladder that forced me to crouch against the ceiling, and I photographed the girls from directly overhead as they looked upward and outward.

While taking these shots, it struck me that another way to differentiate the two polarized reactions to music was to have the girls fully realized, in colour and detail, but to leave the preoccupied and inattentive pedestrians in complete shadow. The only remaining challenge was how to reinforce the girls' connection to the music. Certainly, if the other folks were stepping all over the musical notation, then the girls wouldn't be. I imagined the musical notes near them being in the air, not on the ground, and the girls' faces looking upward to indicate that they'd sensed them. Thinking further, I realized that I could show them as ever more deeply engaged by depicting the musical notes intersecting with their bodies. That would signal that they'd taken the music in, internalized it, fully connected to it. To cement the visual message, to reinforce the difference between the distracted pedestrians and the engaged children, I changed the colour of the musical notes that connected to the girls from red coral to blue turquoise. Was I subconsciously thinking about the power of The Blues? Maybe. **x**

My young models.

My clandestine photo of a pedestrian.

Finding Bobby 2009

It's always a great pleasure to receive a commission from a performer whom I admire and who is also a friend. I suspect any luthier would tell you the same thing. This particular friend is certainly a talented singer and performer, but his day job, and additional talent, is working as a master mason. In fact, he is one of the most skilled in Canada, which is why he was brought to Ottawa to oversee much of the restoration work on the Parliament Buildings. And before this, he worked as a cop for a time after taking an early break from masonry. He spent much of his time in the police force as an underwater diver, putting into practical use what he'd been doing for pleasure since he was seven years old. It was his earlier career, as a police diver, that sparked his inlay theme.

He confided in me that his task as a diver was more often than not to pull drowned children from rivers and lakes. It became a bleak way to spend his working hours, day after day, which is why he decided to leave the force and resume his masonry career. So, while he wished his inlay to have a diving theme, he wanted it to be cheerful. He had a number of very specific elements I was to try to include, all of which would enhance the positive vibe of the scene:

— He wanted to borrow from the animated film *Finding Nemo*, in which a clownfish father goes looking for his missing son, but to flip it around to have himself looking for Nemo.

— He wanted me to make a cameo appearance.

— He wanted another mutual friend to appear.

— He wanted to be depicted underwater, wearing a snorkel mask (but no other diving equipment).

— In the film, Nemo had a friend named Dory. He wondered about perhaps including a Newfoundland dory (a small, wooden fishing boat).

— He considered possibly having air bubbles up the fretboard, in lieu of other fret position markers.

With a client who has already given this much thought to the theme, my job is certainly easier. I still have the creative challenge of incorporating all the desired elements in my restricted space, but I don't have the same degree of worry as when I'm second-guessing what my client sees in their head and trying to succeed at creating something that fulfills that vision.

While I was awaiting photos of my client, I began to ponder the challenges of this theme. We needed to be underwater, of course, to show my client and Nemo, but simultaneously we needed to be above the waterline, in the dory. We had both realized that our mutual friend and I could logically appear in that boat, so it was as critical an element as the others. Still, I'd need to show both views — beneath the water surface and above it — on a very narrow guitar neck. The only solution I could envision was to tilt the horizon line. To further differentiate the two locations, I ultimately depicted the background above the waterline with clear turquoise, representing a cloudless blue sky. But I'm jumping ahead of myself.

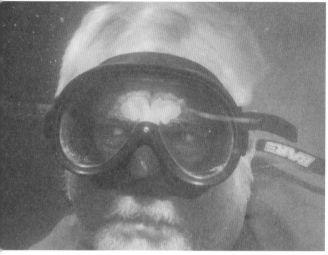

My client under water.

My friend Tam on his front porch.

Me, in my role.

Before I could begin drawing, I needed photos of all the characters, human and otherwise. My client sent me photos of himself, but none of them seemed suitable for what was taking shape in my mind. I asked him if he could photograph himself underwater. He could, and he did. Next up was to photograph our mutual friend. Before grabbing my camera and driving over to his house, I'd begun imagining various things he and I could be doing in the dory. It made sense that one of us would be observing, or appearing to observe, the client/Nemo scene. I imagined this person, leaning over the edge of the boat, hands on the gunwale, facing up toward the nut. This seemed like it would be a trickier view to capture, and I chose to keep it for myself so I could take my time getting posed just right. That left our mutual friend. Given that I'd be placing us inside a fishing boat, it didn't take a genius to realize I ought to show him fishing. I was quite certain that he owned a fishing rod—and I was right. I sat him in a chair on his open front porch, with his rod perched over the railing, and photographed him from a variety of angles.

Back in the shop, I took pictures of myself gripping a piece of foam that was standing in for the boat. This was done with a timer on my camera, not in the contemporary selfie style of our smartphone age. Images of Newfoundland dories and of little Nemo were easy to find online. From there, my task was layout and sizing in a way that both conveyed the actions and avoided frets and tuners. When I thought I was done, the final drawing complete, I stood well back and viewed it as a whole. Something nagged at me and pushed me to make one tiny change. To visually reinforce the surface waterline where ebony water met turquoise sky, I created the smallest of wavelets and showed it releasing a single drop of water. **x**

Emilia's Journey 2009

This commission turned into one of my more fascinating learning experiences. It began with a seemingly very simple comment by my client: "I am enamoured of photography." In conversation, my client didn't have any particular ideas about how or what to include about photography. He wasn't giving me any direction, only directing me to view photos he admired and trusting I'd take inspiration from them. He provided names and online links to the work of seminal photographers. Henri Cartier-Bresson topped his list, and a number of names from the illustrious New York–based Magnum Group were there. Alfred Stieglitz came up, as did Robert Doisneau, famous for his 1950 shot of an apparently spontaneous kiss on a Paris street.

My client explained that he preferred images that focused on people: "meaning less about sunsets and pretty flowers and babies, but more about capturing something that tells a story for those willing to spend the time looking." Then he added: "I'm very in love with my new little girl and would love to wrap her into this in some way."

Well, I had certainly been given my themes. But at this early stage I'd describe them as amorphous. I had a story to find, a narrative to shape.

My first destination was books on the work of Bresson, Doisneau, Diane Arbus, and other famous twentieth-century photographers. What a joy to have a bona fide reason to sit for hours at a time poring over brilliant photographs, bookmarking any I felt had aspects that might be interesting to incorporate, even if it was only how they used light or how they captured the expression on a face. During this time, I was also stumbling over footnotes about

the history of photography. This is when things began to get exceptionally interesting.

When I first picked up those books, I knew almost nothing about the origins of photography. My reading took me back in time to the device used by Renaissance artists but that was actually first described in ancient China: a camera obscura (this is the Latin phrase for "dark room"). This clever device can be as simple as a box or even a small room with a hole in one side. When light from an external scene passes through the hole, an image of that scene is projected on the first surface it hits, although it's upside down and much smaller than the real thing. Artists could use the camera obscura to let them trace the image of, say, a building and then accurately reproduce it. The early history of photography is the pursuit of a way to permanently capture the images projected through the camera obscura.

Above **Robert Doisneau.**

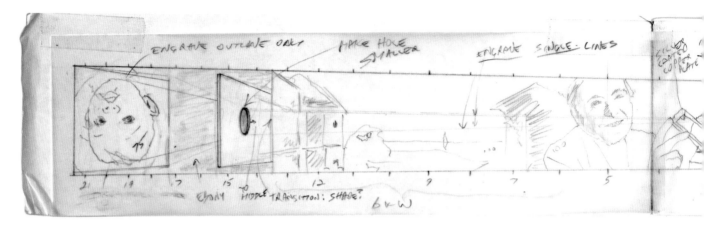

Having observed that some substances appeared to be altered by exposure to light, inventors around the globe began to experiment with various chemicals and surfaces in the search for a way to secure an image. A Frenchman named Joseph Nicéphore Niépce was the first to succeed. He's now generally accepted as being the inventor of photography. The oldest known camera photograph in existence, dating from 1827, is an image Niépce created of a view of the rural scene outside a window of his home. He achieved this by coating pewter with bitumen and leaving it exposed to sunlight for two full days.

From there, photography developed quite rapidly. Louis Daguerre, a friend of Niépce, eventually developed his own system in which he exposed images on a glass plate coated in silver iodide then developed them with mercury fumes: daguerreotypes.

As I was winding my way through this engrossing history, I was beginning to sense what the story of this inlay could be.

I began flagging portraits of some of the seminal photographers my client mentioned — it was them I was after, not their work — made prints of some early cameras, including a daguerreotype and an early SLR from the late nineteenth century, and found a reproduction of Niépce's 1827 image. I also asked my client to send me photos of his daughter, Emilia.

In a subsequent email, my client asked: "In the event it adds value to your thinking… I live half my life on my bike, my main means of transportation, especially when photo hunting." Could I include his bike somehow? At this stage I had no idea if it would fit, but I printed out the images he sent and set them aside.

A loose narrative was forming in my head. I would try to illustrate a select history of photography and include some illustrious photographers. But what about Emilia? How would she fit in? My client was flexible, but I understood his affection for his little girl and was determined to find a way for her to appear. But at this point I couldn't picture her role.

For the fourth time, I scrolled through the forty-nine image files of Emilia. I wasn't looking for anything in particular, just letting my mind go where it would while I enjoyed the photos. And that's when it hit me — Emilia was, for my client, a favourite subject to photograph. In my narrative, she could be the subject being photographed.

Immediately, layout possibilities flooded into my head. My first decision was that Emilia would be at the very top of the headstock; her location in this primary spot commensurate with her primary position in my client's life. And since

My client's irresistible photo of his daughter, Emilia.

My client's irresistible photo of his daughter, Emilia.

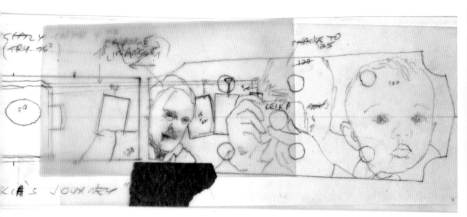

Bresson was top of my client's list of favourite photographers, I would have him taking Emilia's picture.

Placing Bresson, a relatively modern master (died 2004), at the uppermost part of the head-stock could serve as the culmination of my historical timeline. That meant the earliest point showing in my timeline would reside at the opposite end of my canvas, in the highest frets. There was my story arc—things were falling into place.

As for what aspect of photography's history would begin my story, I wasn't certain. I certainly liked the idea of reproducing Niépce's ground-breaking image. Perhaps that could begin my narrative—there was logic to it, after all. I returned to one of my books and began flipping to the page that reproduced this image. By happenstance the bookmark had slipped out and I had to flip through many other pages en route to the Niépce image. This is where serendipity intervened. One of the pages I was flipping through showed early examples of the effect of the camera obscura. Revisiting these images made me realize that this was a better place to start my narrative—the root of photography. The very next image that popped into my head was of my lead character, Emilia. I'd already decided to place her at the very top of the headstock, so it made sense to me that she

would also be the beginning of the narrative arc, pictured as the upside down projection of the camera obscura.

I began the layout, managing to bring in Stieglitz observing Bresson and Doisneau inserting a photo-plate into a daguerreotype camera. (Yes, this part was fantasy—Doisneau did not live in Daguerre's time—but this was my narrative and I could do as I pleased.) All the elements were falling into balance, and Emilia's journey, from camera obscura to modern times, felt like a satisfyingly seamless narrative. That was when I remembered my client's bike.

How could I possibly fit his bike into this story? Should I picture Stieglitz riding it? Too silly. Should I have my client riding it in the back-ground? His appearance made little sense. I looked again at Stieglitz, on either side of whom I'd left a bit of space, wondering if the bike might have some logical reason to appear there. That's when I realized—this is about photography, so stay with the theme. I would depict black-and-white photoprints of the bike hanging in the manner of a darkroom, as if the prints had just emerged from their chemical bath and were drying. A final clue for the viewer is the red stone, inlaid in the space between Bresson and Stieglitz, representing the red light spectrum, the only safe light in a photo-printer's darkroom. **x**

Imagine 2009

"**As we discussed,** the theme is John Lennon. He likes John, especially from toward the end of The Beatles (*Let It Be, Abbey Road*, etc.) to the beginning of his solo period (*Imagine*, etc.). He wants not only the music, but also John's lifestyle, conviction, ideas (love and peace, etc.) from this period. He also wants to picture the influence of other Beatles to John."

My client was the "he" in that quote, not the speaker. His wishes were conveyed to me through a translator because his English wasn't up to the task. That was the sum total of my instructions. Because of the language barrier, there wouldn't be any opportunity for further clarification, not to mention any chance to hear tone of voice and emphasis during a phone discussion. Despite these limitations, I wasn't concerned. I too was a fan of John Lennon, and admired him for many of the same reasons as my client expressed. My very first reaction was that this was going to be a pleasurable design challenge. And unlike some of my other inlay designs, this one came together smoothly.

One of my all-time favourite songs happens to be Lennon's "Imagine." The fact that my foreign client cited that song title specifically, coupled with his request for me to represent Lennon's "conviction, love, and peace…," made it obvious to me that the now iconic song title itself could be my overarching theme; it met so many of my client's criteria. What I thought might work was to stretch the letters of the title across the whole of the neck, using a thick and blocky font, which would leave me space within each letter shape to depict particular scenes. This wasn't a new design approach by any measure, but for me it was a first. So, before searching for images of Lennon and the other Beatles, and before even deciding

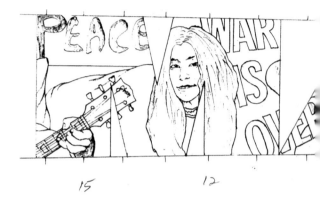

what instances or periods I would show, I began sketching out the letters. My goal was to maximize how much of the neck they would occupy while still leaving their shapes recognizable.

I knew one of the scenes would have to be John and Yoko Ono's bed-in for peace. My search for photos from those events (there were two — Montreal and New York City; I ultimately used shots from Montreal) sent me on a wonderful nostalgia trip. I pored over some of the many books that documented The Beatles' every step and was reminded of where I was and what I was doing when their albums came out, and when they were making their final appearance as a group. En route to the bed-in images, I encountered numerous photo portraits of Lennon and countless (truly!) images from the band's recording sessions, album cover shoots, films, cartoons, etc.

As the primary theme was John Lennon, it felt appropriate to begin my visual narrative with his portrait, and to give it deserving prominence on the headstock. Following that, it made sense to put the bed-in scene at the opposite end. This way Lennon bookends the design, giving it its narrative symmetry. Also, putting John and Yoko at the end of the fretboard meant they'd

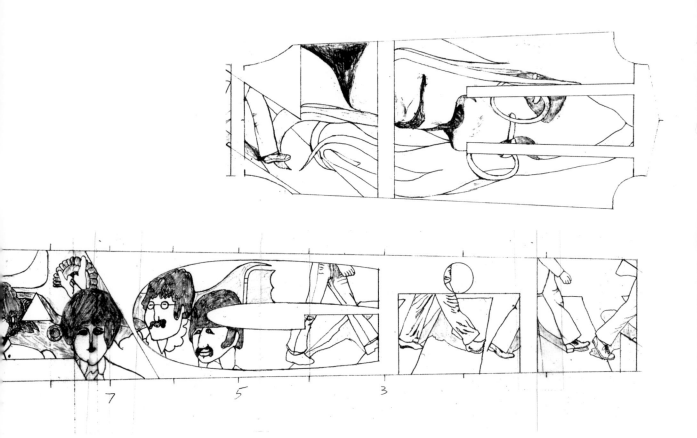

be depicted with engraved mother-of-pearl in my more typical dimensions, which is to say, in the space of a few centimetres each. And that would give me the freedom to portray Lennon much larger in the headstock, composing his features from cut materials versus with a graver. I hadn't done a portrait that way before, so I was anxious all through the cutting and inlaying stages. Only after I had sanded down the inlay did I see that I'd successfully translated to bone, lapis, and laminated shell the portrait I had drawn.

Next, I needed at least a couple of scenes of the Fab Four. From my client's instructions, I sensed that he didn't want a Beatles inlay per se. The focus was on Lennon, but of course, he was influenced by his bandmates, so they had to make an appearance. I went back to my various books and skimmed through all the photos, leaving my mind open to ideas. While looking at the *Abbey Road* album cover, which at that very moment I'd forgotten that my client had specifically mentioned, it struck me that the band's body language as they were striding across the striped crosswalk was the central element of the picture. I realized that I could limit my depiction to their legs crossing Abbey Road and

the viewer would instantly recognize this iconic shot. In other words, I could depict The Beatles without showing their faces. This meant no portraits would compete with Lennon's.

I returned once again to flipping through the photo books. When I hit on images from the animated film *Yellow Submarine*, it struck me that this was yet another way to show the band without having to use portraits of the other lads. And it wasn't lost on me that reproducing cartoon versions of the four Beatles would also provide contrast to the more realistic portraits of John (and Yoko). By the time I added the Abbey Road and Yellow Submarine scenes into the lettering, and kept them of a size to allow for engraved detail, *Imagine* was full.

You might be wondering about my client's reaction. The guitar was shipped overseas, and I waited many days for word that it had arrived safely—and to learn if my client was pleased. I didn't have to wait too long, though, before receiving translation of a wonderfully heartfelt letter of thanks he'd composed. And I was told by the translator that when my client had opened the case and seen the guitar for the first time, he was overcome with tears. I like my job. ✖

Blue 2009

What follows is the full extent of my exhaustive and detailed notes on this tenor mandolin project: "Surfing theme! Water! Him? Brother? Children?"

Instances such as this, where I am given the theme and little else in the way of direction, are rarely a reflection of a client's lack of imagination. More often it's a compliment to me; it's an expression of their confidence in my ability to come up with something they'll like from the barest of suggestions. Or, as this client put it: "From what I've seen of your work, your imagination is plenty to go on. So I put the process in your hands."

My client's initial musings about including himself and/or his brother or children as surfers were eliminated from consideration when he confessed that he was travelling so much that he'd not be able to gather — or take new — photos for me. So, with few restrictions and the most minimal direction, I began. I didn't just research images about surfing, I also started reading accounts from people who chased the big waves, specifically those waves that have become powerful over long ocean distances: ground swells, or colloquially, mackers (big enough to drive a Mack truck through!).

The more I saw of these huge waves, the more two aspects stood out for me: a definite blue/green tint to the darker parts, leaning a bit more heavily to blue, and the striations of the water flow. The streaky appearance, I immediately realized, would provide me with the opportunity to represent reality simply by layering my materials in thin, curved strips. Another feature of these waves is their massive dimensions relative to the surfer. I knew I'd need to convey that size and power to the viewer. The very simple solution to that was to allow the wave to occupy pretty much the entire headstock. Showing a surfer as just a tiny figure, tucked into a low corner and seemingly overwhelmed by the curling wave, would reinforce those proportions. This design felt fine but for the fact that the scene was restricted to the headstock, and I wasn't seeing a logical or appealing way to have it cross the nut barrier, as I usually prefer. I let this idea simmer while I contemplated the fretboard.

I was skimming through more images of surfers in action when I began involuntarily to think of the term *macking*, which was new to me. The fact that it referenced a Mack truck was amusing. However, my brain, which generally loves to pun, had turned *Mack* into *macro*. Which naturally led me to *micro*. Macro. Micro. I glanced back at my roughly sketched idea for the headstock, where the surfer was just the littlest figure. Micro! It only made sense, then, for me to go macro (relatively speaking) with a surfer on the fretboard. I went back to the surfing images, seeking a captured moment that would convey the human action as a complement to the wave action I'd featured in the headstock. And, of course, I'd depict the surfer as large as possible. Macro!

I suppose the fact that I'd begun thinking in opposites — micro/macro, wave action/surfer action — was why another set of contrasts occurred to me. I had already recognized the appealing blue tint in the wave and knew that I'd do my best to recreate that with shell, stone, and some minor tinting. I'd decided that depicting the surfer as a black shadow would provide a striking contrast. However, that was only the start. It struck me that if the wave leaned to blue (and the surfer was black ebony), then I'd flip it on the fretboard. The surfer would be blue (clear turquoise) and the black ebony surrounding him would be the water, in all its splashing exuberance. Blue wave, blue surfer. Blue. **x**

JATP49 2009

I was building this guitar to take with me to the Montreal Guitar Show, which was always presented as part of the prestigious Montreal International Jazz Festival, so it seemed appropriate to think about a jazz theme for the inlay art.

I confess I don't listen to a lot of jazz, but one artist has never ceased to astound me — the pianist Oscar Peterson. Four things conspired to make me want to pay tribute to him. One was that Peterson is considered one of the best jazz pianists of all time, and secondly, he was Canadian. Another was that I am always moved when I hear his music (whereas much modern jazz leaves me cold). And the final thing was that I'd always felt a piano and player would make an interesting inlay. I did depict a pianist once before, in 1998. But though I liked that version, where a pianist and keyboard are seen in only the headstock and the first fret, I have always wished for a chance to do it differently, more boldly. Why not now, I thought.

Further back than I can recall, I remember attending a concert and staring at the neck of the performer's guitar and suddenly picturing the pattern of the fretboard, with its semi-tone divisions of fretwire making vertical cuts, as if it were a piano keyboard. It didn't literally resemble a keyboard, of course, but its pattern reminded me of the regularly divided keys. That image had stayed with me over the years, and I realized I now had my chance to overlay a piano keyboard onto a guitar neck and recreate the image across the entire playing surface.

To balance my bold approach to the image of the keyboard, I would take a similarly bold approach to my design of Peterson himself.

Instead of seating him at a piano, which would be redundant, I decided to focus on a portrait. I sifted through dozens of great shots of Peterson and settled on one where he had just the hint of a smile and a gleam in his eyes. My tasks were then twofold: to size and position this portrait until it fit snugly onto the headstock with his important features avoiding the tuners; and to redraw the image, delineating the colours and shadows in each of the various sections. This I did simply by observing Peterson's face closely and making judgements about which parts to make darker, which lighter, which to leave in deep shadow, and which to have picking up the light.

For the keyboard, it was immediately obvious that if I placed it on the fretboard at a perfect right angle, the narrow lines separating the keys and the positions of the frets would compete with each other and confuse the viewer. My solution was to tilt the keyboard just three degrees so the key divisions were off parallel. As I was doing this, it also struck me that since I had chosen to not depict Peterson sitting at a piano and playing, perhaps I could have him playing my keyboard. I searched through close-up shots of his hands in performance, selected a set, sized them to my keyboard, and sketched them into their true positions. (I didn't ever want to hear someone remark, "Oscar would never have played a chord like that!")

My initial intention was to reproduce his hands with shell and stone, similar to my plans for his portrait. But the more I looked at the keyboard, and the more I began to picture his hand positions forming a chord, the more

I saw that it would create an appealing contrast against the walrus ivory keys if they were in shadow, as if they'd emerged out of the ebony portion of the fretboard. So that's what I did.

I call this inlay JATP49, the acronym for Jazz at the Philharmonic, 1949. From 1948 through 1983, jazz impresario Norman Granz presented concerts, initially at a California venue called the Philharmonic Auditorium but ultimately around the globe, featuring the jazz greats of the era. During a cab ride to the airport in Montreal, Granz heard Peterson playing live on CBC Radio and told the cabbie to turn around and take him to the club where the pianist was playing. Granz was so impressed when he saw Peterson play live that he wanted to invite him to New York to be a part of his JATP concert series. The upcoming concert, at Carnegie Hall, was too soon for Granz to organize all the paperwork needed to get Peterson across the border and formally book him, so he instructed him to simply travel to Carnegie Hall on his own and sit in the audience. At a suitable point in the show, Granz would throw out an invitation to any musician in the audience who would like to come up and jam with the band (Charlie Parker, Buddy Rich, Roy Eldridge, Lester Young, and Ray Brown) and Peterson could volunteer. According to *Down Beat* magazine at the time, his performance "stopped the concert dead in its tracks."

This concert marked the beginning of Peterson's international renown. Inlaying JATP49 was my way of acknowledging that pivotal moment. **x**

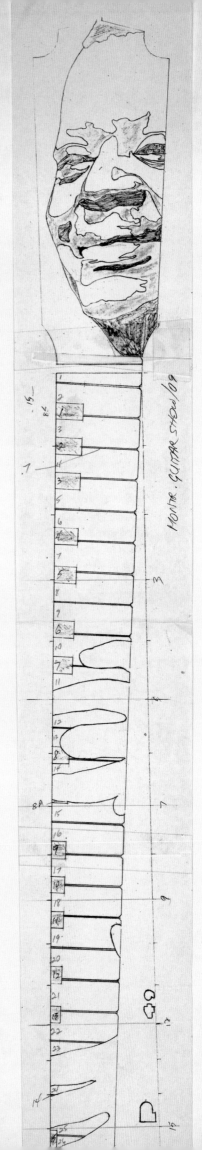

Haply I Think on Thee 2010

When the theme is very general, or an all-encompassing subject, I have as many conversations as possible with my client, trying, as I've said before, to distill their novel's worth of ideas down to a focused narrative. Here is another of those instances where the theme could head me off in multiple directions.

My client was inspired by a recent visit to the newly rebuilt Globe Theatre in London, England, and had decided on a William Shakespeare theme. The mind reeled: characters from the Bard's plays? His sonnets? His acting company? His life and times? Where would I start?

The emails and phone conversations with my client stretched over four months. That process didn't result in a definitive overall design direction, though it did confirm elements that my client wanted me to consider incorporating:

— The Globe Theatre (originally constructed by Shakespeare's performance company).

— A portrait of Shakespeare.

— Elizabethan costume.

— "*A Midsummer Night's Dream*, with all of its rich imagery of gardens and forests."

— "The words, from the sonnets as much as the plays."

— A quill writing some line of greater meaning to my client.

Some of these instructions were clear and specific; others were simply thoughts, indicative of what my client found appealing. Together, they formed my starting point.

As is my habit, I began by reading all I could about the subject: William Shakespeare, his personal life, his writing, his company of players, the politics and social mores of his era. Information was easily found, and I relished exploring and learning—and discovering. I left my mind open to any and all ideas that might occur while reading and viewing the images. What surprised me was that no collection of Shakespeare's plays was published in his lifetime. The famous title page to his folio *Comedies, Histories & Tragedies*, with the iconic engraved portrait, was the first published collection, and he wasn't alive to see it. I encountered this fact very shortly after viewing pictures of his birth house in Stratford, which must have been about when the birth-to-death narrative arc first occurred to me.

My client and I shared the same idea of placing a full portrait of Shakespeare in the headstock. I pictured his birth house somewhere behind him in the scene. Thus would begin my narrative, at the very top of the headstock, all going well. First, though, I needed to select one of the portraits.

Some years before, out of curiosity, I had read a book titled *Shakespeare's Face* by Stephanie Nolen. This book told the story of the 2001 discovery of what appears now to be the only portrait of Shakespeare painted during his lifetime. The small canvas, painted by a John Sanders and examined and tested and ultimately authenticated over the last fourteen years, is now simply referred to as the Sanders portrait, and it has become the hot topic among Shakespeare scholars. Particularly amusing to me was that it was (re)discovered in the private home of a descendant of Sanders: Lloyd Sullivan, of Ottawa, Canada. How could I not use the Sanders portrait for my inlay? It held the perfect mix of intrigue and Canadian connection.

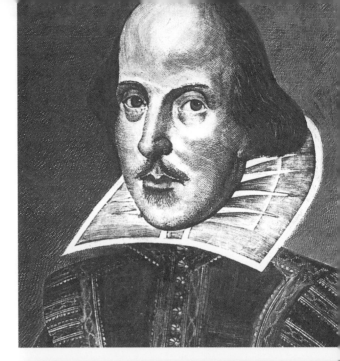

The cover of the first folio collection of Shakespeare's plays, published after his death.

Lord Chamberlain.

The John Sanders portrait.

With the portrait and a view of Shakespeare's birth house in the headstock, my coalescing narrative then sent me to the end of the fretboard — the end of the story — to include something connected with his death. This was the moment when I reminded myself that the famous first folio collection of his plays was published after his death. I looked again at the folio's cover page. It had the bonus of the engraved portrait. (We now know it very likely doesn't resemble him, especially in light of the Sanders portrait, but the image has been identified with him for more than four hundred years, so it wasn't easily ignored.) I made a photocopy of the cover page and began playing with angles as I positioned it on the fretboard until I found the sweet spot where enough of the title text and the engraved portrait were in view to be recognizable.

It appeared that I had my bookends to the story. It was now time to think about the middle. In fact, some of the middle story (which I was now thinking of as the second act of the play) had already been suggested by my client. He proposed including the rebuilt Globe Theatre and had sent me some photos he'd taken during his recent visit, although they didn't quite show enough of the thrust stage and its pillars, the open-air wooden construction, etc., the key aspects of the theatre. But while searching online for additional views, I stumbled upon engravings and woodcuts of the original members of Shakespeare's acting company. I recalled this troupe being called the Lord Chamberlain's Men, but could I find a portrait of this lord? Sure enough, there was more than one portrait. I liked the idea of including the man who had essentially financed Shakespeare, and I wondered whether there was anyone else critical to the theatre that I might include.

I went back to the description of the actors in the company. Perhaps I could show one of the men dressed as a woman? Maybe. Could be fun. Then I read about Richard Burbage. This man premiered more of Shakespeare's leading roles than any other actor. However, there were no images of Burbage in the books I had. I went online and found one single portrait — but one was all I needed. I sketched in Lord Chamberlain and Burbage on either side of my selected view of the Globe. Given that they represented two different but no less critical aspects of the functioning of the theatre and its acting troupe, I liked the symmetry of placing them alongside the theatre.

It was time to take stock. I had covered Shakespeare's birth, put in a symbolic connection to his death, and included his authenticated portrait as well as his most iconic image. The Globe was there, along with his patron and leading actor. Was I done? I returned to my earliest notes, as well as the stack of printed emails from my client, and was reminded that he had ultimately settled on a line from Sonnet XXIX that he wanted me to incorporate: "Haply I think on thee." I selected a font actually called "William Shakespeare." Created by The Walden Co., it was florid but seemingly authentic. It would make for an attractive graphic. I was playing with its size and the location of the wording when another memory popped up.

It appeared that Shakespeare's earliest published work was not one of his plays but one of his poems, titled *Venus and Adonis*. So, it occurred to me that if I showed the title page of that publication and slipped it behind/beneath the quoted phrase from Sonnet XXIX — and placed it between the headstock portrait and the Globe Theatre section — I would more convincingly, more completely, create my narrative arc. x

Music Never Dies 2010

Certain commissions begin with a varied and wide-ranging set of possible themes, all of special import and meaning to the client, but on the surface at least, disparate and unconnected. The inlay for this client was one of those commissions. It was going to be very personal and would clearly incorporate multiple themes — all going well, that is.

"I've pushed a lot of thoughts your way over the past couple of days," my client began in an email some days into our discussion process. At this early stage, the following elements had been emerging:

- He regularly travels to China, to teach English and music.

- China.

- Art.

- Ming Dynasty style?

- 1920s Western art.

- Adventure, travel, taking risks (heavily underlined in my notes).

- Draw a theme from one of his poems or songs, illustrate the theme? Use actual text as part of the art, as in Chinese and Japanese fine art.

- His wife, Cheryl.

- Pochoir prints by George Barbier.

- Mission-style furniture.

- Frank Lloyd Wright.

Then, this, from my client in his email: "Through all the complexity of those thoughts I would just say that as I get older there is a growing desire for simplicity."

At this stage, given his comments, I was really unsure of where to begin. I couldn't get a handle on what the underlying narrative could be. My client had described some of the art he collected (pochoir prints), the many photos he'd taken in China, objects he'd acquired on his travels, books of his poetry, etc. Given that he lived only an hour away, I decided to pay him a visit. I'd have the chance to see his home and his art, and, by meeting face to face, I would get enough insight to be able to find my route into this design.

And I did.

One of the first things I learned was all about George Barbier. He was a French illustrator from the early twentieth century, whose work and style of drawing became synonymous with theatre and ballet costume design and, most importantly, haute couture fashion illustrations. He was an early star of the Art Deco movement, and prints of his fashion designs used the latest pochoir (stencil) process, delivering clean lines and vibrant colours. My client owned a number of these original prints.

Our meeting also provided me with the chance to hear at length about his frequent travels in China, his experiences there teaching Chinese children English and singing to them, and his admiration for much of the country's history and culture. While listening to him speak, I began to understand what lay behind his words *adventure, travel, taking risks*. In very real ways he frequently experienced all of these, and felt somewhat driven to pursue them as life goals rather than as experiences.

As we toured his house, I took photos of the art on his walls, having no idea if any piece would turn out to be important. Before leaving, I was handed copies of his poetry to take home with me.

EC LES FILLES DES ÉLÉMENTS OU DES MORTEL;
LLO DESCENDAIT DE LA SCYTHIE, OU ELLE S'ÉTAI
EVÉE JUSQU'AUX SOMMETS DES MONTS RIPHÉES, E
RÉPANDAIT DANS LA GRÈCE, AGITANT DE TOUTE
RTS LES MYSTÈRES ET PORTANT SES CLAMEURS SU

Left George Barbier prints.

My client's photo of one of
his young Chinese students.

Facing Chinese characters
as drawn by my friend.

That evening, I sat down with his poems and
began reading, searching for a key phrase (or
theme?) in the texts. I read through everything,
just to be sure, but early on I had encountered
the line "Music never dies," and no other
phrase stood out with such perfect declarative
intensity. These three words summarized not
only a general truth but also a truth of particular
relevance to my client, whose singing carried so
much meaning in his cross-cultural adventures.

My client had requested that I incorporate
text into the art, but didn't dictate how. My first
thought was to explore the approach I'd used
in the *Imagine* guitar (page 64), in which the
outlines of the letters become the frames for
the imagery and the text phrase becomes the
underlying, linking theme. Given my client's
interest in Barbier's prints, I started my font
search with the Art Deco period. Many of the
decorative fonts designed in the early twentieth
century were too narrow or flowery for my need,
but some heavier fonts, such as the Italian-
designed Mostra, were closer to what I wanted.
In the end, I just took inspiration from this style
of Art Deco fonts and sketched out a variation
of my own.

I had the spine and frame of my theme, based
on his poetry, but still no focus on exactly what
would fill that frame. In an earlier conversation,
my client had said: "One day I will move to a
place where I can see and hear water, a place
where I can see the stars more clearly and
where mountains in the distance remind me
of challenges conquered and challenges yet to
overcome." This eloquent statement remained
in my mind as I sifted through the design
possibilities.

I made the firm decision to include his wife.
I also wanted to portray one of the Chinese

children he had taught. In particular, I'd asked him to send me a photo he'd shown me of a little girl whose head was covered in Post-it notes, each of which displayed the English word for her corresponding feature. Still assembling content, I took a closer look at Barbier's prints in some Art Deco books I owned. One print in particular, a very stylized portrait, also showed mountains in the background. I thought of my client's recent statement, and set the image aside.

At this point I found myself thinking more about the China connection, about my client's travels and work there, about his suggestion to include "adventure, travel, taking risks," and lastly, about the concept of text within the art. All of these thoughts bumped around in my mind for the better part of a day before they coalesced into a single idea: to include Chinese characters in the design. One or two characters could sum up a complete idea or concept. I realized I could use them to describe some of my client's qualities while clearly symbolizing his connection to China.

It wasn't hard to locate Chinese language sites, plug in possible English phrases, and see what Chinese characters would translate them.

After some trial and error, I opted for symbols that described these key aspects of my client:

— Willing to take risks, or be involved in an adventure.

— Teacher.

— Able to compose music.

To be absolutely certain that I had the correct character sets, I had a Chinese friend check them for me. I was glad I asked: she had me change one character of the three pairs to more definitively clarify my meaning.

Once again I took stock of what I had on deck for the design:

— The underlying theme from a line of his poetry, depicted in an Art Deco font.

— His wife.

— A Chinese student.

— Chinese characters describing my client's character and attitude.

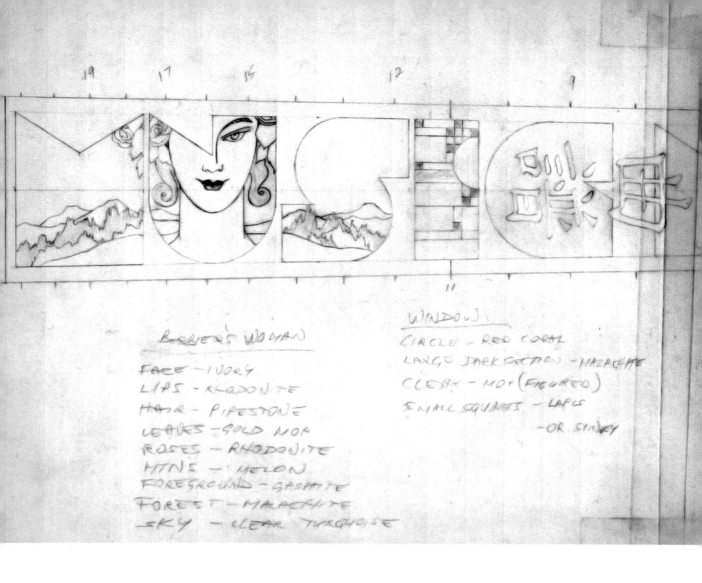

In reviewing points from our earliest discussions, I was reminded to include something from the architect Frank Lloyd Wright. I was familiar with Wright's work, having toured some of his houses near Chicago. I also owned books featuring his designs. While perusing these books, I realized some of the letters of "Music Never Dies," specifically the two i's and the one v of the heavy font as I drew it, were very basic geometric shapes not dissimilar to the angular geometry of Wright's furniture, windows, and decorative trim. My next thought was that the three letters could be filled as if they were stained-glass windows, in patterns drawn from those created by Frank Lloyd Wright. The "frame" was filling in.

It was time to return to Barbier and to make a firm decision about which of his pochoir prints I could incorporate. I revisited the one I had set aside, with the stylized woman's head and the mountains in the background.

The more I looked at it and imagined how I could draw it into the design, the more I realized my instincts had been correct. The last comment from my client, about one day living near water where he could see the stars clearly and where distant mountains were visible, came back to me. By using this particular print, I could represent not just an artist my client felt a passion for, but also something from his life's wish list. To incorporate his other two wishes, I first turned one of the letters into a view of the night sky. For the other I used a shell laminate, ribbon awabi, whose tight layering creates an undulating surface that resembles water in daylight. Instead of having the base of the ebony fretboard and headstock veneer show through, this shell encases the letters of the entire layout, a quiet symbol of water for viewers to discover.

In the end, with this very personal design, I felt I had captured much of what was important to my client, in essence telling a story of his life. **x**

Three Wise Men 2010

"The only idea currently floating around my head is a hand in a peace sign shape." This emailed sentence from my client followed a phone conversation during which he had given me the inlay theme of "peace." (This is the commission I referred to in the preface.)

The concepts for this design actually developed much quicker than usual. It had only been a few months since I had completed the *Imagine* guitar (page 64), so I was still very conscious of both its design approach and its theme. As soon as my client said the word *peace*, another of John Lennon's songs, and specifically its refrain, "All we are saying is give peace a chance," immediately started playing in my head. And when my client said he envisaged a hand forming a peace sign, in my mind's eye I saw it as a sizeable shape that could be filled with other images very much as I'd done with the letters of the word *imagine*.

My first step was to outline the peace sign, which was easily done by modelling my own hand. Who to place within the shape came to me almost as easily. Both anti-apartheid activist Nelson Mandela and the Dalai Lama, the spiritual head of Tibetan Buddhism, were still frequently in the public eye when I asked myself, who are strong symbols of peace? There are, of course, many, many people of both sexes who dedicate themselves to making the world a more peaceful place, but these two men stood out for me because of their global reputation, making them instantly recognizable to most people. In our time, Mandela has been seen as the epitome of racial and political peace-making; the Dalai Lama is his equivalent in the sphere of religious tolerance.

I returned to the refrain from Lennon's song and tried to visualize how I might show the lyrics. Inlaying a continuous band of shell all along the fretboard then engraving the music and lyrics as they would appear on a sheet music score was one thought. I had taken this approach many years ago with a section of classical music, so I knew how it would appear. Still, it didn't excite me. Perhaps I could simply inlay the lyrics and, if possible, create a font based on Lennon's own writing. I found images of pages from Lennon's notebooks and random song drafts online, some of which had writing clear enough to make the text decipherable. This was certainly a better idea. However, as I dwelled on the lyrics, I found myself focusing on the "we" of "All we are saying." Lennon himself had clearly heard a crowd of voices singing this line together when he wrote and recorded it, and I wondered how I could evoke a larger group expressing itself. A collective action? A peace march, maybe? Yes, people hoisting placards and signs, or maybe just the placards them-selves, expressing Lennon's lyrics. I could make each placard different, symbolizing different people, different voices, being sure to show enough of the wooden handles that it would be clear to the viewer what they were seeing.

It was almost an afterthought to include Lennon's portrait. Yes, for some his words would have been enough. But I decided it would be prudent to reinforce the authorship so that even those less familiar with Lennon's music (and political activities) would be in no doubt as to their source. I had been thinking of calling this inlay *Two Wise Men*. Now it became *Three*. **x**

Humpbacks 2010

I have included this more basic inlay with the more complex projects for a couple of reasons. For one thing, it's a minimalist approach to the subject—very much as the client requested—and as such is in quiet contrast to most others you've seen in this book. Think of it as a visual palate cleanser, providing your senses with a break from the denser imagery. The other reason, and perhaps the key one, is that despite its minimalism, it still succeeds in telling its story.

This client's ancestral home is on the North Atlantic coast where humpback whales are common, and so they hold special significance for him. He conveyed his own ideas about how to depict humpbacks in the design, mentioning a tail fluke (or two?) and "picturing the whale being nearly as long as the fretboard."

With his "minimalist" instructions as my guide, I went in search of humpbacks. There was no lack of great imagery to be found. When humpbacks dive, their flukes flip up; when they surface, their backs are visible; when they're moving underwater, they're seen in full.

As I scanned photo after photo, it became clear that an above-water tail fluke had to be in the design—it's such an iconic and powerful image. But I also knew I had to include another whale, ideally shown in full, given my client's suggestion of filling up a large portion of the fretboard.

Combining these two images seems simple enough in theory, but on the narrow canvas of the neck—really just a slotted view of a scene—how would I maintain the visual logic of both above and below the water's surface?

Complicating things further, I felt obliged to create a horizontal orientation to the design, seeing it as my only way to successfully present a full-length whale. The downside to this choice was that I had almost no vertical depth. So, how to show the underwater and overwater scenes simultaneously? Tilt the horizon line. The tail fluke above the water surface could be in the headstock; the fretboard would be the underwater scene.

Staying true to my client's wish for minimalism, I decided to indicate the mammals primarily in outline. For the tail fluke on the first whale, however, I knew that showing cascading drips of water would add drama while helping to delineate its shape. To achieve a realistic effect, each of the more than 120 tiny droplets was cut from a different piece of mother-of-pearl. The many reflective angles, in addition to the natural colour variations, create a shimmering effect, not unlike cut jewels.

By imagining the second humpback as being relatively near the surface of the water, I could rationalize daylight penetrating the water and casting a diffused natural light over its back. Then, to help further delineate its shape, I could use lapis, a stone whose shade can be so dark blue as to be nearing black, to represent the transition to the underwater darkness.

When the inlay was completed, I stood back about two metres from the neck, and with that distance I truly got a sense that I was seeing these two mammals in their natural habitat. It may have been a minimalist approach, but in my opinion, and more importantly my client's, it succeeded. ✘

- SKY - TURQUOISE
- BACKGROUND - EBONY
- WATER - DRIPS - MOP SPLASH
- TAIL HIGHLIGHT - AWABI
 RIBBON

O'ahu Waterworld 2010

I have never been to Hawaii, much less snorkelled in its lagoons and coral reefs, so when my client's instruction was to inlay "the creatures of the Hawaiian sea," and specifically those that could be found around the island of O'ahu, not one single example of animal, vegetable, mineral—or fish—immediately came to mind. My client's subsequent bit of guidance was simply: "Whale, dolphin, sea turtle, tropical fish, etc." As the saying goes, I had my marching orders.

I did some research and learned that the humpback whale swam through this region. I also found O'ahu's varieties of coral, specific family of sea turtle, and a sampling of smaller fish species. Sea horses thrive in the region, as do dolphins. My list took shape in fairly short order.

Hardly had I begun to think of a layout, though, when I realized there was only one way to show the many undersea creatures. For a start, the orientation had to be vertical, and most of the scene would be as if underwater. But to visually reinforce that conceit, I soon understood it would be helpful to have an above-water portion as well. In fact, I kept coming across photos of playful dolphins, jumping high into the air. These jumps (also called "bows") are part of a dolphin's natural behaviour, and I learned that they are done not just to be playful but to scout the environment looking for predators or flocks of birds feeding on fish that could be the dolphin's own next meal. A jumping dolphin would certainly supply some visual drama. And placing it in the headstock would logically locate its corollary, the sea floor, covered in coral, at the opposite end of the fretboard.

When positioning the other creatures—fish, turtle, whale—between these two locations, I knew I would have to play fast and loose with reality. The humpback couldn't be in proportion to the other species on my narrow canvas. If it were, the section of its body in view would be so tiny you'd be unable to identify it. To make it work, I angled and sized it so that its eye, its striated underside, and one of its flippers were fully in view. I depicted it at maybe a fraction of its real size relative to the smaller creatures, but on the inlay it remained the dominant animal. That aspect fairly reflects its position in the ocean's hierarchy. At least, that's how I rationalized it.

The corals that bookend the design weren't a specific request from my client. I chose to incorporate them not only because they gave me the ideal frame for the scene, but also because these marine invertebrates are at risk in many regions of the world. It was my chance to remind people of the contrast between the beautiful colours of living corals and the washed-out whiteness of dying reefs. Of course, I have no idea who might see this guitar, other than its owner, so my tiny contribution to ocean environmentalism may be wholly irrelevant—except to me. **x**

1964 2011

I was ten years old on February 9, 1964, when The Beatles made their first appearance on *The Ed Sullivan Show*. In that era of limited television channels, no other show in that time slot had the viewer reach of Ed Sullivan's. And on that particular evening, North America got its first glimpse of England's "four lads." Like me and 73 million others in the United States alone, my client, then aged fourteen, sat mesmerized in front of his family's TV set as The Beatles performed five songs over the course of the hour. His life changed that night —or as he put it, he became "guitar crazy."

He described that pivotal moment so eloquently in his letters and emails that I'll let his own words speak:

> The Beatles looked excited by their music and the whole world was about to fall under their spell. Remember that the USA was in a real saddened state since our most beloved President Kennedy was assassinated in November 1963, just months before The Beatles appeared on *The Ed Sullivan Show*. We really needed something to help us out of this emotional frump. I will never forget the sound of the guitars and the bass. I was especially struck by the way George "up picked" the intro to his solo on "All My Loving" and the way John strummed the ¾-sized Rickenbacker. I have never gotten over the sound and I swear I hear that music in my mind every day.

One month after The Beatles' appearance, my client's fledgling folk group learned all the Beatles songs they could and switched to electric guitars. Two years later, his parents bought him a Gretsch guitar, exactly the same

Country Gentleman model played by George Harrison. Eventually my client owned each of the guitars that The Beatles had played in those early years, adding to his collection a Rickenbacker and a Höfner bass. And so it was that as we discussed the inlay theme over many months, and as we inevitably settled on a theme based around The Beatles' first *Ed Sullivan* appearance, I came to understand how deep his guitar craziness went, and how it has fired his passion for music and The Beatles over the decades.

My client had another interesting link to The Beatles' appearance on the *Sullivan* show. His parents happened to own a high-end, professional reel-to-reel video recorder, and they had recorded that original show. The act of his parents' recording remained an important memory of that night, and my client had described it to me in the hopes that either the concept of the taping or the actual recorder might somehow find its way into the design. At this point I hadn't the slightest idea if that might work—hadn't the remotest idea what shape the inlay might take overall—but I noted his comment.

I began receiving photos from my client. There he was in his first band. And there was a picture of his first guitar, a Harmony. He also forwarded images he'd captured from a video of the *Ed Sullivan* appearance and described why some shots were his favourites. In the interim I had picked up a few coffee table books on The Beatles, choosing those that contained archival shots of this *Sullivan* show appearance. At one point my client commented that his favourite photo showed John Lennon, Paul McCartney, and George Harrison lined up at their vocal mikes; Ringo Starr was nowhere to be seen. Said my client: "I know that people will ask 'Where is Ringo?' so maybe we could have him running

My teenage client performing
in his first band.

off the back of the headstock, just a pair of feet
and some crossed drumsticks?" My client was
being somewhat facetious, but at some level I got
the message and ultimately gave Ringo a quirky
placement. But I'm jumping ahead of myself again.

I was now amassing a great variety of potential
elements. The file on this guitar, with my pages of
notes, printed emails and letters from my client,
photographs, and books, was substantial. I had
a theme, and I had more than enough content.
Yet after all of this, after all the stimulating
conversations with my client, I still didn't know
how I'd put it all together. What was the spine of
this story? As is so often the case, I sensed the
answer was right in front of me, but I still had
to find my way to it. I began by re-reading every
word in the file and scanning every photo. I sat
down with my books and revisited every image
I'd already viewed, staring intently at details, yet
leaving part of my mind wide open to any idea, no
matter how wild or impractical. Many of the shots
of The Beatles on the *Sullivan* show featured the
three front guys, each with a guitar hanging from
his shoulder, and it seemed to me that the guitars
were getting equal billing. Perhaps it was that

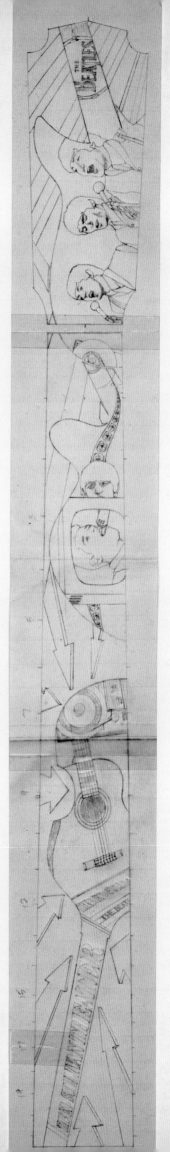

impression that sent me back to my client's own words, describing himself as guitar crazy, explaining his thrill at owning each of the same guitars as The Beatles played.

The guitars! Why I didn't see this narrative spine sooner, I'll never know. I'd use the silhouette of the three guitars played by The Beatles on their first *Sullivan* appearance to fill the neck, and within those shapes I'd insert the bones of the story. And to mirror their stage positions, Lennon's Rickenbacker would be to the right (viewing the neck horizontally), McCartney's left-handed bass would be on the left, and Harrison's Gretsch would be in the centre. As I began sketching possibilities, I was whittling down the other elements. I'd depict The Beatles as they appeared that night. My client's parents' tape recorder (a Roberts) should appear. My teenaged client himself, singing in his band, would be important to include. I stopped there for the moment and began to sketch in these elements.

While fitting The Beatles into Lennon's Rickenbacker, I was mulling over how I'd get my client into this story. Portraying his own band felt inappropriate given the presence of The Beatles. But I absolutely wanted him there. In a lower corner of one of the backstage shots from the Ed Sullivan Theater, I spotted a big, clunky camera monitor with a shot of The Beatles on its screen. Something about that monitor, the way it spoke of the era… I knew that I could put my client's portrait onto the very screen that should be reflecting The Beatles. It would be both a symbolic and a playful placement—my kind of inlay.

While gazing at the long, narrow silhouette created by the neck of Paul's Höfner bass, I wondered if I could orient my client's Harmony guitar so its neck pushed into the space. I decided it would look incongruous with the two similar shapes overlapping, but I could flip the Harmony so its neck's contrasting position would be easier to discern. I did that. But I was still stumped about the bass neck area. I went back through my books yet again, this time stopping at an image of the marquee on the Ed Sullivan Theater I'd previously passed by. I suddenly recognized the lettering on the sign as a long, thin shape… I sketched it in and then stood back from my drawing. While I never take the approach that every square centimetre of the design needs to be filled, I was getting the feeling that I'd left too much empty space around the guitar shapes. Although I had told my client's story, it still felt incomplete.

I had a look at some of my raw materials, imagining laminated figured shell or grained stone filling the space though not contributing to the story. But that didn't seem to be the answer, and in these situations I trust my instincts. I had begun thinking of the space that still needed to be filled as the background to the guitars. And the word *background* reminded me of some of the very odd stage backdrops that were used behind The Beatles' appearance on *Sullivan*. I say backdrops, plural, because when the band returned for the second half of the show, the stage set had changed. During the first set, above and beside the band there had been some long, narrow, light-coloured strips, perhaps ten inches wide (at a guess) that emanated from behind them like rays of light. Later in the show, giant arrows as big as the old Austin Minis surrounded them. And it was these hokey but era-defining backdrops for the show that became my backgrounds for this inlay. **x**

The Blue Trumpet 2011

After a two-year absence, I was returning to the Montreal Guitar Show. When I attended in 2009, I had brought the guitar I call JATP49, my tribute to Oscar Peterson (page 70). Jazz was in my thoughts as I was considering what to build for the upcoming show, and I was thinking about artists from earlier eras whose music I admire. One of them was trumpeter and singer Louis Armstrong.

To pay tribute to Louis Armstrong, I wanted to take a similar approach to the portrait I'd done of Oscar Peterson, where his face filled the headstock. It's only the recent invention of laminated shell sheets as well as the introduction of Recon stone to the guitar world that makes these kinds of very large portraits possible, so I looked forward to the chance to use them once again. But first I needed to find the right image.

I sifted through the many extant images of Mr. Armstrong, looking for one that captured his irresistible gap-toothed smile. I found one I liked and set it aside, but then realized that I had jumped onto the idea of the portrait without giving much thought to what the whole inlay would be about. My initial thought was to show him playing his trumpet—or to at least show his hands on his trumpet. One day I was in my workshop listening to CBC Radio One and using my laptop to find and sift images, when the host of the radio show introduced a young female singer and I heard the opening chords to her version of "What a Wonderful World."

Almost everyone knows that Louis Armstrong was the first person to record that song (in 1967), and his version is still as popular as ever—not surprising given his utterly engaging voice. While the woman sang, I sat in my shop and wondered how I could work this song into the design. I began by digging a bit deeper into the song itself. I learned that the co-writers, Bob Thiele and George David Weiss, had first offered the song to Tony Bennett, who turned it down. (Something Mr. Bennett has stated he regrets to this day, although he recorded his own version years later.) I had a look at the full set of lyrics. There were some great lines:

The colours of the rainbow so pretty in the sky
Are also on the faces of the people going by

A perfect description for a multi-racial society.

Or:

I hear babies crying, I watch them grow
They'll learn much more than I'll ever know

Doesn't that encapsulate the ever-increasing pace of change?

But the more I thought about the song, the more I kept returning to the title, "What a Wonderful World." It makes a statement about how we all must feel from time to time, and its optimism is as infectious as Armstrong's voice.

I sketched out the title in script, then in a serif font. Neither felt right. When I changed to a bold, sans-serif font, it felt more declarative, more confident. And when I looked at the dimensions of the lettering, I realized it would create enough space for Armstrong's trumpet and hands to be seen, almost as if the lettering were made of glass and the viewer were peeking through.

With the design settled, I then turned to the materials. For the trumpet, my first instinct was to use actual metal. The Dix gold used by apprentice jewellers would certainly resemble brass once it was inlaid and sanded.

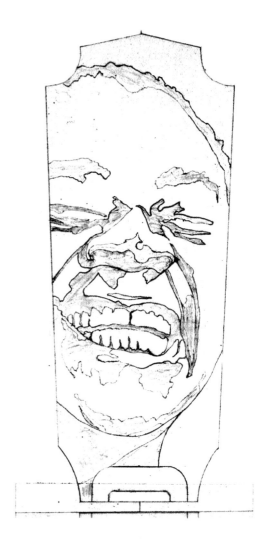

But my plan to stretch the colouring on Armstrong's portrait, using a hot shade of red for his hair and facial shadows, meant that I should carry this interpretive colour sense to the opposite end of the design for balance. Ultimately, I chose to depict his trumpet with Mexican turquoise. It was the coolest of the blue shades in my palette. And the hot red and the cool blue were colour tones that I felt represented the breadth of Louis Armstrong's music. **x**

The Impossible Dream 2011

I don't build archtop guitars. To me, these guitars, whose top and back are carved into an arch similar to violins and cellos, are a different species. I get all the challenges and satisfaction I need from building steel-string, classical, and flamenco guitars. (These are known as flattop guitars, even though their top is gently arched. The arch effect is created by lightly pressure-gluing the top rather than carving it from a solid wedge of wood.) But that doesn't stop me from admiring archtops and appreciating their uniqueness. That was why, when the conversations with my client headed us in the direction of archtop guitars and their legendary builders, I was intrigued.

In our email and phone discussions, my client began by explaining his love of archtop guitars and jazz. At the same time, he said, simply, that he likes faces, and that he loves when I tell stories with my inlay. Through successive conversations it also emerged that he liked my use of humour. Ultimately, we settled on finding a way to incorporate three legendary archtop guitar builders: John D'Angelico, Jim D'Aquisto, and John Monteleone.

The more we discussed concepts, the more some quirky possibilities began to emerge. One that stayed with me: "guitars from these legends for sale with ridiculously cheap price tags." That's somewhat of an inside joke, as these guitars are among the most expensive in the world.

I carried these ideas in my head as I began my search for images. D'Angelico died in 1964, so the photos of him were nowhere near the quantity you'd find in our era. Still, there were enough of him at his workbench or in front of his retail shop that I felt gave me possibilities. When it came to D'Aquisto, who died in 1995, I had a lucky source for images. My luthier pal

Linda Manzer had spent a number of months working with D'Aquisto in his New York studio, and she kindly sent me a CD of all the photos she'd taken. John Monteleone is still alive, so finding appropriate views of him online was not a challenge.

I had a collection of images, of these luthiers and their guitars, but I had yet to work out a way to put them all together. I didn't have a story. I re-read my notes and the emails from my client; I reviewed all my images. I was waiting for my brain to do some unconscious assembly work and push some useful thoughts into my consciousness. My client's permission for humour led me back to our idea of a ridiculously low price tag on these (almost) priceless guitars. That thought in turn caused me to imagine a retail store where these guitars could've been for sale. And that's when I remembered the photo of D'Angelico standing in front of his own retail shop (with its overhead neon sign within the frame of the image).

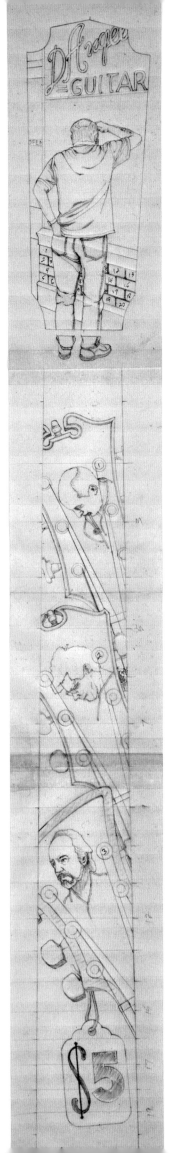

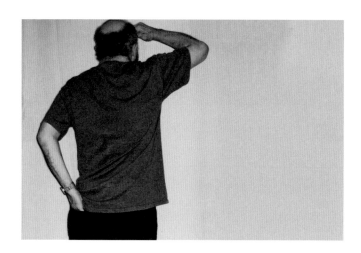

How often have we found ourselves peering through the front window of a retail shop, after hours, to see what's on display? I immediately imagined myself similarly engaged at D'Angelico's shop window. I pictured guitars sitting on their display stands, neatly aligned one behind the other as in any good guitar store. What I'd be seeing, of course, would be guitars made by these three archtop builders, lined up as they might be in a retail display. My narrative was emerging: the headstock would find me looking into D'Angelico's shop through its street window and the fretboard would show what I was seeing.

Each of these archtops has a distinct proprietary headstock design that would be easily recognizable to anyone familiar with the guitars. Recalling that my client liked faces, my next decision was, for me, the instinctive solution. I would inlay a headshot portrait of each maker on the corresponding headstock. The $5 price tag? That was my exaggerated interpretation of "some ridiculously cheap price" for guitars that usually sell in the range of $50,000 to $100,000 or more. One can always dream…

A final note. I faced an interesting challenge in completing this design. I wanted to show strings running from each of the tuners in the headstocks. The challenge was how to keep the string lines perfectly straight, as they would be when tightened to pitch, while also keeping together all of the other parts of the inlay, which the strings would interrupt and break into separate pieces. My solution was to first inlay the headstocks, but without the strings. Once they were inset, I used my little Dremel router, following clamped-on guide strips, to route the narrow string channels into the headstocks. The strings themselves were cut from a sheet of laminated abalone shell and were pressed into position, essentially inlaid into the inlay. **x**

Blueprint for Curves 2011

The perfect word to describe this client is *erudite*. He is a delightfully well-informed person generally, but as we spoke about the arts and industrial design and architecture, I realized his knowledge was profound. As a result, our inlay discussions were very wide-ranging to begin with; over much time, the focus necessarily narrowed.

I also chose the word *delightful* to describe my client for more than one reason, but largely because it was a delight for me to learn so many new things. I discovered Herbert Leupin, the Swiss poster designer. I learned that some of the objects I'd grown up with (our toaster! our fridge!) were imagined by the French industrial designer Raymond Loewy. We spoke of the various artists of the Arts & Crafts movement and the furniture and fabrics they created. Charles Rennie Mackintosh (page 120) was mentioned, as was William Morris. Motawi Tileworks came up — another new name to me — and that very day I received dozens of examples of their work in my inbox. These conversations extended over eight months, so it would be impossible to convey all the topics and options we batted around. As the focus was narrowing, however, somewhere around month number six, a shortened but varied list of potential themes was emerging:

- Arts & Crafts movement.

- Miracle of the human body (cellular and/or neural pathways).

- Industrial design and architecture of the 1930s and 1940s.

- The passage of time.

But still we kept veering off into other areas:

- History of medical illustration.

- 1930s cars.

- Posters from the late 1930s and '40s (Leupin's work).

In the end, our lengthy conversations did yield results. They certainly helped my client realize that an element common to many of the themes we had debated was curves: the curve of 1930s cars, mid-twentieth-century industrial design, the female nude, Art Deco sculpture, and, of course, natural plant forms. So that became my theme. Curves. I went to work.

I found images of my client's favourite car, a 1930s Bugatti, with its lengthy and graceful curves. I found natural curves, in the nautilus shell, in an ocean wave, in fiddleheads, in the human female. I found great curvy industrial designs from the '30s, such as toasters and Art Deco vases. While thinking of industrial designs, I recalled an illustration that had something to do with mathematics but was shown as a curved line spiralling within smaller and smaller divisions of a rectangle (or was it a square?). I could see it in my mind's eye, and it resembled the curve of the nautilus. But what was it? It turned out to be one illustration of the effect of what's known as the Fibonacci number sequence. (Fibonacci was a thirteenth-century mathematician who brought Europe the Hindu numbering system — what we now call the Arabic system we all use — and is most famous for evolving a sequence of numbers based on ratios and exponential growth that explains much of nature and ultimately led to modern probability theory.) I had found what I wanted.

3

144

89

3 2 1
1

13
21 8

34 55

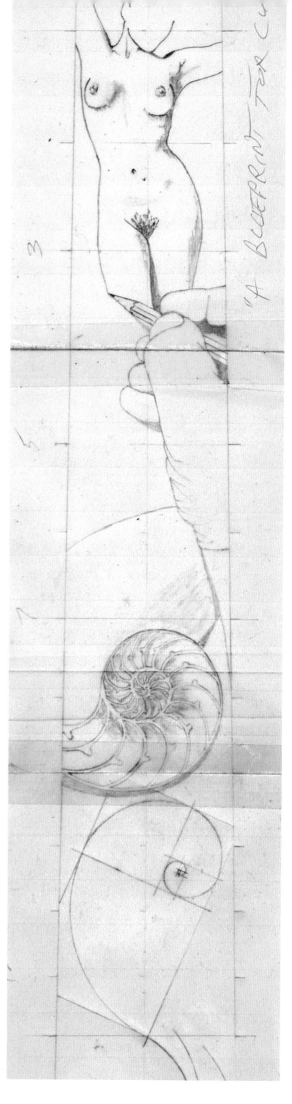

"A BLUEPRINT FOR C4

Facing **A nautilus shell.**

**The curves created
by Fibonacci's
number sequence.**

My hand.

I stared at all my collected images and let my imagination run free, connecting these ideas. The woman could be in the car, heading to a beach, where she finds a nautilus and sees an ocean wave. Or, I could insert Leupin or Loewy or Mackintosh into the story, showing one of them drawing/designing a "still life with nude" or some such, and his Bugatti is seen on the street, outside his studio window. Some of these scenarios were just silly, each presented its own design problems, and, truthfully, none felt right. I decided to revisit the works of these and other designers we'd discussed, hoping that something I'd see or read would spark an idea.

Hours later, as I was idly flipping through a wonderfully exhaustive book on the work of Charles Rennie Mackintosh, I was struck by views of his preparatory drawings as well as some architectural blueprints. I wish I could literally see the process by which disparate thoughts find each other, but all I can say now is that I was looking at Mackintosh's blueprints, which showed his curving floral designs for the building's interior, when I suddenly pictured my inlay as a blueprint. A blueprint for curves!

Ideas tumbled out quickly after that. I would show my hand in the act of drawing one of the curved elements. (I do take quiet pleasure in any opportunity to be self-referential.) The blueprint wouldn't span the entire neck; it would in effect have edges, like any real blueprint. The top and bottom of the design—the headstock and the higher frets—would be largely (but not entirely) off the blueprint page and rendered more lifelike. When one part of these full-colour elements encountered the blueprint, they would revert to simple line drawings. In the end, it made sense for the blueprint to cover no more or less than one full octave of the fretboard, from the nut to the twelfth fret. I had my storyline.

As I began drawing in elements, selecting all that could aesthetically fit, I refined the design. I created a coloured centre so the design would not be top- and bottom-heavy with lifelike colour. I sat the nautilus shell adjacent to its mathematical partner, the illustrated Fibonacci curve, but depicted it as if it were sitting on the surface of the blueprint, as are my hand and my pencil.

My challenge with this project was to illustrate and create a narrative out of a concept rather than out of a recognizable scene or event or list of pivotal moments in someone's life. I'm not tasked like that often, but when I am, and when I feel I've succeeded, it's all the more satisfying. Perhaps that's why this inlay remains a personal favourite. **x**

Playing with Light 2012

"I paint with light." My client from Singapore was describing how he views his professions as a photographer, a television producer/director, and a filmmaker. I then asked him what moved him most about his work. He was effusive but thoughtful, as some excerpts from my notes during our phone call make clear:

— "A single image becomes a multi-image [multi cameras in TV] becomes a moving image."

— "All disciplines blend into each other. Skills learned in one are useful in another."

— "In TV you are orchestrating a lot of people to achieve the end result."

At this point, it wasn't clear to me how these comments might affect the inlay design, but I was pleased to be getting a fuller sense of what was important to him. We had settled on the inlay theme, centred on his professions. However, the only specific item he asked that I include was a map of Singapore, given that this unique city-state would shortly celebrate fifty years of independence.

Naturally, my first task was to have a look at the various cameras. I began with standard single lens reflex (SLR) models, of course, and then earlier, iconic film cameras. And I looked at newer models, all the way to the most contemporary digital television cameras.

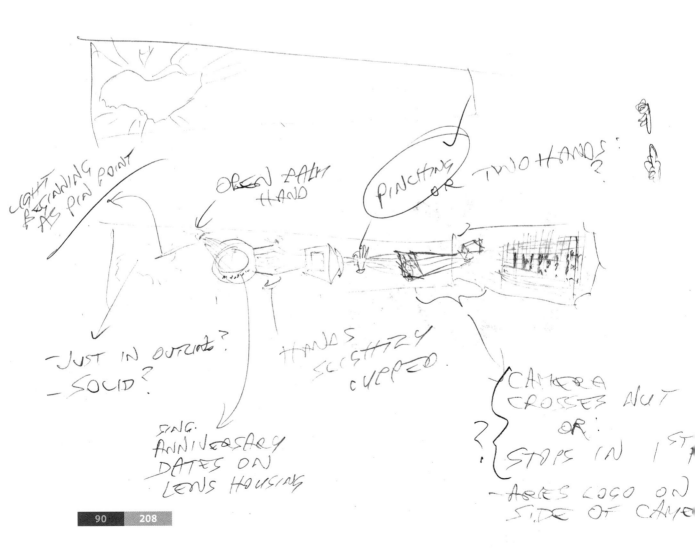

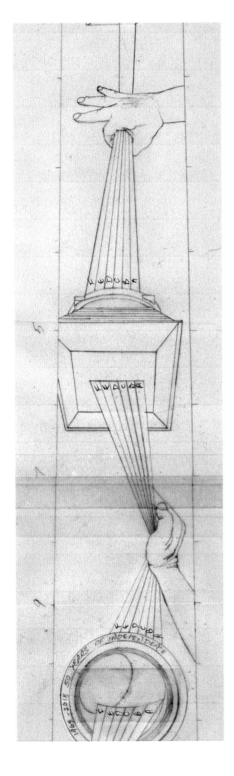

Facing **Working out
a pixillation pattern
for the letters.**

All the while, his phrase "painting with light" was like an earworm. Painting with light. Painting with light. My mind was trying to visualize it. Light... Light... Light! I pictured light travelling through the camera, being gathered by the lens and reshaped. I imagined it as a collection of wavelengths, each wavelength a different colour on the spectrum. And I thought about all those wavelengths being bounced around the camera by reflective plates, bounced around like a pinball or a snooker ball, hitting the side at one angle then veering off in its opposite.

Game, play, playful, playful with light... my brain was free-associating, and it felt like a storm, a brain storm, as images flashed by. One thought having led to another, to another, I saw a way to include all my client's disciplines. I would illustrate a beam of light bouncing around the fretboard and passing through the lenses of three types of cameras located at various intervals. The bouncing would be the playful part. As a way to send the message that it's human intervention — my client — that shapes the light, I would depict hands deflecting the beam.

I was off and running. While doing my rough-sketching, I realized that showing just the lenses, rather than the full cameras, would

suffice. Mostly, that worked. However, when I looked at a digital TV camera, it felt right to include the whole of its simple elongated shape. That served me in two ways: it helped differentiate it from a film camera and it gave me enough length to span the nut, the "barrier" I enjoy breaking. And then, as I was drawing out the path of the light beam (emanating from the island of Singapore — which got the map in) and sketching in the cameras and controlling hands, working my way up the fretboard, I made what I now feel was my best decision in this inlay theme. As the light travelled, I showed it broken into its six primary spectrum colours and then gathered together again by one of the hands and re-formed into white light.

I was really enjoying the playfulness of this concept; it felt like playtime, given the fun I was having thinking it through. My final decision served to bring the visual narrative full circle. I instinctively understood that once the light passed through the third camera, the digital TV camera, it would be split into pixels of data. Depicting that effect delivered a full blossom of random, pixellated colour to the headstock. The narrative arc was the light's journey, beginning as a simple tiny point and ultimately achieving its fullest modern expression as broadcast data points. **x**

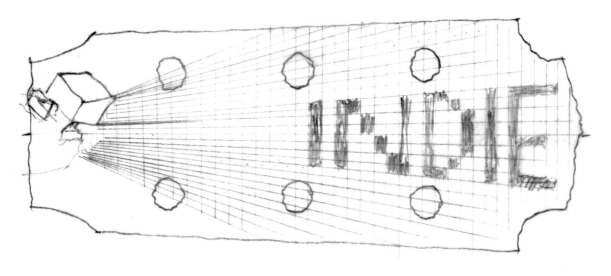

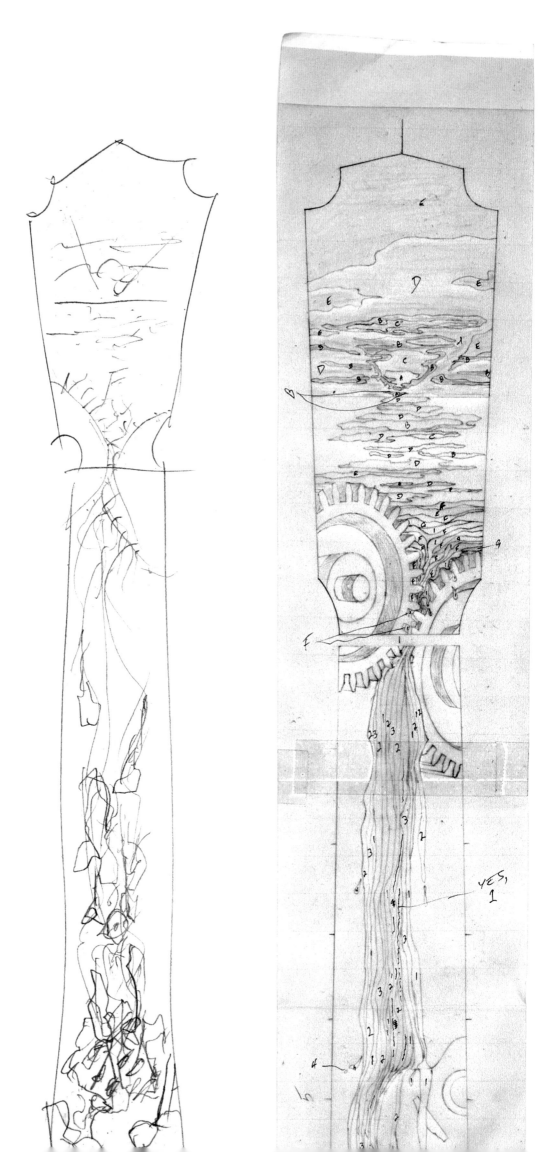

Water Music 2012

"**Gears meshing;** water flow; sunsets; music; the music of life itself; the note theme of music; symmetry and patterns." This is the point we had reached, my client and I. These were his phrases, my guidelines. He is in the pump business, so water and gearworks are a primary part of his life. But music and guitars are his big passions.

Our conversation had also veered near the spiritual as he expressed his love of life, his sense of something out there greater than himself. It's difficult to guarantee those kinds of feelings can be translated into an inlay design. Regardless, I seek out these revelations. They help me understand the significance of a client's suggestions.

At first glance, these potential elements seemed particularly disconnected. Often, in the midst of discussions with clients, images and possibilities have already begun to form in my mind—but not in this case. However, my client got the ball rolling by sending me a number of his own photographs of sunsets. Most were taken while looking out over a body of water. The rippling water reflected the colourful setting sun terrifically. He really did take some spectacular shots. I picked out a favourite and set it aside, determined to use it.

Clearly, it was the fact of looking at the sunset over water, all the while remembering his wish for "water flow," that made me think of a waterfall. I pictured the sunset lake scene in the foreground, draining off an edge of some kind. Or, if not an edge, draining through a chute, perhaps?

A picture of a waterwheel popped into my head. I could visualize the water pouring onto it and flowing out the bottom. The wheel image brought me back to my client's theme list, specifically "gears meshing." It might work to have the lake water draining or falling into meshing gears, almost as if the water were driving them, like a waterwheel. This idea, I thought, was interesting.

But I was still a long way from a key element. Music and guitars. How could they come into this picture? I really didn't know. No brilliant images were popping into my head. I went out for a walk.

As I walked, vague and fuzzy images came to mind. I pictured water droplets raining down but turning into other objects (animal? vegetable? mineral?) before they hit the ground. I also sensed more than saw images of a waterfall turning into magical beings of some benevolent kind. For all I could tell, I may have been re-viewing snippets of old Disney cartoons or illustrated fairy tales. I can't identify them to this day. Happily, though, these images led me directly to the idea of a waterfall transforming into something else. In this case, musical notes.

Once I had this concept, the continuity of the design fell into place. The lake would drain through a set of meshed gears and flow out the other side; as the water progressed down the fretboard, it would transform into musical notes. Then, in much the way a natural waterfall spills onto a rocky base (I was picturing Niagara Falls), the musical notes would pile up in a heap at the bottom. As I was picturing the rocky base of a natural waterfall, it struck me as wrong to have the cascading musical notes piling up onto rocks. Instead of rocks, there should be a pile of guitars at the bottom! And I chose to add one additional guitar partway down the fretboard, the equivalent of a rocky outcrop that water spills over as it descends. I positioned it jutting into the flow. Key for me was the logic of the flowing water beginning to transition into musical notes only after it bumps into this guitar on its way down. **x**

I Hope I Didn't Wake You 2012

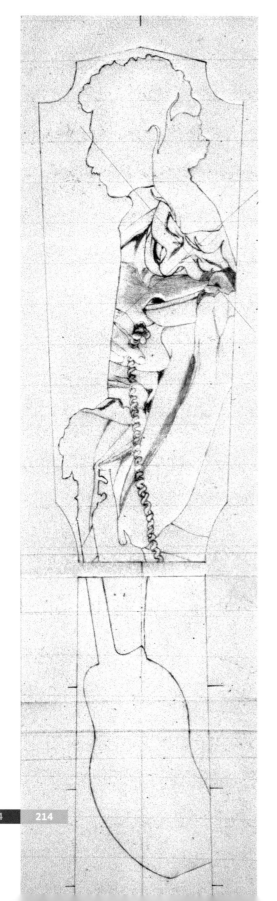

Here we have another Short Story. The client's instruction was minimal: the Jim Croce song "I'll Have to Say I Love You in a Song."

Jim Croce was a folk-pop singer/songwriter who died in a plane crash in 1973. I knew his name, but that was about it. So, clearly, I needed to learn more about him, and, of course, hear him sing that particular song. After listening, I printed out the lyrics and read and re-read them, all the while monitoring any images that immediately came to mind. I repeatedly found myself drawn to the opening lines: "Well, I know it's kind of late / I hope I didn't wake you." I pictured a situation common to touring musicians, where Croce was calling from a hotel while on the road, his wife already in bed for the night, sleepily holding the receiver to her ear.

Those first two lines were quite brilliant — they set up the scene perfectly. Perhaps that's why I kept returning to them, over the other twenty-four lines in the song, and why the image that formed in my mind felt so convincing. But I needed to find a way to show both parties in this phone call. I could place one of them in the headstock, the other at the bottom of the fretboard, a stretched phone cord connecting them. Too hackneyed, too cartoonish, I decided. My client had mentioned that this theme was in celebration of his wife's birthday. The design needed to be subtler.

It was also requested that I consider doing something different in the rosette, the decorative work around the sound hole. My default position is to insist on my trademark rosette design — the dimensions of the narrow 21-millimetre band around the sound hole don't lend themselves to my style of bold

Jim Croce.

My model, in her bed.

Excerpt from Jim Croce's
handwritten lyrics.

imagery—but when prodded with a compelling
artistic reason that connects to the inlay art
in the neck and moves the story forward, I will
accept my client's challenge. Whatever I did
around the sound hole must play a part in the
narrative. What if I just wrapped those opening
lyrics that I was finding so compelling around
the sound hole?

That approach would be unlike anything
I'd done before, which was all the more reason
I was keen to give it a shot. While reviewing
possible fonts for this purpose, I wondered if
I could find some of Jim Croce's own writing.
Happily, that was easily done. A few photos of
his original notebook pages were online, and
I chose to use some of his printing, since his
cursive writing was sometimes indecipherable.

I began my story at the sound hole with
the song's opening lines. The essence of the
song would be in the neck. How might I show
each participant in this late-night phone
call? I dwelled on the song's imagery, placing
myself in Croce's position, missing his partner,
being far from home, having her constantly
on his mind. My thoughts tumbled: on his
mind; inside his head; inside; within. And word
association is pretty much how I got to my
solution: use Croce and his guitar as the outer
frame of a scene, and depict the woman he
longs for inside his outline.

I photographed some friends, a musician/
actor couple. I shot the musician resting his
guitar on the ground, knowing he'd be rendered
only in silhouette. His actor wife was happy to
inhabit a role. I photographed her in their bed,
on the phone.

And to those who would spot it, yes, that
is Jim Croce's head in silhouetted profile, not
my friend's. **x**

A Year of the Cherry 2012

The short span of early springtime when fruit trees blossom is celebrated in many parts of the world. But the Japanese custom of Hanami, appreciating the transient beauty of the cherry (sakura) blossoms, is said to have begun more than 1,200 years ago. This celebration is such an entrenched part of Japanese culture that there are even newscasts tracking the cherry blossom "front" as it moves from Okinawa in the south to Hokkaido in the north. So, when a Japanese client asked me for an inlay built around the cherry blossom, I wasn't surprised. The only additional instructions I received were to indicate the cycle of the seasons and to use only the space of the headstock and the fretboard down to the seventh fret.

My first stop was to have a look at Japanese cherry trees. I needed images of the trees in all seasons, not just blossom time, and they were easy enough to source. What first struck me about the tree was the jerkiness of its branches. They are like long arms with multiple elbows and wrists, twisting and kinking as they grow. Second, as I scanned the images, I realized that it would be impossible to recreate the tree and its blossoms in my medium if I depicted an entire tree. The blossoms would be too tiny to show individually. And how would I indicate all four seasons? Would the top of the tree be in blossom; the middle sections be free of blossoms but with leaves, first green and then turning brown; the bottom just bare limbs? With only shell and stone as a palette, and the relatively small space in which to render it, this image wouldn't succeed and certainly wouldn't provide any logical reason to extend down the fretboard.

I went back to the first thing to catch my attention, the individual branches. I realized that if I focused on a single branch, the relative size of the blossoms would be ideal for inlay. This idea sent me searching for different views of the tree, more close-ups and primarily

winter scenes with the branches bare of leaves, revealing their structure. If I was going to focus on a single branch, it needed to be a very interesting one, with lots of decorative kinks and twists. In the end, I drew my own branch, composing it with shapes taken from a few different trees.

It was while sketching out variations of a branch that I realized I could make this branch extend out as far as I chose, stretching its length down through the headstock to the seventh fret, as my client had requested. And with this structure, I could indeed indicate the seasons. At the base of the branch, where it's thickest, I would show full cherry blossoms. Next along the branch we'd see the cherries of summer, then the colourful leaves of fall and, ultimately, a bare winter branch. Yes, it was a version of the full-tree concept I had just rejected, but changing the dimensions to a more micro perspective had brought it into the realm of the possible.

My client had asked me to depict the cycle of the seasons. With that repeating cyclical process in mind, perhaps it wasn't a surprise that I hit on the idea of adding the day/night cycle. In the headstock would be the sun alongside a clear, turquoise blue sky. Moving into the fretboard, we'd see a deep royal blue sky of lapis, and eventually the full-night blackness of the ebony fretboard itself. Jutting into the final fret, the seventh, would be a crescent moon.

I felt confident that I'd captured my client's ideas, so I scanned him my sketch for approval. He replied within the hour that he loved it, but he asked for one addition: snow. And that is why you see snow flurries beginning near the bared branch ends. There is a small buildup of snow at the octave fret, and along the fretboard edge, as if these two planes were the edges of a window frame. My client's inlay now extended five frets farther than originally instructed, but he was delighted. **x**

Courage in Sarajevo 2013

Sometime in 2009 I read Steven Galloway's novel *The Cellist of Sarajevo*. It is a fictionalized retelling of riveting true events: during the Bosnian War, for almost four years from 1992 to 1996, the city of Sarajevo endured the longest siege in modern warfare. (Yes, it lasted a full year longer than the brutal Nazi blockade of Leningrad during World War II.) Early in the siege, Serb forces shelled a bread line, killing twenty-two innocent people. This tragedy inspired the musician Vedran Smailovic, a cellist with the Sarajevo String Quartet and the Sarajevo Philharmonic Orchestra, to bring his cello to the bombsite and perform Albinoni's *Adagio in G Minor*

at four o'clock in the afternoon, the time of the deadly attack, for the next twenty-two days. His performance took place in an area of the city where factional sniper fire was constant, yet he ignored the risk and, amazingly, was never shot at. Snipers from both sides held their fire.

Even though Galloway's novel fictionalized the truth, it still left a powerful and long-lasting impression. A year or so after reading the novel, I discovered that a friend of mine, Jim Musselman, had recorded *Sarajevo to Belfast*, an album for his Appleseed Recordings label, featuring Smailovic and the Irish singer Tommy Sands playing songs of tragedy and healing from Bosnia and Sands's own conflict-ridden Northern Ireland.

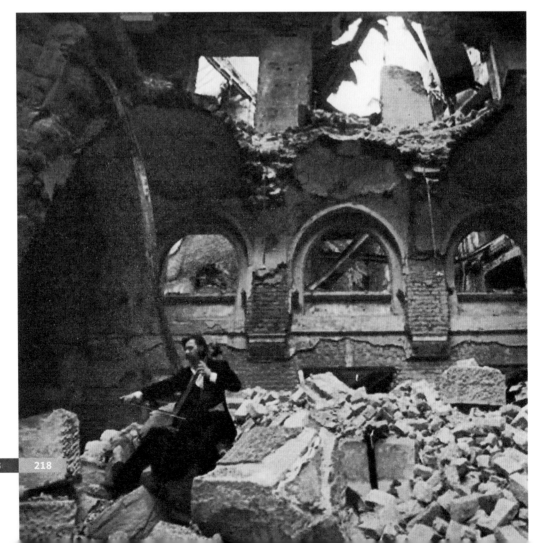

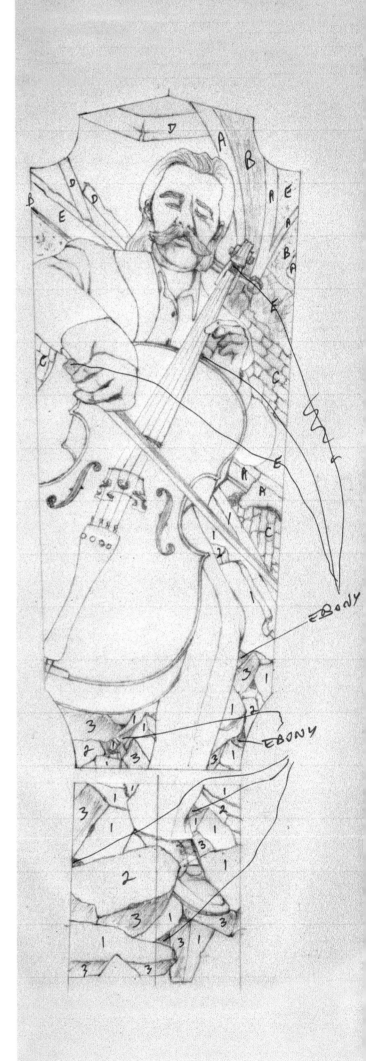

This story of courage kept coming back to me, reinforcing my own belief in the power of music to unify. And so, when I was returning to California's Healdsburg Guitar Festival after a many-year absence and debating what to build for the show, the cellist of Sarajevo came to mind.

While I was building this guitar but before I had reached the inlay design stage, four Canadian women, three of them Aboriginal, began a national protest movement that they called Idle No More. Their act of courage was to stand up to the federal government and declare that their communities would take action, would be idle no more, against the long history of Native peoples being treated like second-class citizens. They would fight back against centuries of physical and sexual abuse by non-Aboriginals and demand that their legally negotiated treaty rights be recognized.

The effect of this powerful protest was to remind me how often women were at the forefront of anti-violence protests. It brought to mind the Mothers of the Plaza de Mayo in Buenos Aires, who marched in public every Thursday, from 1977 to 2006, to protest the "disappearance" of their sons during Argentina's Dirty War. It also brought to mind the images of young women tweeting each other on the streets of Cairo, using social media to begin what became the Arab Spring. Both Smailovic's and these women's courage felt to me like two sides of the same coin. I decided to find a way to link both in my inlay.

I began my preparation by seeking out photos of Smailovic playing in the bombed-out buildings. I found a number of good images, including one where he was playing inside the crumbling structure of a destroyed building—that one became my favourite.

However, the storyteller in me sensed that if you didn't know his story, you wouldn't understand the significance of what might appear to be simply a cellist in an odd setting. His city was under siege and bombardment; he faced danger. I had to show that somehow to make my point. As it was described in the novel, Smailovic was in the sights of any number of sniper rifles, so that was the image that jumped to mind: a sniper's gun aimed directly at him.

How to bring women into the story? With one of my messages being anti-violence, I recalled images from the 1960s hippie era of women sliding flowers into the barrels of police guns. Could that work? It might be too linked to a specific era in people's minds and detract from my point. And if I was including a gun, I reasoned, perhaps the women could be taking riskier action, shielding Smailovic, symbolically protecting him from violence. That didn't feel exactly right, but it did lead me to the certain idea of placing the women between the sniper and the cellist. When I made that decision, I saw what the women needed to do. They had to put their hands — not flowers — directly in front of the rifle's muzzle. Their gesture had to say: STOP! With that dramatic arc, and all going well, I would illustrate my themes.

I had a suitable image of the cellist. I needed to get a photo of the women, so I asked a young actor/director friend of mine if I could photograph her and a younger female student actor. After one of their rehearsals, I went to the theatre, climbed up to the low balcony, leaned over the railing, and photographed both women. The younger student I instructed to look directly up at me. I knew I wanted one of my characters to be looking outward, connecting with a viewer and engaging them, drawing them visually (and emotionally) into the scene.

My final image task was to get an accurate shot of the kind of sniper rifles used in Second and Third World conflicts. I scanned endless shots of rebel and guerrilla armies from around the globe. The rifle most of them appeared to favour turned out to be a Yugo M76.

When I began laying out the design, Smailovic was in the headstock, playing amidst rubble and crumbling walls. Next, I placed the sniper at the opposite end of the neck, and drew a line directly between the rifle's barrel and Smailovic's heart. I purposely showed only the sniper's right hand supporting the gun. I wanted the weapon to be wielded anonymously, as is so often the case, the better to become a symbol of violence. Lastly, I positioned the two women also directly in the line of fire, but holding their hands in front of the gun. Surrounding the gun is a shade of coral stone that is blood red and tapers to a knifepoint just past the gun's muzzle. From that point drips a single drop of blood. That blood was deflected, could not pass through the hands of the women. The defiant music could be heard; the women risked their lives to halt the bloodshed. This is courage in Sarajevo — and around the world. ✘

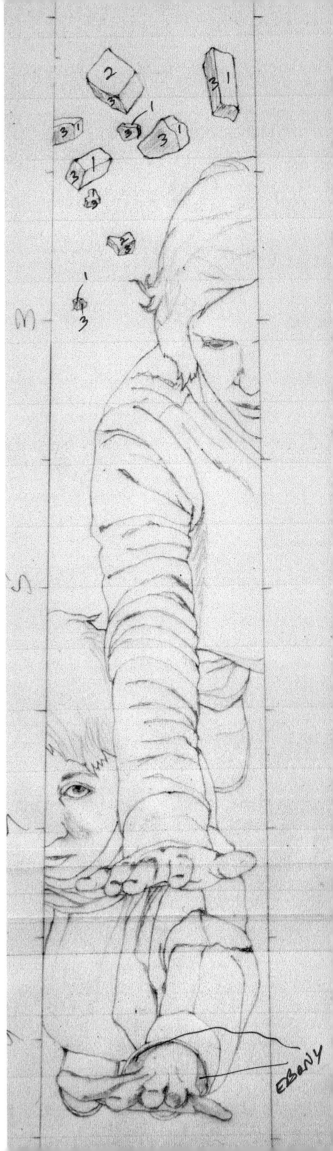

Southbound

In **1971**, when I was seventeen years old,
I got my first full-time job (at a Toronto record-
ing studio). With my first paycheque of $45
I established what would become my weekly
payday routine for the next few months: on the
walk home to my rented room, my very first stop
would be the local record shop. I could afford
to buy one album per week, and the album I
purchased on my first visit was Doc Watson's
Southbound. It was a somewhat impulsive
purchase. I had never heard any of Doc's music,
only heard his name reverently mentioned by a
musician I'd seen perform at Toronto's Riverboat
coffeehouse. That single comment was enough
to make me curious. And from that impulsive
start I became a dedicated fan of Doc Watson,
improving my own guitar playing by learning
many of his songs and guitar arrangements.
I play some of those arrangements to this day.

When my client asked me to create an inlay
design in honour of Doc, who had died less than
two years earlier, you can imagine how delighted
I was. Not to mention that I now had a reason
to delve deeper into the life of someone whose
music I admired. I knew Doc was not just a
guitarist but an excellent banjo player as well,
and he played the harmonica. I knew he had
toured and recorded with his son, Merle. I knew
that Merle had died in a tragic farming accident
when he was only thirty-six. Two years after
Merle's death, a music festival — Merlefest —
was established in his honour and continues to
focus on music based on American traditions.
That was the sum of all I knew about Doc.
It was time to hit the books.

As I read about Doc's life history, I kept a
mental note of anything that could become
an element of my design. I learned that Doc's
first instrument, at age six, was a harmonica.

His first guitar was a $12 Stella. I was especially
interested to learn that *Southbound* may have
been the fourth album he recorded but is
considered the one that catapulted him to
prominence. Merle, too, needed to appear in
the inlay. While reading about him, I stumbled
across the logo of Merlefest, a raccoon, and
added that to my list of potential elements.
At this point, my growing list of disparate items
included images of Doc and Merle that I felt
should form the key aspects of my design,
but what I did not yet have was the link to pull
them together into a narrative.

I returned to my notes, to my pages of Doc's
history, to my printed photos, and let ideas bob
to the surface. I considered placing a childhood
Doc (his real name was Arthel Lane) in a string
band (guitar, banjo, fiddle) with his adult self
and his son, Merle, but quickly dismissed that
idea as too contrived. And then I came across
a sentence in one of the biographies I'd found:
"Doc's mother would frequently sing old-time
songs and ballads while doing chores during the
day, and she sang her children to sleep at night.
In the evenings the family read from the Bible
and sang hymns from *The Christian Harmony*,
a shape-note book published in 1866." That told
me that Doc's earliest experience of music was
from his mother's singing, so he was exposed
to songs and ballads in the traditional manner,
by ear, from an earlier generation, and that
his earliest act of singing was with shape-note
hymns.

In the early nineteenth century, each note —
each Do, Re, Mi, Fa, So, La, and Ti — was given
its own shape so that whole communities
could sing together without people having to
learn standard musical notation. As I looked
at those seven shapes, an idea started to form.

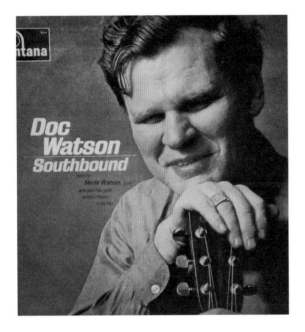

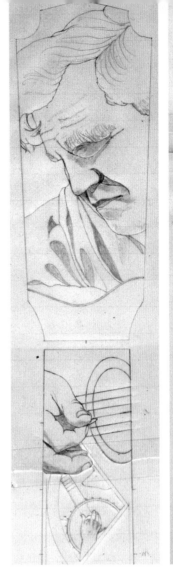

If I treated those shapes almost like picture frames, they would provide seven different spaces in which to insert other elements. And if I stretched those shape-note frames across the length of the fretboard, they would become not only the spine of my narrative but also the representation of the origin of Doc's music, the roots that fed all that he did in his career.

This concept felt so right that I dived in with much enthusiasm. It made sense to me to show, within the spaces of the notes, a few important chronological markers in Doc's life. I started with his first instrument, a harmonica; moved on to his first guitar; followed that with the title font of his seminal album; blended that into the Merlefest logo and Merle himself; and finally reached the image of Doc's own right hand, playing a banjo. I was sketching my way toward the headstock. My initial plan was to show a full musical scale in shape-notes, Do Re Mi Fa So La Ti, and the higher octave Do. However, when I reached the second Do, where I intended to place my crowning image of Doc playing guitar, I became frustrated with the triangle shape of that note. It was too limiting. And to my mind, given Doc's prominence and his very recent death, he deserved a fuller portrait. So my plan changed.

I worked from the top of the headstock down until I'd sketched in a large portrait of Doc, and blended it into the note Ti. If you look closely, you'll notice that I included two more shape-notes in this portrait: another So in the angled elliptical appearance of the guitar's sound hole and a subtle Do, really just an invisible guide to my layout, where the diagonal line of Doc's profile forms a triangle with his guitar.

As I completed the drawing, I loved the idea that this inlay would contain its own melody. By adding the second So and the final Do to the depicted scale, you now have: Do, Re, Mi, Fa, So, La, Ti, So, Do. Try singing it yourself! ✗

The Boxer 2014

"I am just a poor boy / though my story's seldom told…" So begins "The Boxer," first released in 1969 by Paul Simon. It is a timeless, powerful, and captivating story-song, so it didn't surprise me when a client asked me to take it as the inlay theme for his guitar. His wish was simple: "Base the guitar on 'The Boxer.'" There was a proviso, however: "The rosette could use the lyrics of the song." He had seen *I Hope I Didn't Wake You* (page 94) and wanted me to create some variation on that approach.

I began my design with the rosette, the decorative work surrounding the sound hole, because it is inlaid into the soundboard very early in the construction phase. My client and I discussed many possible excerpts from the song, but settled on: "I was no more than a boy." My next step was to settle on a font for the lyrics. I soon realized that Paul Simon's own handwriting would be the best option.

Thanks to the Internet, I was able to find actual pages of Simon's handwritten notebooks, but his hasty cursive scrawl was nearly illegible. Hoping to find neater examples, I kept searching, and ultimately I stumbled across pages where he'd block-printed his lyrics. I saved and printed a page that contained every letter I'd need, and then began my layout.

Once I had evenly spaced the letters around the sound hole, I stood back from my sketch and considered it. It seemed fine as far as it went, but the rosette space seemed incomplete somehow. My instinct was telling me I wasn't finished, that more was needed. And I generally obey my instincts. Does it need colour, I wondered. There was not much room for images around the text, but I pulled out the song lyrics again, on impulse, and re-read them. No new image appeared, but the line that immediately followed the one we had chosen—

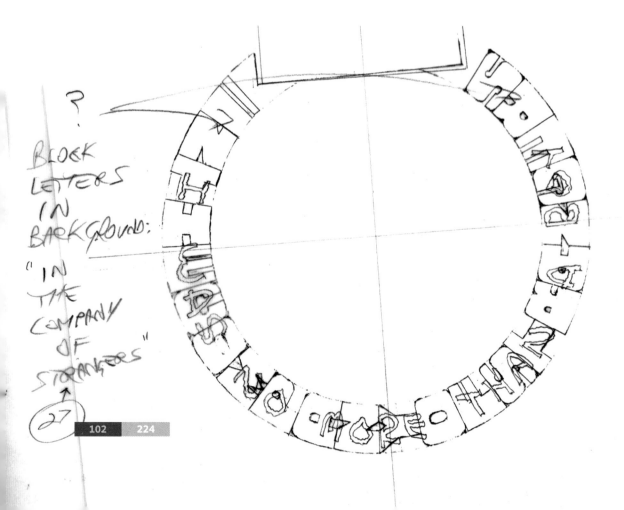

"In the company of strangers"—not only completed its own small two-line narrative but also got me thinking more about the lyrics themselves. And that's when it struck me that there might be a way to put both lyric lines in the same space. Interweave two different fonts? Layer one over the other? I wasn't sure yet, but I had a feeling I was on the right track.

After a short time playing around with a variety of fonts, I ended up drawing my own. I decided to create something that was a total contrast to Simon's printing, and the more I worked at it the more I liked the idea of turning the lyric line into letters so blocky and closely spaced that they'd appear at first as some sort of graphic underlay. Only on closer examination would the words be perceivable. I fell in love with this subtle, almost subversive nature of the second lyric line.

When it was time to design the inlay for the neck, I felt that I could focus on Simon as an adult since I'd touched on the "boy" in the rosette. I knew that one element, of course, would be Simon's portrait, and it took very little time to settle on an early image, dating from the period when he would have composed "The Boxer." And, logically, I should pair him up with a boxer. A generic one? A specific one? Simon was born in 1941, in Newark, New Jersey, just across the river from New York City. I searched for boxers who would have been active when Simon was a boy, when he might've become a fan of one of these fighters —or certainly have been aware of them. That's when I landed on a name that even I was aware of, despite being someone who finds no appeal in violent sports like boxing: Jake LaMotta. I later realized I likely knew his name because of Martin Scorsese's 1980 film

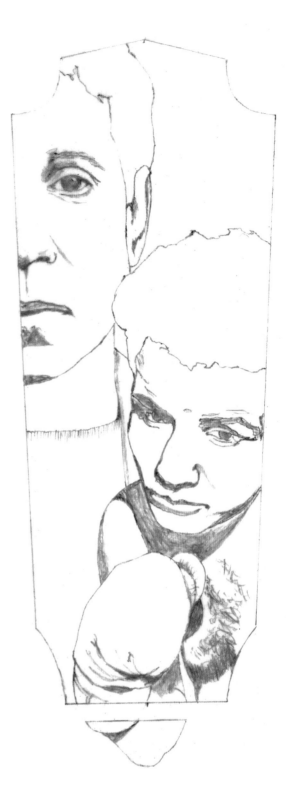

Raging Bull, which is based on LaMotta's life story. The fighter was based in New York City and was most active in the late 1940s and early '50s, exactly when Simon would have been old enough to be aware of him, and perhaps even follow his career. I had found my boxer.

Was LaMotta in Simon's head when he composed "The Boxer"? Unless Simon tells us, we'll never know. But as a theory, I'll stand by it. **x**

Darwin to DNA 2014

One side-effect of having pushed the envelope with my inlay designs for a number of decades is that new clients often come to me with definite ideas about the art they want on their guitar. Occasionally, the client's idea isn't workable—or certainly not in the way they envision it—and we explore another approach. That, however, was not the case with this client. As it was first put to me: "[It] could go from Darwin, HMS *Beagle*/Galápagos to DNA, so I suppose evolution/science rather than just Darwin. Should be plenty of scope for you telling a story." Indeed!

I had clear direction, sure, but the topic was immense. My knowledge of Charles Darwin was pretty limited. Yes, I knew of his ground-breaking theory of evolution and of his trips to the Galápagos Islands, but little more. What were Darwin's origins? What happened on Galápagos? What was the connection to DNA? What exactly is DNA? I had much to learn. I went shopping.

I bought a 150th anniversary edition of Darwin's *The Origin of Species*, as well as his travel memoir *The Voyage of the Beagle*. I also couldn't resist picking up a copy of *Darwin: A Graphic Biography*, thinking that another artist's images might provide inspiration for my own. I read and read and read. At the same time that I was learning about Darwin, I needed to understand DNA and how it was connected to this scientist who died seventy-one years before its double-helix structure was discovered. DNA, deoxyribonucleic acid, is a molecule that carries most of our genetic instruction. Its structure comprises two biopolymer strands that coil around each other, forming the familiar double-helix shape. The linkages between the two strands of the helix are extensions of four primary chemicals: guanine, adenine, thymine, and cytosine, represented most commonly by their first letters: G, A, T, C. They are bonded to each other, in their sequences, by either a sugar called deoxyribose or a phosphate. But that's all there is—four basic chemicals, responsible for all that we are. I find it astonishing.

I found it even more astonishing when I pulled my view frame outward a bit and encountered the chromosome. Contained within the nucleus of a cell, and only visible under strong magnification, chromosomes are dense packages of DNA. I became fascinated when I saw that the 2 metres' worth of wound strands within each tiny chromosome are themselves made up of tightly aligned and densely packed balls of the DNA strands. Each of these balls (technically, histana) is like a child's ball of string, but in this case the string is DNA. I was struck by how minute the DNA really is, and how many microscopic layers deep it resides.

But there was an inlay to design, and I needed to begin imagining my story. My client had given me the phrase "Darwin to DNA," and illustrating that journey was my goal. As I was beginning to mentally list possible elements for my narrative, I learned something that sparked an aha! moment. In our current understanding of how DNA allows genetic inheritance, one strand of the double helix pairs with another strand from the molecule/chromosome of the second parent to form a strand of DNA that is a new variation of the two strands that have created it. Minor errors in "copying" may lead to permanent changes in the sequence of the genetic chemicals, resulting in variations of characteristics, commonly called mutations.

The elder Darwin.

Title page from the first published edition of Darwin's controversial *The Origin of Species*.

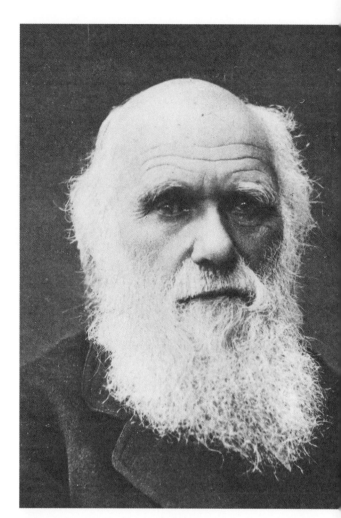

This means that Darwin's theory of natural selection, in which lifeforms whose traits enable them to survive better than others of their kind are able to reproduce in greater numbers and ensure their perpetuation, is accurate to this deepest molecular level. I had come to understand the direct and proven connection between Darwin and DNA. The picture was filling in; ideas and images were rapidly forming.

My narrative arc could have two strands, not unlike the double helix. One would be Darwin's own journey of discovery, from relative youth to old age, ultimately showing the way he is most commonly depicted. The other strand would be the elements of DNA itself. I began a list of things I should try to bring into the story:

— Portraits of Darwin, young and old.

— The HMS *Beagle*, the Royal Navy survey ship on which Darwin travelled as its naturalist.

— The Galápagos Islands, the volcanic archipelago whose isolated terrain makes it a home for animal and plant species found nowhere else in the world.

— Finches (Darwin's own notes tell us their beak variations signalled to him that species might change their traits over time, adapting to new situations).

— The cover page from *The Origin of Species*.

— Text from Darwin's early notebooks.

— The DNA letters: G, A, T, C.

— Chromosomes.

— Down House, Darwin's home in Kent, England.

affinities . theory comparative Anatomy & it instincts . heredity ... here let, it would lead to closest ... causes of change in order to know what we

Images of most of the items on my list were easily found, including a rarely published portrait of the young Darwin painted shortly before his first voyage. And that seemed a fitting place to start. I sketched the younger Darwin into the headstock. The HMS *Beagle* came next, given its critical role in his life. Moving down the fretboard, I followed the ship with the Galápagos Islands themselves, depicting them as if the blackness of the surrounding ebony were the dark ocean.

I knew I wanted to include some of Darwin's own writing from the now famous notebooks that contained his evolving theories. Incorporating a full page vertically would make the proportionate writing tiny and unreadable. Shifting to a horizontal view would be better, but if I made it large enough to read, the page would take up more space than I wanted to use. I paused, unsure of an approach, and found myself staring down at the most recently completed part of my sketch, the islands. At that moment I had a sense of looking down from the sky. Simultaneously, my brain inserted clouds floating by, and as I thought of the clouds and then recalled the way children play at seeking recognizable shapes in them, I suddenly saw Darwin's written words floating across the sky, like clouds above the islands.

I re-read some pages from Darwin's earliest "transmutation" notebook until I hit page 228, where I discovered key phrases and words that signalled he was truly onto something: "competitive," "instincts," "it would lead to," "causes of change." Those words, in Darwin's own handwriting, I sketched in diagonally. The top half of my "canvas" was occupied.

Before continuing down the fretboard, I needed to introduce the elements of my second narrative strand. I wanted the four primary chemicals to be represented, and chose an approach I'd used for other designs. I'd make the four letters—G, A, T, C—large and sans serif enough to enable other elements' depictions within their outlines. I drew them in, starting at the bottom of the neck and working up toward the midpoint, taking this story arc in the opposing direction from Darwin himself. I sketched in four of Darwin's finches. Next came the cover page from the first edition of *The Origin of Species*. My penultimate sketch was the famous image of the heavily bearded older Darwin.

I should mention here that I'd earlier decided how I would incorporate a chromosome. Under magnification, the dense strands of DNA-filled histanas that make up the chromosome resemble nothing so much as a

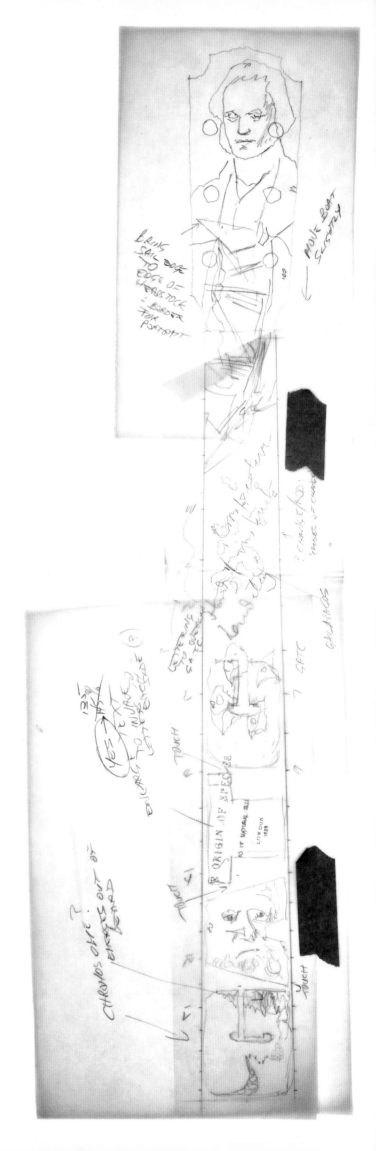

scrappy, unkempt beard. That had given me the idea of showing a chromosome emerging from the elder Darwin's beard. From there I could show it untangling until its loosened strands symbolically flowed into the G, A, T, C lettering.

I completed the drawing, confident in the integrity of the story arcs, and scanned it to my client for approval. To my surprise, though he did like many parts of the design, it turned out he was not a fan of big lettering on guitar necks. My approach in the lower half would need to change. I phoned him, and during our conversation he asked if I could emphasize the DNA double helix instead of using lettering. It was very literally back to the drawing board for me.

In the second draft, I left the elder Darwin roughly where I'd situated him, near the end of the fretboard, to complete the first story arc. From his beard a chromosome still emerged. But this time I completed the picture. I showed long, linear DNA chains unravelling and enlarging into the visible double helix. The helix then twists its way back up the neck toward the headstock, growing ever more magnified until it encounters the Galápagos Islands.

I sent the revised sketch to my customer. The change had made the design more cohesive, and it now better represented Darwin's journey to DNA. My client had been right. He was thrilled. **x**

Wall 2014

The year is 1989; the location Berlin, Germany. On November 9, with less than twenty-four hours' warning, the gates of the Berlin Wall were opened. Border guards were given very little instruction on whether to continue to restrict movement or not. Tower guards, whose usual task was to shoot first and ask questions later, were nervously unsure of what to do. East Germans streamed through the gates and over the walls to get to the West. For weeks, euphoric East and West Germans chipped away at parts of the wall. Formal demolition began eleven months later. After twenty-eight years, the infamous Berlin Wall had fallen.

On the twenty-fifth anniversary of the fall, November 9, 2014, my wife and I were in Berlin. We participated in the moving, city-wide celebration of this anniversary of freedom. Our primary reason for being in Berlin, however, was not this historic occasion but the inaugural Holy Grail Guitar Show, produced by the newly formed European Guitar Builders Association. I prefer to attend most luthier trade shows with an instrument I've built with no client in mind, since I then have full control over the inlay theme. In this instance, given the location of the show and its auspicious dates, how could my inlay theme be anything other than the collapse of the hated wall?

Google "Berlin Wall, Fall Of" and you'll see reams of captivating images: people smashing the concrete walls with sledgehammers; people climbing and standing on the very top in triumph; outstretched arms reaching to help fellow Berliners cross from one side to the other. I viewed photo after photo, letting an overall sense of the occasion impress itself upon me. I then scanned archival images of the wall's original construction. The seamless but graffiti-covered concrete barrier most of us picture was installed in later years. The first sections of the wall were formed from cinderblocks and topped with barbed wire. I saw maps of the wall's wildly zigzagged route through the city. I let all of these pictures sink in until they dominated my thoughts.

I tried to imagine myself in Berlin in 1989,
when the gates magically opened, as well as
in the year before formal demolition, when
the anger and frustration—and joy—of the
populace were expressed at and on the wall.
I understood that what my inlay had to be
about was the journey from east to west, from
totalitarianism to democracy. And, if possible,
it also had to try to capture the period when
the citizens of both Berlins were victoriously
reuniting.

As is my habit at this stage in my process,
I re-examined all the previous images I'd
selected. Most photos of the wall show it
face-on at ground level, so you are staring at a
high, flat surface. A view like that does not fit
on the narrow canvas of a guitar neck, so I'd
chosen a horizontal viewpoint which would
give me more latitude. A few of the images had
been taken in the summer of 1961, the earliest
days of the wall's erection. I stared long and
hard at one particular photo. Certainly, I was
fascinated by the terrible action it portrayed.
Soon, though, I was also struck by how the
scene was depicted, with the snaking top
edge of the wall dominating the frame. Given
the research I'd been absorbing, it was no
surprise that my mind instantly placed many
things into the image: a triumphant Berliner
in 1989, standing on this very section of wall;
Eastern hands reaching across to their Western
brothers and sisters; fists pounding away at the
wall from both sides. These and other images
cascaded into my thoughts. I now knew for
certain how I would tell my story.

I began rough-sketching how a top view of
the wall could flow down the neck. I knew I'd
need some space to its left and right sides to
depict activity, so I would have it make a small

directional kink at some point. I made two other firm decisions at this stage. One was to create my version of the wall out of separate blocks, similar to how it was first assembled. The other was to make the wall two cinder-blocks thick. Although this idea contradicted the historical record, where the first stages of the wall were only one large block thick, my decision was inspired by modern-day Berlin's continuous line of paired bricks, which marks the complete route of the wall on the city's roads and sidewalks. To our surprise, my wife and I even saw the bricks continue seamlessly into the foyer of a modern building. The foyer was walled in glass, an intentional choice so that the wall's path would remain visible.

I knew I would show someone standing atop this wall, proudly hoisting a chunk of it: one large cinderblock. To get the precise body language I wanted, I photographed a friend, looking down at her from a low balcony. A second model, also shot from above, acted in the role of a Berliner attacking the wall with a sledgehammer. So far, so good. Two strong roles in my storyline were covered.

Now I returned to my concept of hands reaching across not only the wall but also the political barrier that divided East from West. I began to fill in an imagined scene with many hands, some reaching out to help, some grasping, some reaching out to be helped. This seemed the ideal way to illustrate the longing of the separated inhabitants of the city to reunite. Again, I photographed models, instructing them to give me a variety of hand and arm positions. I made sure I also had fists in a punching motion. Again, as symbols, I wanted bare fists, fearlessly pounding into the wall and succeeding at cracking it.

As I filled in my sketch, locating all the elements, I realized that my choice of materials could also help create the sense of division between East and West. To the right of my wall, the east, I'd leave the background in the darkness of the black ebony. In contrast, I'd depict the west side as blue sky, with clear turquoise. In addition, I would cut the hands emerging from the east out of bone, knowing it would have a flatness and very little sheen. The hands from the west would be cut from gold mother-of-pearl, its yellow gleam representa-tive of an existence more fully alive.

In doing my research for this inlay, I often found myself looking farther back into Berlin's history, purely out of curiosity. The period immediately following World War II, when the city was divided into sectors—US, British, French, Russian—fascinated me. Images that I encountered repeatedly were shots of the road signs from that era, warning people that they were now leaving one country's sector and needed all the requisite border documentation to enter another. For the benefit of the native Berliners within each sector, the signs were also in German, and began with the phrase *Sie verlassen*, or "You are leaving…"

With the fall of the Berlin Wall, East Germans were able to leave a corrupt totalitarian state and travel to the West, to freedom. The confluence of these two pivotal periods, though separated by forty years, resonated with me. For that reason I placed the text *Sie verlassen* at the top eastern side of my wall, and wrote the destina-tion, *Freedom*, on much of the lower west side. I purposely used a grained but similar turquoise for the word *freedom* and placed the letters as tiles embedded in the road, illustrating how solidly the concept is embedded into Western democracy. **x**

God Natt Oslo 2014

This guitar was commissioned by a very well-known and respected Norwegian artist. We had been having lengthy email conversations, as well as phone calls, over the previous months, and we were both very much enjoying the collaboration. However, when it came time to discuss a theme for the inlay, he said he didn't want to give me any direction. That gave me pause, and I quickly prodded him again for even the vaguest of themes. "Feel free with the artwork," he wrote, "as long as you make it a masterpiece" (and here he inserted a winking emoticon). He explained that in addition to composing and performing, he is also a visual artist, and he would never want to have anyone looking over his shoulder while he was painting. In his mind, it followed that he didn't want to be looking over my shoulder when I created his inlay design. He then made two final comments on this subject: "I trust you—and your art," and (here I am going to break my own rule of never revealing a client's name) "I want the ultimate Lillebjørn Nilsen guitar."

Alarm bells were sounding in my head. With not even the slightest hint of direction, I was going to have to create something that he would like, would be happy to live with, yet I barely knew him. How was that going to be possible? I tried to take some comfort in his expressed confidence in my abilities. I hoped I was reading him right, that he would be open to whatever I chose to do. One part of me felt I had the freedom to do anything at all. Another part remained anxious about delivering the "ultimate Lillebjørn Nilsen guitar." I set out to learn what I could about Mr. Nilsen.

He had recently emailed me a link to an online gallery of his own work, assembled in preparation for an upcoming show, and getting a sense of his creative sensibilities seemed like an ideal starting point. His online gallery showed me impressionistic oil paintings and loose, playful pen-and-ink drawings. He seemed to like portraying the people in his life, and I made a mental note of that.

Above all, however, Lillebjørn (we had long ago moved on to first names) was a musician. I needed to learn about his career, which wasn't hard to do. I watched videos of him performing with the legendary American folk singer Pete Seeger. I found a film of him shot during an outdoor concert in the centre of Oslo, where he is singing what I discovered was a signature hit song, "God Natt Oslo" (Good night, Oslo), in front of fourteen thousand people. I found videos of his daughter Siri, a performer in her own right. I found lists of his recordings and purchased a 2010 box set containing ten albums and a DVD. While I waited for that to arrive from Norway, I printed out song lyrics, in both Norwegian and English, for a couple of his songs that I was learning were his most famous. One was his translation of Pete Seeger's "My Rainbow Race," which had been a top-ten hit throughout Scandinavia. Lillebjørn had also authored a guitar instruction book that had already sold over 180,000 copies. That's a lot of books! Out of curiosity, I ordered a copy.

While I was in the midst of my research, Lillebjørn and I continued our ongoing conversations. During one of these phone calls he made an offhand remark about being influenced by—and writing a song about—the Chilean singer Víctor Jara, who had been publicly tortured and killed by Augusto Pinochet's government in an attempt to stifle the power of his music. Víctor Jara, Pete Seeger; these were

intriguing connections, and my curiosity about my Norwegian client only grew.

In an email, Lillebjørn also filled me in on the guitar quartet, essentially a Norwegian supergroup, he sometimes performs and records with, called Gitarkameratene. In that same email he signed his name as "Little Bear." That was the translation of Lillebjørn. Here was another little fact I added to the mental notes I was already keeping.

I asked him if there was any other significance to his name, and he relayed something he'd explained to a nephew: "I told him about the bear, and that his Norse name, Bjørn, meant what a bear possesses—twelve men's power and twelve men's wisdom." I had no idea whether this was something I could make use of, but I made a note of it all the same. At this point I was simply gathering; people, places, songs, curious facts were all being added to my mental list.

It was becoming clear to me that the "ultimate Lillebjørn Nilsen guitar" should contain the Lillebjørn Nilsen story. There were so many compelling aspects to his career that to think otherwise made no sense. How to show it? What to include? What to choose as the guiding narrative? I had as yet no concrete ideas. I continued to read, listen, and watch.

I came across the fact that Lillebjørn's translation of "My Rainbow Race" was titled "En Himmel Full Av Stjerner," which means "A Sky Full of Stars." Immediately, a star-filled night sky came to mind, as you'd expect. But in the next moment, I recalled my childhood astronomy lessons in which I'd learned that one of the most common constellations in the northern hemisphere is the Big Dipper, more formally known as Ursa Major, the Great Bear.

The Little Dipper is, of course, Ursa Minor, the Little Bear. It's no wonder my imagination jumped to the idea of Lillebjørn represented as a constellation of the night sky. With that thought, this inlay began the transition from stressful to interesting.

But I was still missing the spine of my storyline. I went back to my reading, absorbing all the bios and histories of Lillebjørn I could find. I repeatedly saw him described as "the voice of Oslo," and he had won the Oslo City Culture Award. This caused me to look closer at the song he had created for his home city, "God Natt Oslo." His city revered him, and it in turn so defined him that I realized focusing on this song might be worthwhile. Translated, I could see that the song was indeed a beautifully crafted tribute to the city, its streets, its people. I understood why it was beloved, and why its composer was too.

Lillebjørn Nilsen - God natt Oslo

Solen har for lengst gått ned bak Vestkanten et sted og
langs fjorden seiler natten sakte inn.
Den legger til ved havna og stryker gatelangs
forkledd som en kjølig sønnavind.
Min by, du ligger rastløs selv om dagen din er over. For
du vet at natten din blir aldri lang.
Ditt lys blir aldri slukket, ingen klapper på din pute -
men av meg skal du få en vuggesang:
God natt, kiære Oslo God natt. God natt.
God natt, kiære Oslo: sov godt inatt!

I Schøningsgate går en enslig kvinne til entreen og
låser med en lenke satt i spenn.
- I morgen er den tyvende, da er pensjonen her
tenker hun og går og legger seg igjen.
På Drammensveien hvisler det en drosje gjennom natten og
ved Skøyen blir den praiet av et par,
som smiler til hverandre i lyset fra kupeen
før døra slår igien og bilen drar

I Tollbugata kjører en Mercedes for seg selv
og en pike står og ser mot Akershus.
Så møtes de i Kongens gate, lyset skifter gult
og ved Vippetangen er de to blitt dus.
Ved Egertorvet står et par og snakker nokså streite.
Den grønne folkevogna har de sett.
Så må de begge flytte seg for siste Sinsen-trikken og
Freia-uret blinker kvart på ett.

Så feier feiebilen Grønlandsleiret opp og ned
fra Enerhaugen ned mot Grønlands torv.
Og Lompa stenger døra og siste giesten går
forbi en mann som sitter stille utenfor.
Fra Vippetangen går en kvinne sakte ned mot Børsen,
ved Grev Wedels plass tar hun en sigarett
og tenker pa en by som er mye mindre enn denne og
en bror som hun så gjerne skulle sett.

I read the lyrics, over and over, in search of an image that would capture the essence of Lillebjørn. I found it frustrating at first, because the song is not about him. After some time it finally dawned on me that the link to my client was not in the song but in its title. What the song symbolizes for Lillebjørn seemed to me a perfect way of indicating where he is rooted, where his creative output emerges from. That is how "God Natt Oslo" became the unifying frame to Lillebjørn's story.

As I'd done previously for *Imagine* (page 64), I made the lettering large enough to encase imagery — only this time I created my own variation of a relatively modern font, choosing it simply because of its pleasing curves. Before I started sketching a rough layout, I took an inventory of what aspects of Lillebjørn's life I wanted to depict:

—　Lillebjørn himself, but not front and centre (I got the sense that he didn't need to grandstand).

—　Lillebjørn as a young boy. I stumbled across an old photo quite by accident and felt it might fit in somewhere.

—　Víctor Jara.

—　Pete Seeger.

—　His daughter Siri. (Lillebjørn has a second daughter, but I could find no images of her. Siri, however, had a flourishing career, so there were published images aplenty of her.)

—　Lillebjørn's own visual art. I liked the idea of his art residing in the midst of my own.

—　The Gitarkameratene group.

I remembered the sky full of stars and Little Bear. I definitely wanted to incorporate those images into the inlay, but squeezing a night sky into the constricted forms of the God Natt Oslo font would not work. I started to think:

This is Lillebjørn's story. He needs to be above and around all aspects of it, but not too overtly. If I put the sky full of stars in the headstock, I could put his current portrait there as one of the constellations. What about the Little Bear? Well, he could be there too. Yes, put a young bear cub front-and-centre of the headstock. Lillebjørn's symbol would thus have the primary role and he, himself, would be "in the wings" of the headstock. That feels right. And perhaps I could sneak the young boy version of Lillebjørn into the frame, suggesting that we all carry our younger selves with us. Now, the young bear cub... what would he be doing? In the ancient sky charts the animals of the constellations were relatively static. But this is Lillebjørn's own Sky Full of Stars. Hah! Yes. The little bear should be doing what Lillebjørn does, playing guitar!

I began flipping through images of Lillebjørn until I confirmed that it was indeed an old Gibson guitar that he was seen performing with more often than not. That's the guitar shape I sketched in, placing the cub's paws on the body and the neck, not cartoon style but in a natural possessive stance.

The words for "God Natt Oslo" became the entire fretboard portion, linking into the headstock with the last letter o. Within the lettering I placed all the aspects of Lillebjørn's life that I, the outsider who had to make guesses, felt were pivotal. As I was completing my drawing, I realized that I too had now become part of Lillebjørn's story, so I slipped myself into the letter at the bottom of the fretboard.

My client refused even to look at the final drawing. He still held an immense trust in what I would create for him. He saw the design for the first time when he flew to Toronto and opened the case. Was he happy? Oh, yes. **x**

Above **Lillebjørn's drawing**
Freddy Reddy.

The Peruggia Caper

In 2011, the Martin Guitar Company celebrated its 1.5 millionth instrument by dedicating its inlay theme to Leonardo da Vinci. The headstock reproduced his *Mona Lisa* painting; the spread-eagled Vitruvian man was inlaid into the back; the plastic pickguard depicted da Vinci's *Last Supper*; and the fret positions were marked with the iconic portrait of the elderly da Vinci. My awareness of this guitar rushed to mind when my client indicated that he wanted a da Vinci theme. "I would like to include da Vinci himself, *Mona Lisa*, Vitruvian man, and the helicopter," he said. "I leave the rest up to you."

I mused aloud that this subject had already been done, and very publicly at that. He wasn't dissuaded. I had little option, and promised to see if I could come up with an original take on the subject. Of course, after that conversation, I realized it was one thing to make a promise like that and quite another to deliver on it. Working in my favour was my desire to always tell a story. Just having disparate da Vinci works decorating a guitar isn't my idea of a satisfying design, not to mention its lack of narrative. I took encouragement from this and set out to uncover a story. Of course, my first task was to obtain clear images of all the requested elements.

Some years earlier, my wife and I had been given a gift of a very large and heavy book exhaustively covering the complete works of da Vinci, including every page of his famous notebooks. I hauled the thick book to my workshop and, for the first time since we'd received it, began reading it in depth. I was enjoying seeing the exquisite details of every painting and drawing, and learning about da Vinci's life and times. Filled as they were with speculative devices and precise human anatomy, his notebooks proved to be fascinating. But I wasn't sensing a narrative that could link together the elements I'd been tasked with including.

Next I tried Google, starting with what Wikipedia had to say about the *Mona Lisa*. I already knew the painting was a portrait of Lisa del Giocondo. But as I was scrolling through the painting's history, reminding myself to find out more about Ms. del Giocondo, I was surprised by a section titled "Theft and Vandalism." It appears that the *Mona Lisa* was stolen only once in its lifetime, in 1911, when Vincenzo Peruggia, an Italian employee of The Louvre in Paris, hid the painting under his smock after closing hours and simply walked out the door. His reason? To return the *Mona Lisa* to its rightful home in Italy. What made this theft so important, I soon learned, was that until that event the portrait was largely unknown outside of the art world. Even within art circles it was simply lumped in with many other Renaissance portraits and wasn't considered particularly exceptional. But the notoriety surrounding the theft, as well as its return to The Louvre fully two years later, propelled the *Mona Lisa* on a trajectory toward being acknowledged as a masterwork. Today, it's arguably the most recognized painting in the world—and it's all due to Peruggia. Now, here was a story!

I found images of Peruggia, taken by the police, staring right at the camera, his thick curling moustache dominating his face. I read a few more accounts of the theft. The more I read, the more a storyline was solidifying. I contacted my client and checked that he'd accept a humorous aspect to his theme. His answer was yes.

I'd decided to depict Peruggia scurrying from The Louvre with the painting under his smock. The scene would have to leave enough of the painting revealed for us to recognize it—

My stand-in model for Peruggia.

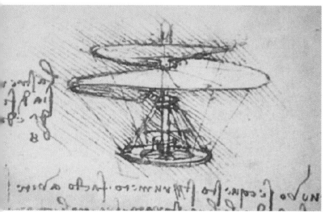

Da Vinci's design for a helicopter, from his notebooks.

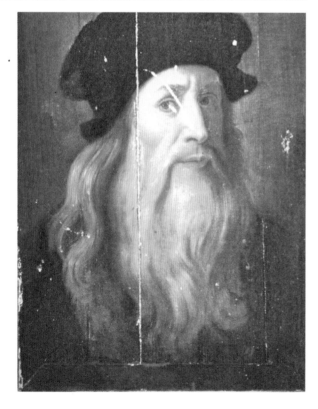

The Lucan portrait of the young da Vinci.

a slight stretching of the truth, as I can't imagine Peruggia wouldn't have fully covered it, but it would serve my purpose. One account said the painting's outer frame was discarded in a stairwell, so I knew I could show the painted image right to the edge of its underframe. But where was this story going? I pictured da Vinci and his creations all attempting to stop the theft. I'd alter the Vitruvian man so that he'd be eyeing Peruggia and trying to prevent him from escaping by grabbing one of his feet. I'd show da Vinci launching his helicopter, presumably to give chase. I was loving this idea and couldn't wipe the smile off my face.

Before starting to draw, I hired a musician friend to model for me. He was roughly Peruggia's age when the theft occurred. From a theatrical costume supply house he rented an artist's smock, of the type worn at the turn of the twentieth century. I cut a piece of cardboard to the precise dimensions of the painting, and instructed him to be walking forward with it under his arm, but cautiously looking behind him for pursuers. I now had my Peruggia. I considered using da Vinci's iconic image of the old man with long hair and beard, but it has never been authenticated as the self-portrait many believe it to be. It may well just be a drawing he made of an unnamed elderly man. So, I looked further. As recently as 2008, a portrait emerged that appears to be a true likeness of da Vinci, albeit as a

younger man. This painting, dubbed the Lucan portrait in honour of the ancient name for the southern Italian township of Vaglio Basilicata where the portrait currently hangs, became the basis for my depiction of the man launching the helicopter.

I liked how this design was evolving as I sketched it out, but something was nagging at me. That iconic image of the elderly man must surely be what my client was expecting, yet I had no place for him in my playful tale. I wasn't certain how to solve this dilemma, so I let the problem simmer while I worked on the elements of the drawing I already had. As I positioned my "players" and my sketch progressed down the fretboard, I noticed a sizeable area of uncovered real estate near where I'd placed the Lucan da Vinci. As I stared at this space, I found myself thinking the phrase "da Vinci is behind all of this." I'm not sure where that came from, but it was quickly replaced with an image of da Vinci "behind" the story. It occurred to me that if I placed the elder portrait at right angles to the narrative, the man (da Vinci?) would appear to be separate and overlooking the scene. It would almost appear as if the elderly man were observing the actions of his younger self.

To further accentuate the fact that this portrait is only the backdrop to the narrative, I filled my engraved cuts not with black but with the milder shade of red, simulating the original red chalk used almost universally for sketching in da Vinci's era. ✖

AFTERWORD

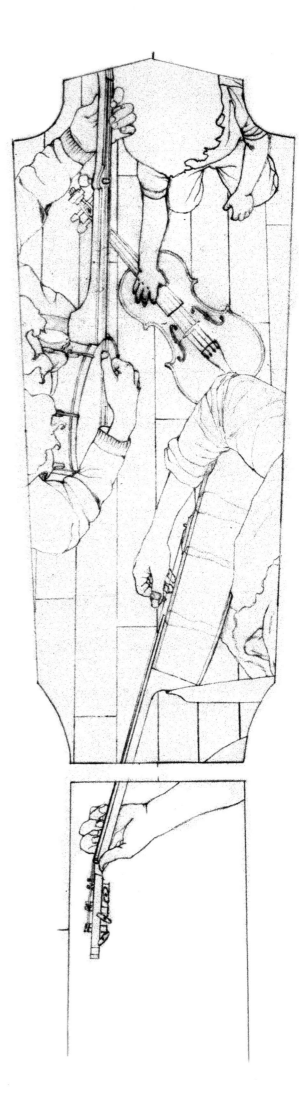

At every moment of our lives we are surrounded by stories. In songs, novels, plays, musicals, dance, visual art, conceptual art, television drama, reality shows, cooking shows, newscasts, journalism, the Bible, the Torah, the Koran, and even the best advertisements or old-fashioned gossip, stories are what engage us. They are truly how we learn about and connect to the world.

For me, this love of stories began when I was a child, listening to my parents read bedtime stories that I never wanted to end, and then sitting rapt on the carpet during storytime in kindergarten. Next came comic books and young adult novels. As a teenager, in addition to developing what became a lifelong love of fiction, I found stories in music, especially the dramatic story-songs of earlier traditions. So it was only natural that, as I found my confidence in guitarmaking and inlay, I would drift away from the typical decorative approach to use the medium to tell my own stories. What attracts me to any and all art forms is story, and if I can successfully illustrate mine then I am successfully communicating. That's always been my goal. I want to engage you, my audience. I hope I've done that.

When my wife and I go to a movie, we always stay seated through the credits. It's our way of showing respect for those who have done all the work. Every so often a director rewards the handful of us still in the theatre with an outtake. In the same manner, I'd like to thank you for reading to these last pages. Here is a drawing of an inlay I've remained fond of — a final Short Story. The full project is not included in the book because I never managed to take proper photographs of the finished work. This drawing is all I have. It's titled *Pass the Music On.*

Grit Laskin, November 2015

ACKNOWLEDGMENTS

There are many who deserve thanks.
At the top of that list is my agent Bill Hanna, of Acacia House Publishing Services, who championed this book on both sides of the Atlantic for more than three years until at last he found it its perfect home, with Figure 1 Publishing. Bill, your perseverance was a gift.

To help me raise my financial contribution to the publishing of this expensive book, my dear and talented friends Cathy Fink and Marcy Marxer, Grammy-winning artists and producers, insisted that an online crowd funding campaign would work. And because they were the energetic directors of that campaign it did work! I'll never be able to thank them enough for all their time and effort. That Indiegogo campaign brought in 194 backers from thirteen different countries, all of whom deserve thanks for being willing to pre-buy and invest in an elaborate book many months away from fruition. But there were a few who contributed more than their share and became what I labeled my Special Supporters and my Contributors, and I want to name them here:

Special Supporters:
Kerry Bourgeois
Rena and Ken Kirshenbaum
Martha Pedersen
Kevin Rank
Charles Tauber
Glenn Webster

Contributors:
Emilyn Stam
Agave Guitars

It has been a pleasure to work with the entire team at Figure 1, Chris, Richard, Lara, Jennifer, Natalie, Jessica, Mark, Lucy, Lesley, Renate. You've all made me feel welcome and special. I particularly want to thank Jennifer for her friendly and supportive management of this project, Natalie for the honour of her stunning design work, and Lucy for the best editing I've ever experienced.

And how could I not thank all of my guitar clients? Without your commissions I wouldn't be having all this fun, and there would be nothing to write a book about!

As ever, because she is my rock and the love of my life, I want to thank my wife, Judith. She supports me in all I do and in every way she can. I am a very lucky man.

WILLIAM "GRIT" LASKIN is a master guitar-maker, a musician and songwriter, an artist and a storyteller. He's been hand-building guitars for more than forty-five years for such luminaries as Stan Rogers, Jesse Cook, Rik Emmett, and k.d. lang, inlaying many of these instruments with his personalized designs.

A member of the Order of Canada, winner of the Saidye Bronfman Award for Excellence (Canada's most prestigious craft award), co-founder of the Association of Stringed Instrument Artisans (A.S.I.A.) and both Borealis Records and the Canadian Folk Music Awards, Laskin is a true craftsman, and his insights make fascinating reading for lovers of art, music — and the creative process.

Cataloguing data available from Library and Archives Canada
ISBN 978-1-927958-84-1 (hbk.)

Editing by Lucy Kenward
Copy editing by Lesley Cameron
Proofreading by Renate Preuss
Design by Natalie Olsen
Cover photograph by Brian Pickell
Author photograph by Naomi Finlay
Printed and bound in China by C&C Offset Printing Co., Ltd.
Distributed in the U.S. by Publishers Group West
Distributed outside of North America by Prestel Publishing

Figure 1 Publishing Inc.
Vancouver BC Canada
www.figure1pub.com

LANG & SON
- "DATEBOXES"
 best for a date
- GLASHÜTTE
 - engraving
 on back
 spring
 — add to date
 info
MARIE ANTOINETTE
watch just
recovered
 (BREGUET)
 made
 → his
 patron

something
from this?

89

144

3 2 1
 1

21 13
 5 8

55

34